FRENCH PAINTINGS FROM THE USSR

Watteau to Matisse

THE NATIONAL GALLERY LONDON

15 June – 18 September 1988

BP

Sponsored by The British Petroleum Company p.l.c.

NATIONAL GALLERY PUBLICATIONS
Published by order of the Trustees

© The National Gallery 1988

BRITISH LIBRARY CATALOGUING IN PUBLICATION DATA
French paintings from the USSR: Watteau to Matisse.
1. French paintings – Catalogues
I. National Gallery, London, England
759.4'074
ISBN 0–947645–55–1
ISBN 0–947645–48–9 Pbk

Printed and bound in Great Britain by
W. S. Cowell Ltd.

FRONT COVER Picasso. *Les Deux saltimbanques.* © DACS 1988
BACK COVER Robert. *The Villa Madama, Rome.*

© Ministry of Culture of the USSR
excluding Forewords and Biographies

Catalogue authors
A. A. Babin E. G. Georgievskaya
M. A. Bessonova A. G. Kostenevich
E. V. Deryabina I. A. Kuznetsova

Exhibition co-ordinated by
Dr Vitaly Suslov John Leighton
Dr Irina Antonova Alistair Smith

Exhibition design by
Robin Johnson Design Consultants Limited
Herb Gillman (National Gallery Design Studio)

Audio-visual programmes
Joan Lane, Carol McFadyen,
Neil Aberdeen, John Leighton, Alistair Smith

Catalogue designed by
Trevor Vincent

Catalogue translated by
Irene Gore and Catherine Matthews

Catalogue edited by
Lucy Trench and Diana Davies

ACKNOWLEDGEMENTS
Sue Curnow, Jacqui McComish, Margaret Stewart
Hugo Swire, Joanna Kent, Jean Liddiard, Lindsey Callander
John Morrissey, Ann Stephenson-Wright

PICTURE CREDITS
The Mansell Collection: Lampi, *Catherine the Great.*

© Novosti Press Agency: The Hermitage, Leningrad;
The Pushkin Museum, Moscow (Photo I. Zotin)

Contents

Foreword

The arrival in the National Gallery of thirty-eight great French paintings from the Soviet Union is cause for serious celebration. They are of course pictures of the highest quality. But they are more than that: they offer a conspectus of one of the great schools of European art, which is not available in any single gallery in London. For admirable historical reasons the tale of French painting from Watteau to Matisse is, in London, told in fragmentary chapters divided among the Wallace Collection, the Courtauld Institute, and the National and Tate Galleries. For the next three months, thanks to the generosity of the Hermitage State Museum (Order of Lenin) and the A. S. Pushkin State Museum of Fine Arts, it will be possible to follow that story through supreme examples in Trafalgar Square.

At the same time an equal number of National Gallery masterpieces from all schools will be exhibited in Leningrad and Moscow. There is a pleasing historical aptness about the National Gallery's participating in this remarkable Anglo-Soviet venture; for the nucleus of our collection, purchased by the Government in 1824 to form the National Gallery, was the group of old master paintings put together by Julius Angerstein, a Russian who had long lived in London. And we hope that this present exchange of pictures will be the first of many co-operative ventures of all kinds between the three institutes.

It would not have been possible for us to mount this exhibition without the extreme generosity of British Petroleum PLC, who have also assisted with the production of the catalogue. The National Gallery is most grateful that they have enabled us to bring these pictures before a British public and to show them to our visitors free of charge.

Our debt of gratitude to our Soviet colleagues is great, in particular to Dr Vitaly Suslov at the Hermitage, Dr Irina Antonova of the Pushkin Museum, and to Mr Grigor Fedosov, Cultural Attaché at the Soviet Embassy in London and his assistant Mrs Inna Khanzhenkova. Catalogue entries compiled by A. A. Babin, M. A. Bessonova, E. V. Deryabina, E. G. Georgievskaya, A. G. Kostenevich and I. A. Kuznetsova were translated by Irene Gore and Catherine Matthews. Within the Gallery's own staff, many have shouldered the considerable burdens that such an exhibition brings. Special mention must, however, be made of Herb Gillman, Head of the Design Studio, Margaret Stewart, the Registrar, Lucy Trench who has overseen much of the catalogue production, and Alistair Smith and John Leighton, who negotiated the exchange of paintings and carried most of the administrative burdens of the exhibition. We are also indebted to the Oppenheimer Charitable Trust. To all of them I should like to express the National Gallery's thanks.

Neil MacGregor Director

Sponsor's Preface

BP's arts sponsorship programme is chiefly aimed at young people with a view to helping them understand and enjoy the great heritage of artistic wealth that has been passed down to them. It is also designed to help them participate in continuing the process of artistic creativity.

We are delighted to be associated with the Exhibition of French Paintings from the USSR at the National Gallery because it meets so many of the objectives of our sponsorship programme and more besides.

It will enable young people, and adults alike, not only from the UK, to see, for perhaps the only time in their lives, these outstanding examples of the French masters. It also helps to illustrate what can be done at an international level, given cooperation and commitment by the parties involved.

The National Gallery in London, The Pushkin Museum in Moscow and The Hermitage in Leningrad are to be congratulated on the agreement to the exchange of these wonderful paintings and we extend to them our best wishes for the success of the Exhibitions both here and in the USSR.

Sir Peter Walters, Chairman, The British Petroleum Company p.l.c.

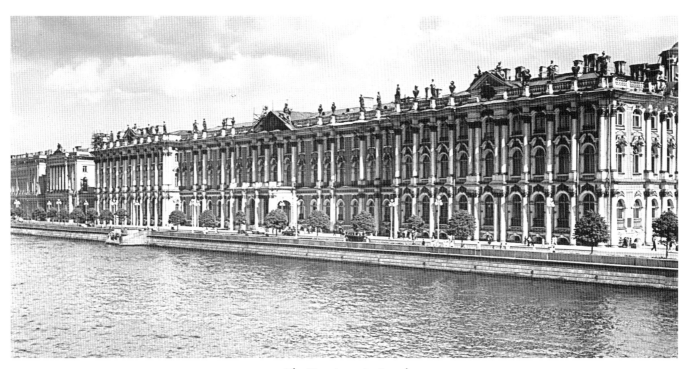

The Hermitage, Leningrad

The Hermitage, Leningrad

In Russia the methodical collecting of art was initiated by Tsar Peter the Great (r. 1682–1725), who also took the first steps towards the creation of museums. In order to study the art and science of the Western world and to make use of them for the benefit of his own country, he travelled extensively in Europe. On his second visit to Paris, in 1717, he became interested in the work of the Académie Royale to which he was elected as an Honorary Member. He also took an interest in various crafts, including textiles. At that time he commissioned from Jean-Marc Nattier a portrait of his wife, the future Empress Catherine I, and then a portrait of himself, conceived as a pair. It was also during that visit that the emperor decided to invite the French artists Louis Caravaque, Philippe Pillement and François Jouvenet to Russia.

The interest in French art was further kindled in Russia during the reign of Peter's daughter, Elizabeth (r. 1741–1762). The best-known portrait painter in Paris, Louis Tocqué, came to work at her court for a year and a half. The St Petersburg Academy of Arts was also founded in her reign, taking the Paris Académie as a model.

However, the most consistent development of cultural and collecting activity in Russia occurred in the reign of Catherine II, known as Catherine the Great (r. 1762–1796). This resulted in the formation of the Hermitage gallery, which was begun a year after Catherine's accession to the throne and was politically significant in Russia's claim to a leading place among the great powers of Europe.

The date of the foundation of the Imperial collection is usually taken as 1764, when the first of the important acquisitions made by Catherine reached St Petersburg, forming the basis of the museum which became known as the Hermitage. The collection had belonged to the Berlin merchant Johann Ernest Gotskovsky, and had been offered in settlement of his debt to the Russian Treasury. It consisted mainly of Dutch and Flemish paintings, but also had three pictures by French artists. This first purchase was followed by a series of acquisitions reflecting a planned and considered formation of the gallery, and some of the best-known collections in Europe were acquired one after another for St Petersburg.

5

In her selection of both individual works of art and of complete collections, Catherine allowed herself to be guided by experts. She corresponded avidly with many of the prominent French writers of the day and three of her mentors – the celebrated philosopher and art critic Denis Diderot, the sculptor Etienne-Maurice Falconet and the critic Melchior Grimm – spent time in Russia. In addition, Russian ambassadors to European courts, together with other 'special agents', were given leave to exercise their initiative to the full.

Works by both old and contemporary masters were acquired in Dresden, London, and Rome, but principally in Paris, which had become the main European market for works of art and was seen as the centre of artistic taste. One of the most erudite men in Russia, Prince Dmitrii Golitsin, who was the Russian ambassador to Paris and The Hague, contributed greatly to the progress of these acquisitions.

Golitsin became involved when the empress requested him to arrange several commissions on her behalf. For the projected monument to Peter the Great in St Petersburg, Golitsin recommended, on Diderot's advice, the sculptor Falconet and signed a contract with him in 1766. A little later Falconet came to Russia and brought with him two paintings, one by Chardin, the other by Boucher, who were the two leading painters at the time. Chardin's *Still Life with the Attributes of the Arts* (no. 10) had been commissioned from Chardin by Golitsin a year earlier and was destined for the St Petersburg Academy of Arts. Golitsin had also acquired '*Le Paralytique*' by Greuze (no. 11) at that time. The picture had appeared at the 1765 Salon and thanks to Diderot, who exalted it as a great example of 'moral painting', had become renowned throughout Europe. The two paintings by Claude-Joseph Vernet in the present exhibition – *The Villa Ludovisi* (no. 8) and *The Villa Pamphili* (no. 9) – were commissioned in 1746 by the Marquis de Villette and completed in 1749; they were acquired by Catherine the Great in the 1760s.

The late 1760s and the early 1770s saw the arrival at the Hermitage of three important collections, without which the museum would hardly have achieved its present status. These were the collections of Count Heinrich von Brühl (1769), François Tronchin (1770) and Pierre Crozat, Baron de Thiers (1772). The Brühl and the Crozat collections included several masterpieces of eighteenth-century French painting.

The collection of the Saxon Prime Minister, Count Heinrich von Brühl (1700–1763), was acquired in Dresden. Brühl had been in charge of accessions to the gallery of the Elector of Saxony and King of Poland and had built up a collection of his own which was in many respects the equal of the royal one. Together with the principal holding of Dutch and Flemish pictures, the Hermitage received two works by Antoine Watteau: '*La Proposition embarrassante*' (no. 2) and the *Holy Family*.

In the eighteenth century the celebrated Paris collection of Pierre Crozat (1665–1740) was second only to that of the Duc d'Orléans. Crozat, an outstanding connoisseur and collector,

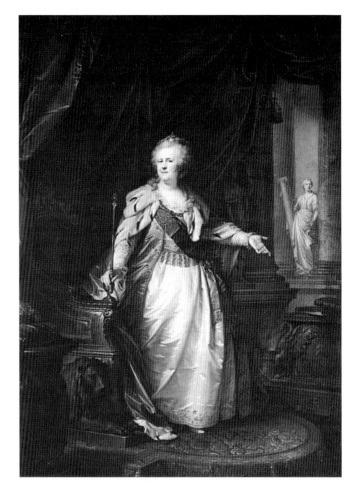

G. B. Lampi: *Catherine the Great.* Leningrad, The Hermitage

spent a fortune on the acquisition of paintings in France and of drawings in Italy. His collection, begun at the end of the seventeenth century, numbered approximately four hundred works and included masterpieces from literally every school. After the death of Crozat it passed through inheritance to three successive owners with various changes and further additions, especially of French works. When the last of these owners, Louis-Antoine Crozat, Baron de Thiers, died in 1770, the gallery was in danger of being sold at auction. Thanks to the Geneva collector, Councillor François Tronchin, however, it came to the notice of Diderot and Golitsin, and in 1772 the entire collection was acquired by Catherine the Great. This acquisition was highly significant for the general character of the St Petersburg gallery since it laid the foundation for its collection of seventeenth and eighteenth-century French painting.

The inventory made by Tronchin records under no. 369 a landscape by François Boucher which coincides precisely in size with that in the Hermitage, signed and dated 1746. It can be identified with a good deal of certainty as the picture included in the present exhibition and known as the *Landscape with a Pond* (no. 6). Another work, also in the

present exhibition, was the finished study for the composition of *The Mass of Saint Basil* (no. 3); it was acquired by L.-A. Crozat de Thiers, the last owner of the collection.

The sale of the Crozat de Thiers collection to Russia caused a storm of protest in Europe. Diderot in Paris wrote to Falconet in St Petersburg during the negotiations for the sale: 'I am the object of absolutely genuine public hatred – and do you know why? Because I am sending you paintings. There is an outcry from connoisseurs, from artists, from the wealthy . . . The Empress wishes to acquire the collection at a time of devastating war: this humiliates them and throws them into confusion.' (D. Diderot to E. M. Falconet, 20 March 1772.).

By 1783 the Hermitage collection already had about one hundred and fifty works by eighteenth-century French artists, among them thirteen by Watteau, five by Pater, eleven by Lancret, eight by Greuze, one by Vernet, six by Van Loo and one by J.-B. Pierre. The initial period of the formation of the Palace collections, which were the personal property of Catherine the Great, came to an end at the death of the empress in 1796.

FROM PALACE GALLERY TO MUSEUM

During the nineteenth century very little was added to the collection of eighteenth-century French painting, although the picture gallery continued to acquire individual works and whole collections: the interest in eighteenth-century art had disappeared. The Hermitage acquisitions came largely through transfers from royal country residences to which the pictures had been removed by members of the Imperial family. Important new acquisitions for the collection of French painting – and for the Hermitage in general – came after the October Revolution of 1917, when the museum received large private collections and individual works which had been nationalised.

Most of these private collections – including those of the Yusupov, Stroganov, Belosel'skii, and Shuvalov families – were started as early as the eighteenth century, at the same time as that of the Palace gallery. That of Chancellor Prince Aleksandr Bezborodko was one of the most important. Towards the end of his life, in 1798, he bought the Greuze painting 'L'Enfant gâté' (no. 12), which had earlier belonged to César-Gabriel de Choiseul, Duc de Praslin. After the Chancellor's death, his collection was divided between his heirs. Part of it came to the Academy of Arts, part was sold, and that is how 'L'Enfant gâté' came to the Hermitage after the Revolution as part of the collection of the Princes Paskevich.

After the Bezborodko collection that of Count A. S. Stroganov, formed in the early nineteenth century, was the largest and most important. It remained more or less unchanged up to the beginning of the present century. Among the finest eighteenth-century French paintings in the Stroganov collection was 'La Boudeuse' by Watteau (no. 1). It was bought by P. S. Stroganov in the 1850s and at one time

had belonged to one of the most distinguished collectors of the eighteenth century, the British Prime Minister Robert Walpole, first Earl of Orford (1676–1745). It had then passed to his younger son, the author and art connoisseur Horace Walpole of Strawberry Hill.

The third large collection formed in the eighteenth century, and also preserved intact until the present century, belonged to the Princes Yusupov. The collection of Nikolai Yusupov was already regarded as outstanding as early as 1777. It has been of particular significance for the Hermitage because Yusupov's preference was for eighteenth-century French painting. He was a great connoisseur, and in Paris made the acquaintance of Claude-Joseph Vernet, Hubert Robert, and other artists. His collections in St Petersburg and at his estate Arkhangelskoe, near Moscow, contained many pictures by Robert. *A Ruined Terrace* (no. 14) is considered to be the best of Robert's works in the Yusupov collection and one of the most interesting in the artist's œuvre. The two oval decorative medallions by Boucher – *The Birth and Triumph of Venus* (no. 4) and *The Toilet of Venus* (no. 5) – were evidently acquired after the death of the founder of the Yusupov gallery.

In 1922 the Hermitage received from the Academy of Arts its collection of Western European pictures. This contained a wide selection of eighteenth-century French painting, including the two Vernet landscapes, *The Villa Ludovisi* (no. 8) and *The Villa Pamphili* (no. 9) (which Catherine the Great had acquired specially for the Academy), and the *Self Portrait* by Madame Vigée-Lebrun (no. 16). This well-known portraitist had left France because of the Revolution. She spent six years in Russia where her work became very popular, with commissions from the court and from private individuals, and was recognised by the St Petersburg Academy of Arts. A year before leaving for France in 1800 she presented the *Self Portrait* to the Academy and was awarded the title of Honorary Associate. The portrait, like those of other Academicians, hung for many years in the conference hall at the Academy.

THE TWENTIETH CENTURY

Although in the second half of the nineteenth century St Petersburg collectors showed an interest in contemporary French painting, the interest of a constellation of Moscow collectors was undoubtedly far more significant. Particularly prominent among these were two entrepreneurs who belonged to the ranks of the progressive bourgeoisie: Sergei Shchukin and Ivan Morozov whose activities are described below in the section on the Pushkin Museum. Both acquired works of art in Paris through leading French dealers who offered them the very best paintings. Morozov's collection of Impressionists and Post-Impressionists was unique in Europe. The present exhibition includes, from the Hermitage, Cézanne's *Still Life with Curtain* (no. 29), which is one of seventeen paintings by Cézanne from Morozov's collection. In the early twentieth century his group of Cézannes was arguably the

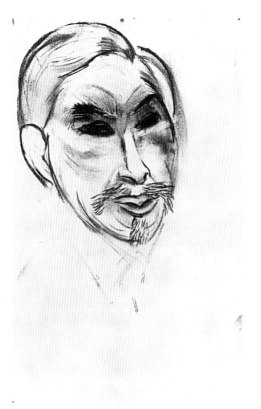

Henri Matisse: *Portrait of Sergei I. Shchukin.* Drawing. 1912.
Private Collection

This exhibition of some of the outstanding masterpieces from the Hermitage collection helps to illustrate the principal developments in French painting that took place during the two hundred years separating Watteau from Picasso.

The first half of the eighteenth century saw the development of the refined, worldly, Rococo style in French art, which was followed by the gradual emergence of an antithetical movement associated with the Age of Enlightenment.

The work of Antoine Watteau (1684–1721) marks a turning point in French art. He conveyed the most subtle emotional nuances and fleeting expressions of the spirit. The paintings included in the exhibition, 'La Boudeuse' (no. 1) and 'La Proposition embarrassante' (no. 2), belong to the genre created by Watteau which resulted in his being described as the 'Maître des Fêtes Galantes' by the Paris Académie. Courtly scenes are set against a background of imaginary gardens. The often enigmatic subject-matter is permeated by a mood of melancholy reverie. A wistful lyricism veils the faces of his characters, the unreal landscapes, and the muted silvery-brown, pale green and yellowish-rose tints. The decorative refinement of the artist's work served as a basis for the Rococo style, although the spiritual content of his paintings was very much more profound and subtle than that of his successors. Watteau was unique within his era, a solitary and sad observer of the festivities in which other Rococo artists took pleasure.

The sensuous and hedonistic art of the Rococo, developed in the 1730s, reached its summit in the work of François Boucher (1703–1770), the premier court painter. The refined execution, virtuoso draughtsmanship and imaginative colour which pervade his oeuvre were developed in the work of purely decorative intent which he undertook for the theatre and for the Gobelins tapestry factory. This can be seen not only in the pair of oval pictures in the exhibition (*The Birth and Triumph of Venus*, no. 4, and *The Toilet of Venus*, no. 5), but also in Boucher's genre and landscape paintings, the latter exemplified by the *Landscape with a Pond* (no. 6). The famous *Virgin and Child with the Infant John the Baptist* (no. 7) from the Pushkin Museum demonstrates how this pleasurable and essentially secular style was employed even in religious compositions.

The late 1730s brought with them the parallel development of a new and opposing direction in art, associated with the more bourgeois aesthetic ideals of the Third Estate and the spread of the ideas of the Age of Enlightenment. These new tendencies favoured the development of genre, still-life and portrait painting. The emerging democratic ideals of French culture were embodied in the work of the artists of the Third Estate: Jean-Siméon Chardin (1699–1779) and Jean-Baptiste Greuze (1725–1805). In contrast to the artificiality of the Rococo style, the lucid and logical art of Chardin emphasised the value of reality and the beauty of everyday life. But his

best in the world, being of exceptionally high quality and containing examples of all the genres of the artist's work.

Shchukin, a major patron and one of the most enlightened men of his time, knew many painters, among them Matisse and Picasso. He started collecting French paintings in 1890. His first enthusiasm was for the Impressionists, then he turned to Cézanne and Gauguin, and finally came to appreciate Picasso as well. Shchukin's collection had fifty-one works by Picasso, including such masterpieces as *Two Sisters, Dance with Draperies, Three Women*, and *The Dryad* which is included in the present exhibition (no. 34). Sisley's *Village on the Seine* (no. 20) and Gauguin's 'Te Avae No Maria' (no. 25) came from the Shchukin collection. All these works came to the Hermitage after the Second World War, when the Moscow State Museum of Modern Western Art was abolished and its collection divided between the Pushkin Museum and the Hermitage.

At present the French collection in the Hermitage is one of the richest in the world. It contains over seven hundred pictures of the seventeenth and eighteenth centuries and over eight hundred of the nineteenth and twentieth centuries. It has become widely known, largely through exchanges of exhibitions and loans of individual works which have been shown in France, Switzerland, Czechoslovakia, Hungary, the USA, Italy, East Germany, Japan, and other countries.

fame rested particularly on still life, exemplified here by the *Still Life with the Attributes of the Arts* (no. 10). Diderot was so impressed by Chardin's talents that he referred to the artist as one of the foremost colourists in painting: 'How the air moves around these objects! . . . Here is one who understands the harmony of colours and reflections.'

By the middle of the eighteenth century the ideological struggle of the adherents of Enlightenment became particularly acute, and art was now seen to have a social role. These aspirations led to the emergence of 'moralising' art which idealised bourgeois virtues. The sentimental and moralising movement in painting was headed by Greuze. His *'Le Paralytique'* (no. 11) was greatly admired by Diderot and in a sense became a prototype for the artist's subsequent paintings.

In the second half of the eighteenth century the new philosophical theories, and in particular the writings of Jean-Jacques Rousseau, stimulated an interest in nature, and consequently in landscape painting. The most important representatives of this genre, who continued and developed the traditions of Claude Lorrain and Nicolas Poussin, were Claude-Joseph Vernet (1714–1789) and Hubert Robert (1733–1808). Both were interested in nature and the various effects of lighting in nature; both liked to sketch out of doors and then used their sketches for their paintings. Vernet became celebrated chiefly for his marine works, but a pair of fine landscapes can be seen in the present exhibition. From the early, Italian, period of the artist's work, they show the Villa Ludovisi (no. 8) and the Villa Pamphili in Rome (no. 9).

Those artists who made the pilgrimage to Italy found themselves inevitably influenced by both the art and the landscape which they found there. In particular, Hubert Robert, travelling there with Fragonard, made drawings of many of the Roman villas and gardens. Such sketches were used in his view of the Villa Madama, Rome (no. 13). The later, Parisian, period is represented by *A Ruined Terrace* (no. 14). Both artists became extremely popular in Russia, with the result that the Hermitage collection has twenty-seven pictures by Vernet and fifty-two by Robert.

The lyrically intimate art of Robert's travelling companion, Jean-Honoré Fragonard (1732–1806) has many associations with Rococo traditions. Particularly well known are his *scènes galantes*, such as *'Le Baiser à la dérobée'* (no. 15), and his landscapes, imbued with genuine emotion, in which the use of subtle tints and rich *chiaroscuro* create a characteristic airy atmosphere.

The art of the first half of the nineteenth century is represented in the exhibition by the only painting by Jean-Auguste-Dominique Ingres (1780–1867) in the possession of the Hermitage. The *Portrait of Count Guryev* (no. 18) is one of his best works, combining complexity and individuality of characterisation with the classical rules governing the composition of a formal portrait.

A link between this traditional, classical approach and the impressionistic styles that were to follow later in the century can be seen in a work by Alfred Sisley (1839–1899). *A Village on the Seine* (no. 20) is outstanding among his paintings. On the one hand it retains the strict balance of frontal composition and on the other it depicts sunlight with the feeling characteristic of artists of the new movement.

The greatest exponent of Post-Impressionism was Paul Cézanne (1839–1906). He endeavoured to capture the essence of visual phenomena and to find new imagery to express the harmony of nature. *Still Life with Curtain* (no. 29) belongs to Cézanne's late period and is one of his finest still-life pictures.

The Hermitage collection has fifteen paintings by Paul Gauguin (1848–1903) from his Tahitian period. *'Te Avae no Maria' (Woman holding Flowers)* (no. 25) is one of his later works, in which the artist combined traditional Christian motifs with the pagan beauty of tropical nature.

Finally, the Hermitage contribution to the exhibition includes *The Dryad (Nude in the Forest)* (no. 34) by Picasso (1881–1973) which, together with some other of his works, played an important part in the development of Cubism.

E. V. Deryabina

The Pushkin Museum, Moscow

The Museum of Fine Arts (now the Pushkin State Museum of Fine Arts) was opened in Moscow in 1912 to house casts of sculptures from all over the world. In 1924 it became a gallery of Western European paintings. These were acquired from various sources, largely from important private collections which came to the State Museum at that time. A significant number of paintings from the Rumiantsev Museum in Moscow and, over a period of time, a number of outstanding canvases from the Hermitage collection also came to the Pushkin Museum. In its turn the Hermitage received from Moscow some masterpieces of late nineteenth and early twentieth-century French painting.

The French school is particularly well represented at the Pushkin Museum with seven hundred works, dating from the sixteenth century to the mid-twentieth. The Museum frequently lends pictures to exhibitions devoted either to various art-historical periods or to the work of particular artists. It also stages, usually in conjunction with the Hermitage, complete exhibitions abroad, selected from its collection of French paintings. In return it hosts exhibitions from abroad, as well as loans of individual paintings for its special-theme exhibitions. The Moscow public well remembers, among others, the splendid exhibitions of English paintings from British museums (1960), of English watercolours (1974–5), and of the work of Turner (1975–6).

The present exhibition of thirty-eight paintings, sent to London jointly by the Pushkin Museum and the Hermitage in exchange for an exhibition of masterpieces from the National Gallery, offers the British public some of the best examples of the Pushkin collection of French paintings. Most of these date from the nineteenth and early twentieth centuries – the large group of earlier pictures (discussed above) from the Hermitage is complemented by just four canvases of that period from the Pushkin Museum.

THE EIGHTEENTH AND NINETEENTH CENTURIES

The French collection in the Pushkin Museum is remarkably rich for historical reasons. Close cultural ties between Russia and France were established in the eighteenth century. During the reign of Catherine the Great, Russian nobles began to fill their palaces with notable collections of paintings, and French works occupied an important place. A third of the four hundred paintings in Prince Yusupov's collection were French, among them works by Claude Lorrain, Boucher, Greuze, and Jacques-Louis David. At present these paintings hang in the Hermitage and in the Pushkin Museum alongside pictures from the celebrated collections of the Stroganovs, the Shuvalovs, and the Vorontsov-Dashkovs. *The Virgin and Child with the Infant John the Baptist* by Boucher (no. 7) came from the last of these. Painted in 1758, the year after the *Rest on the Flight to Egypt* in the Hermitage collection, it is one of several major religious works that Boucher painted for the Marquise de Pompadour in the late 1750s. The painting was generally well received when it was exhibited at the Salon of 1759 and even Diderot, who was later to become one of Boucher's fiercest critics, remarked, ' . . . I should not mind owning this painting'.

The other eighteenth-century exhibits from the Pushkin Museum come from equally distinguished collections. *The Villa Pamphili* by C. J. Vernet (no. 9) is one of a pair commissioned by the Marquis de Villette in 1746 and later acquired by Catherine the Great. It belongs to the best period of the great landscape painter's work, and is full of a freshness and spontaneity of perception that is not to be found in his later pictures. The pendant, *The Villa Ludovisi* (no. 8), is now in the Hermitage collection and, happily, the two paintings are reunited in this exhibition.

Of particular interest is the study (no. 17) by Jacques-Louis David for his celebrated painting '*La Douleur d'Andromaque*' (1783, Louvre, Paris), which was the artist's *morceau de réception* for the Académie. The study illustrates the austerity of French Neo-classicism, with its ideals of moral stoicism and civic duty. Originally from the collection of N. Demidov, the Russian ambassador to Florence in the early years of the nineteenth century, it was later acquired by Auguste Montferrand, the architect of St Isaac's cathedral in St Petersburg. It changed hands several times before being purchased by the Hermitage, and eventually, in 1927, it came to the Pushkin Museum.

David's pupil, Ingres, is represented by his dispassionate *Virgin with the Host* (no. 19). Frozen in its academic perfection, this work shows just one aspect of the complex and ambivalent talent of the artist, who attempted to invest the severity of classical form with a sense of living reality.

I. Kuznetsova

The Pushkin Museum, Moscow

IMPRESSIONISM AND POST-IMPRESSIONISM

The year 1948 was a landmark for the French collection in the Pushkin Museum: it saw the acquisition of the magnificent group of Impressionist and Post-Impressionist paintings from the abolished Museum of Modern Western Art in Moscow. The treasures of that remarkable museum were divided between the Pushkin Museum and the Hermitage. The collections at the Pushkin Museum were thus enriched with masterpieces by Monet, Renoir, Cézanne, Van Gogh, Matisse, Picasso, and other twentieth-century masters. This initiated a new era at the Museum, continuing to this day, of close study, popularisation, and acquisition of new works.

In the second half of the nineteenth century Russian artists and writers followed the various new developments in French art and literature with unflagging interest. Impressionist paintings attracted the attention of two Moscow painters, Konstantin Korovin and Valentin Serov. Their advice on buying pictures was sought by collectors like Ivan Morozov and Sergei Shchukin. Russian art critics reacted favourably to the French Impressionist paintings which were brought to Moscow, even though they had not yet been appreciated widely in France. Early in the 1900s reproductions of French paintings and articles about the work of the artists began to appear in Moscow periodicals. The artists of the group *Mir iskusstva* ('The World of Art') and writers and critics close to them were particularly concerned with the latest currents in French art. Reproductions of Impressionist paintings, and articles and serious essays on the contemporary developments in art, were published in the periodicals *Zolotoe Runo* ('The Golden Fleece') and *Apollon*. Catalogues of new French paintings in the Shchukin and Morozov collections were published and interesting studies of Impressionism were undertaken by Boris Ternovets, Yakov Tugendhold, and Sergei Makovskii.

Moscow art historians were among the first to regard Impressionism as a major artistic phenomenon of the nineteenth century, a point which is of crucial importance in evaluating the role played by Russian scholarship in the eventual recognition of French avant-garde painting. Behind each French painting in the Soviet museums there is a history not only of considered collecting, but also of serious Russian scholarship inspired by the innovative spirit of artistic life in Moscow at the turn of the century.

The work of French artists formed the nucleus of the extraordinary collections of European avant-garde painting in Moscow at this period. Two private collectors, Shchukin and Morozov, laid the foundation for its popularity. Both men had close ties with French artistic circles, and they conducted business with the renowned Paris dealers Durand-Ruel, Druet, Bernheim-Jeune, Vollard, and Kahnweiler. In choosing works by French artists who had not yet been recognised by the general public, or by museums, these two collectors were guided by their love of art and their discerning taste.

Ivan Morozov (1871–1921) was a Moscow industrialist. In 1892 he graduated from the Technische Hochschule in Zurich. His real enthusiasm, however, was for painting and from about 1900 he began to develop close contacts with artistic circles in Paris. He spent 200,000 to 300,000 francs each year on buying French paintings – sums which at that time could only be matched by state museums – and he even had a representative in Paris who arranged many of the purchases and organised their transport to Russia.

Morozov's preference was for the work of Impressionists and Post-Impressionists. His favourite artists were Monet, Pissarro, Renoir, and Sisley, his enthusiasm extending later to Van Gogh, Cézanne, Signac, and Bonnard. In 1907 Morozov acquired a sizeable group of paintings from the well-known dealer Vollard, whose portrait by Picasso he also bought (no. 35). He corresponded regularly with the dealers and with many French artists, including Matisse, Vuillard, Bonnard, and Denis, from whom he also commissioned works. He was a regular visitor to exhibitions in Paris, especially the Salon d'Automne and the Salon des Indépendants, as well as private galleries and studios. In his letters to Morozov, Matisse repeatedly invited him to visit his studio. Morozov was eventually awarded the Order of the Légion d'Honneur and elected an Honorary Member of the Salon d'Automne. By 1913 his collection included one hundred and forty paintings of the French school, not counting the drawings and sculpture which complemented them. There were seventeen paintings by Cézanne, and the Fauve group was well represented by the works of Marquet, Derain, and Vlaminck.

Sergei Shchukin (1854–1937) was a businessman and one of five brothers, all of whom were collectors. He began collecting French masters towards the end of the 1890s. In 1897 he bought Monet's *Lilacs in Sunlight*, which was the first work by this leading Impressionist to come to Russia. Shchukin went on to acquire a whole series of superb paintings by Monet, including the view of Rouen cathedral in this exhibition (no. 22). The principal stages of Monet's artistic development were represented in Shchukin's collection by first-rate examples. Cézanne and Gauguin were also splendidly represented, the latter by sixteen paintings, two of which are being shown in the present exhibition (nos. 23 and 24).

Shchukin developed a particular enthusiasm for the works of Matisse and Picasso; they formed the major part of his collection, with thirty-seven pictures by Matisse and over fifty by Picasso. The quality of the Shchukin paintings by these artists was exceptional and until 1933, when Matisse did the panels for the Barnes Foundation, Merion, the only place in the world where first-class examples of the artist's monumental decorative style could be seen was Shchukin's gallery. In 1910 Matisse executed the celebrated panels *Dance* and *Music* (now in the Hermitage) for the decoration of Shchukin's residence. The artist was invited to Moscow in 1911, and was personally involved in the hanging of his paintings in Shchukin's house. Among the easel paintings by

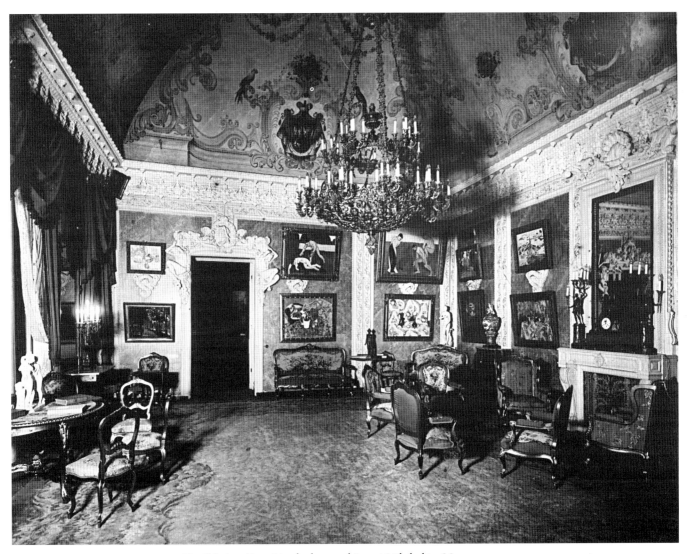

The 'Matisse Room' in the house of Sergei I Shchukin, Moscow, 1912
Photograph courtesy The Museum of Modern Art, New York

Matisse were such remarkable pictures as the *Goldfish* (no. 36), and *Nasturtiums and 'The Dance'* (no. 37). Shchukin himself spoke of the pink drawing-room where Matisse had put his paintings as 'the room of Matisse, my fragrant garden . . . '. Shchukin's collection of works by Picasso was equally remarkable. Most of his purchases were from the artist's Cubist period, but he also owned several superb examples of his earlier work.

The French school of the early twentieth century was fully represented in Shchukin's collection and only the outbreak of the First World War put a stop to his acquisitions, which by then included notable paintings by Henri Rousseau, landscapes by Marquet, and sixteen canvases by Derain. Shchukin's collection was more accessible than Morozov's; his residence was open to young Moscow artists and became in a sense a haven for them, where discussion and arguments could flourish. In contrast, Morozov's collection, though

virtually a museum of modern Western painting, opened its doors only rarely and was practically inaccessible to the general public. The collector had transformed his residence into a temple of art, whose treasures existed for his own enjoyment and that of a select group of connoisseurs.

After the Revolution the magnificent collections of Shchukin and Morozov were nationalised and opened to the general public. At first, Shchukin's gallery was designated the First Museum of Modern Western Painting and remained in situ; Morozov's gallery was designated the Second Museum of Modern Western Painting. In 1923 the museums were amalgamated administratively as the State Museum of Modern Western Art, the two collections becoming the First and Second departments of the amalgamated museum, each remaining in its former location. In 1928 the two departments were finally brought together in one building, on the site of Morozov's former residence.

PAINTINGS IN THE EXHIBITION

This exhibition includes several masterpieces from the Shchukin and Morozov collections. Monet's *Rouen Cathedral* (no. 22) is one of a series of paintings depicting the cathedral façade, in different light, at different times of the day, which Monet exhibited to great acclaim in 1895. The complex relief of the surface of the façade made it possible to record all the nuances of the light effects. The picture is rich in the finest gradations of colour yet, in its methodical observation and scientific exactitude, the artist's approach becomes almost mechanical. It could perhaps be compared with the experiment staged nearly a hundred years later by Andy Warhol, who placed a cine-camera in front of a New York skyscraper to record the effects of the changing light and atmosphere on the exterior of the building.

The pictures by Renoir in the Pushkin Museum characterise brilliantly the Impressionist portrait painting of the 1870s and early 1880s. The portraits may be regarded as lacking psychological depth, but the *Girls in Black* (no. 21) exemplifies the Impressionists' approach to portrait painting as a record of evanescent moods and of fleeting expressions on the faces of charming models. The picture was painted in Montmartre, where in the late 1870s Renoir rented a small house with an overgrown garden. He was a regular visitor at the Moulin de la Galette where young Parisian dandies came to amuse themselves and to waltz with the girls. The girls were often willing to pose for Renoir at his studio nearby and the artist was unsurpassed in conveying the joyful, youthful and friendly atmosphere which then reigned in Montmartre.

Any study of the art of the last two decades of the nineteenth century would be incomplete without reference to the works of Cézanne, Van Gogh and Gauguin in the Pushkin Museum. In the present exhibition, Cézanne is represented by his late works, including two from the Pushkin Museum: '*Le Fumeur*' (no. 28) and *Mont Sainte-Victoire* (no. 31), a view of the artist's favourite motif taken from his studio on the nearby hillside of Les Lauves. In these later works by Cézanne the effect of spatial depth achieved through a build-up of patches of colour produces an enormous impact on the viewer, drawing and holding the eye. The painting is more than a record of a specific landscape; it becomes a truly universal image and, in achieving a balance between nature and abstraction, Cézanne's genius anticipates the methods and means of Cubism.

The *Portrait of Dr Rey* by Van Gogh (no. 26) is painted in his characteristically expressive manner, with the emphasis on the facial expression of the model and on the busy background, covered in elegant scrolls and blood-red drops of paint. It was painted at Arles in the South of France in January 1889. In May 1889 Van Gogh entered the asylum at the nearby town of Saint-Rémy. During his stay at this bleak and remote hospital he painted *The Prison Courtyard* (no. 27) as an expression of his despair and inescapable confinement; the picture was eventually bought by Morozov.

Gauguin's work is usually seen in the context of European Symbolism, even though his art was essentially different in character. He preferred the simple and direct visual language of primitive cultures to the complexities of Western European art. *Her Name is Vairaoumati* (no. 24) is a typical example of the artist's work from his first trip to Tahiti in 1891–2. It is based on an ancient myth which relates how the god Oro fell in love with a beautiful girl, Vairaoumati. The sculpture in the background could represent the union of Oro and Vairaoumati but the artist's title refers to the Tahitian woman seated on a bright tapestry in the foreground. She is a modern incarnation of Vairaoumati, an easily available girl with a cigarette in her hand. In analysing Gauguin's paintings it is clear that behind their triumphantly decorative and elemental qualities there is a layer of imaginative content with its own history and even its own subject-matter. But too much solemnity should not be ascribed to the content of his work lest one succumb to false profundities, for there are also elements of playfulness, artistic irony and sang-froid in his paintings.

The exhibition ends with paintings by Bonnard, Matisse and Picasso from the early part of the twentieth century. Bonnard's panel '*La Glace du cabinet de toilette*' (no. 32) is notable for its refined silvery tones, and indeed this picture was highly prized for its high-keyed palette and its plastic qualities by Morozov's adviser, the Russian painter Serov.

Matisse is represented in this exhibition by *Goldfish* (no. 36), *Nasturtiums and 'The Dance'* (no. 37), and *Still Life with Arum, Iris and Mimosa* (no. 38). He was to become one of the most influential painters of the twentieth century and these canvases are important examples of his work.

The two Picasso paintings, both from the Morozov collection, are among his masterpieces. '*Les Deux saltimbanques*' (no. 33) is an early work from the so-called Blue Period and it is still basically Post-Impressionist in character. The *Portrait of Ambroise Vollard* (no. 35), however, could be described as the apotheosis of Picasso's mature Cubism, and it undoubtedly ranks among the best portraits of the early twentieth century.

M. A. Bessonova
I. A. Kuznetsova

Biographies of the Artists

PIERRE BONNARD 1867–1947

The son of an official in the War Ministry, Bonnard was destined for a career as a lawyer. He entered the law school in Paris in 1887 but within a year he was also attending classes at the Ecole des Beaux-Arts and the Académie Julian. In 1889 he failed his law examinations and, after he had sold one of his poster designs to a champagne company, he decided to become an artist.

At the Académie Julian he met Edouard Vuillard, Maurice Denis, Ker-Xavier Roussel and Paul Sérusier. Drawn together by their shared artistic aims these artists formed a group called the 'Nabis', from the Hebrew word for prophet. From Sérusier, who had spent the summer in Pont-Aven, they learned about Gauguin's work and his theories about Symbolist art; Denis later remembered that Gauguin taught them 'that art is above all a means of expression'.

The Nabis organised exhibitions and produced book illustrations, prints, stained-glass designs and stage sets as well as easel paintings. However, like his close friend Vuillard, Bonnard did not share the group's interest in the reform of religious art and he drew his subject-matter from everyday life.

From about 1889 Bonnard painted in a flat decorative style derived from his knowledge of Gauguin's art and from his study of Japanese prints. He was designated the 'Japanese Nabi' and he was probably the first of the group to become involved in decorative art; some of his paintings were designed as screens, including *Femmes au Jardin* (1891, Musée d'Orsay, Paris), a set of four large panels in which the figures are defined by contrasting patterns and emphatic outlines. In the early 1890s he began to concentrate on street scenes and interiors, often treating his figures with an element of caricature. His fellow Nabi, the actor Lugné-Poë, recalled: 'Bonnard was the humorist among us; his nonchalant gaiety, his wit was evident in his pictures, in which a satiric quality was always embodied in the decorative spirit . . .'

Bonnard met Toulouse-Lautrec in 1890. They collaborated on several projects and Lautrec's influence is apparent in Bonnard's work as a printmaker and poster designer. He produced a number of illustrations for books, including Verlaine's *Parallèlement* (1900) and an edition of *Daphnis and Chloë* (1902).

One of Bonnard's earliest patrons was Thadée Natanson, who, with his brother Alexandre, founded the periodical *La Revue Blanche* in 1891. Bonnard contributed a number of illustrations to *La Revue Blanche* and for Thadée Natanson's first wife, Misia, he designed four large decorative panels in 1910. The Russian collector, Ivan Morozov, was another important early patron; he collected Bonnard's work from about 1907 and in 1911 commissioned three large panels entitled *La Méditerranée* (Pushkin Museum, Moscow).

Around 1900 there was a marked change in Bonnard's art; his work became increasingly concerned with space, colour and light and he adopted a modified form of Impressionism. He painted mainly landscapes and interiors, combining the decorative quality of his earlier work with high-keyed colour schemes and loose atmospheric brushwork (no. 32).

In 1912 he bought a house at Vernonnet, near Monet's home at Giverny, and until 1938 he divided his time between the Seine Valley and the Mediterranean region. From 1939 he lived at Le Cannet, near Cagnes.

In 1947 an article published in *Cahiers d'Art* posed the question: 'Pierre Bonnard – was he a great painter?' The answer was only if you like art that is 'facile and agreeable'. The negative image of Bonnard as a traditionalist no longer prevails. His work has been widely influential, particularly in America, and his determined exploration of light and colour is no longer a barrier to a serious appreciation of his art.

FRANÇOIS BOUCHER 1703–1770

Boucher is the artist who best reprsents the Rococo style in painting. Born in Paris, his first training was at the hands of his father, Nicolas, a humble designer of embroideries. Then around 1720 he spent a brief time in the studio of François Lemoyne, whose Venetian-inspired colour and handling was to have its influence. Subsequently, financial circumstances forced him to design vignettes for the engraver J.-F. Cars. In 1723, he won the Prix de Rome, spending the years 1727 to 1731 in the eternal city with Carle van Loo. He also spent some time in Genoa and Venice. In Italy, he was deeply affected by the classical ruins.

In 1733, two years after his return to Paris, he married Marie-Jeanne Buseau, who was to model for him. The following year he was admitted to the Académie Royale on presentation of his *Rinaldo and Armida* (Louvre, Paris). He was to have a lifelong association with the Académie,

becoming Professor there in 1739, Rector in 1761, Director and 'Premier Peintre du Roi', in succession to van Loo, in 1765.

Simultaneously with his official duties at the Académie he was from 1734 employed, under Jean-Baptiste Oudry, at the Royal Tapestry Manufactory at Beauvais and at the Gobelins, where he was Inspector from 1755 to 1765. His tapestry designs of *Pastorales* like the *Histoire de Psyche* were justly famous, the latter being remade several times for various European monarchs.

It was the support of Mme de Pompadour, King Louis XV's cultured and powerful mistress, which ensured Boucher's success. Not only did she provide him, in 1752, with apartments in the Louvre, she also gave him commissions of the highest status, and acquired many of his paintings, among them two works which Boucher himself considered his most important, the famous *Rising* and *Setting of the Sun* of 1753 (Wallace Collection, London).

Boucher's emphasis on decoration resulted in commissions for the decoration of Sèvres porcelain, and for many opera and theatre sets. His paintings treat mythology, shepherd themes, landscapes and portraits, all of them executed freely and quickly in vivid colour. In contrast to Watteau, the emotional tenor of his output is invariably optimistic, and, while his work is psychologically superficial, it conveys a great sense of charm and wit, and of urbane refinement – the hallmarks of the Rococo.

PAUL CEZANNE 1839–1906

Cézanne's boyhood in Provence was dominated by the personalities of his father, a wealthy banker, and his friend Emile Zola. Under pressure from his family he trained as a lawyer at the University in his native Aix-en-Provence but he also attended classes at the local drawing Academy. In 1861 he abandoned his law studies and spent the summer in Paris with Zola. He returned to Paris in 1862 but failed the examination for admission to the Ecole des Beaux-Arts and instead frequented the privately run Académie Suisse.

Delacroix, Daumier, Courbet and Manet were the principal influences on his earliest works, although he also made frequent visits to the Louvre, where he was particularly attracted to the works of Zurbarán and Ribera. Many of his early paintings are imaginary compositions with violent or erotic imagery, painted in a bold, simple manner and with strong contrasts of light and dark. Often, in imitation of Courbet, he applied thick layers of paint with a palette knife, and he later told Renoir that it took him twenty years to realise that painting was not sculpture.

Cézanne faced continued parental opposition to his artistic career and he was forced to conceal his liaison with Hortense Fiquet who gave birth to their son, Paul, in 1872. From 1872 to 1874 he stayed at Pontoise and Auvers, often working in the company of Pissarro. In several of his landscapes, including *The Hanged-Man's House* (1873, Musée d'Orsay, Paris), he adopted Impressionist techniques, using lighter colour and broken brushwork. However, the spontaneity of Impressionism had little appeal for Cézanne, who attempted to invest his paintings with a sense of solidity and order: he is reported to have said that his ambition was to 'make of Impressionism something solid and durable like the art of the museums'.

In his paintings of the later 1870s and early 1880s like the *Château of Médan* (1880, Burrell Collection, Glasgow), his brushwork became increasingly systematic and ordered. He planned his compositions carefully, seeking to express the underlying rhythms and structures of the landscape rather than capture fleeting atmospheric effects.

Cézanne participated in the Impressionist group shows of 1874 and 1877 where his work provoked some of the most hostile reactions from the critics. His work was regularly rejected by the annual Salon and, disillusioned by his lack of critical success, he began to visit the North less frequently during the 1880s. His sense of isolation was increased in 1886 when he broke off his friendship with Zola after the publication of the latter's novel, *L'Oeuvre*, the story of a failed artist who was clearly modelled on Cézanne. The death of his father in the same year left him with a moderate income and enabled him to marry Hortense.

His mature style evolved towards the end of the 1880s. Although much of his work remained rooted in a rigorous scrutiny of his motifs he developed increasingly independent structures of colour to parallel rather than imitate the appearance of nature; he later described how his major discovery was that 'sunlight cannot be reproduced, . . . it must be represented by something else – by colour'. He worked slowly and methodically, selecting subjects and models that he could study for long periods (see nos. 28 and 30). Still-life painting was particularly suited to his temperament. The simple groupings of his early still lifes, influenced by Chardin, gradually developed into complex and elaborate arrangements (see no. 29).

The countryside around Aix-en-Provence dominates his late work. His landscapes ranged from classical visions of the Mont Sainte-Victoire to dramatic views of the hillside around the Château Noir, east of Aix. In 1901 he constructed a special studio on the hillside of Les Lauves and from here he was able to paint the view across the plain towards his favourite motif, the Mont Sainte-Victoire (no. 31). The fragmented surfaces of his late works verge on abstraction; using subtle modulations of colour he was able to suggest form and space while retaining an overall sense of pictorial harmony.

He continued to work from his imagination, but the erotic imagery of his early career gave way to the theme of male and female bathers in generalised landscape settings. These culminated in three large compositions which he worked on from the mid-1890s until his death. They are now in the

National Gallery, London, the Philadelphia Museum of Art and the Barnes Foundation, Merion, Pennsylvania.

Cézanne's work was gradually discovered by the Parisian avant-garde during the 1890s. He was given his first one-man show by the dealer, Vollard, in 1895 and after 1900 he exhibited in several group shows. A steady stream of young artists made the journey to Aix to visit the prophet of modern art, and his statements on art were published and often embellished, particularly by Emile Bernard and Maurice Denis. His influence was at its height in the first decade of this century and the year after his death there was a large commemorative exhibition of his works at the Salon d'Automne.

JEAN-SIMEON CHARDIN 1699–1779

Chardin was one of the few French eighteenth-century painters of stature who did not make history paintings. Nor did he go to Italy, or even beyond the confines of his native land. He lived in Paris all his life, perfecting a limited number of subjects, still life and genre in particular.

Born in Paris, he was the son of a cabinet-maker who specialised in billiard tables. In 1724 he was received as a master painter by the Académie de Saint-Luc, an institution less powerful than the Académie Royale. He resigned his mastership in 1729, one year after being accepted by the Académie Royale. From the time of his admission, 'skilled in animals and fruits', when he presented his *Skate* and *The Buffet* (both Louvre, Paris), he was a faithful supporter of this particular part of the art establishment, despite its emphasis upon history painting and the grand style. He attended its meetings regularly, showed his work at its exhibitions and became its Treasurer in 1755. This office brought with it the responsibility of hanging the paintings in the Salon, a duty which led to a quarrel with Jean-Baptiste Oudry over Chardin's placing of Oudry's works. Chardin's influence continued until 1770 when Jean-Baptiste Pierre became Director, reducing the power of Chardin's protector Cochin. Chardin resigned his post in 1774, but even then remained faithful, presenting the Académie with a bound volume of prints after his works in 1778.

His link with the Académie was not the only official recognition which Chardin received. Despite the 'unofficial' nature of his training, which took place, not at the Académie, but under Pierre-Jacques Cazes and Noël-Nicolas Coypel, he was granted living quarters at the Louvre from 1757 and a royal pension in 1768. Indeed, it was only in his art that he did not attempt to conform to the establishment's demands. In spite of having to accept tasks which were at odds with his nature, for example the restoration, under J.-B. van Loo, of the Galerie François I at Fontainebleau, he developed an art unique within French painting of the eighteenth century, investing his subject-matter, which was thought to be limited to description, with the kind of morality and universality normally only seen in grander themes.

His sources seem to have been principally Dutch. Chardin would have had recourse to the works of Dutch artists through prints which reached Paris in great numbers. His early still lifes, which tend to feature game, have been compared to the work of Jan Fyt; the kitchen utensils which he rendered in such a pure and meaningful way, he would have seen in the work of Willem Kalf.

Despite the fact that this subject-matter altered only minimally throughout his career, a development can be distinguished. The early works of before 1730 are quite thickly painted and exhibit less balanced and harmonious compositions. Later, he favoured a smoother execution; he also developed compositions in which the intervals between the objects are particularly important, together with lighting and harmony of colour. Chardin was a perfectionist, and painted slowly and painstakingly, although expunging unnecessary detail. Having achieved a satisfactory painting, he was often willing to repeat it on commission. Scholars often disagree over which painting constitutes the prime version; for example his famous *Still Life with the Attributes of the Arts* (no. 10), one version of which was commissioned by Catherine the Great. At times, the quality of the versions is quite variable.

Chardin's humble subject-matter, which includes many simple kitchen scenes and homely, almost Quakerish scenes of mothers and governesses with children, did not appeal to the bourgeois class alone. Louis XV bought a painting, the Marquis de Marigny commissioned friezes (now in the Louvre) and the royal princess of Sweden (sister of Frederick the Great) sought his work. After Pierre became Director of the Académie, however, Chardin's work lost the approval of the critics. Eventually, because of failing eyesight, he took to working in pastel and made a series of portraits, including his *Self Portrait with an Eyeshade* (Louvre, Paris). By the time of his death in 1779, he was virtually ignored as an artist, and rediscovered only in the 1840s, by Théophile Thoré. His work was influential for Cézanne, Picasso, Matisse and Morandi among others.

JACQUES-LOUIS DAVID 1748–1825

David's career spanned a period of change in French art and politics from the reigns of Louis XV and XVI, through the Revolution and the First Empire to the Bourbon Restoration.

His father was a merchant and his mother came from a family of masons and architects. After his father was killed in a duel in 1757, David was placed in the care of two of his uncles. At an early age he showed an interest in art and in 1764, at the recommendation of Boucher (a distant relative), he entered the studio of Joseph Vien, a professor at the Académie. From 1770 to 1773 David made four unsuccessful

attempts to gain the Académie's most coveted award, the Prix de Rome; he finally won the Premier Prix in 1774 with his *Antiochus and Stratonice* (Ecole des Beaux-Arts, Paris). He travelled to Rome with Vien in 1775 and remained there for five years. His sketchbooks reveal that he studied sixteenth and seventeenth-century Italian art; he was particularly attracted to the works of the Bolognese school and Caravaggio, and he studied classical sculpture and architecture.

The Rococo influences on David's earliest works gradually gave way to a more austere style based on his study of the Antique and of Poussin. He sent several works back to Paris, including an oil sketch, *The Funeral of Patroclus* (1779, National Gallery of Ireland, Dublin). On his return to France in 1781, he painted *Belisarius* (Musée des Beaux-Arts, Lille), the first of his major Neo-classical compositions in which he expressed ideals of stoicism and social obligation. With its simple yet dramatic composition and its subordination of colour to drawing, *Belisarius* represented a complete break with the art of the Rococo.

In 1783 he was accepted as a full member of the Académie. No. 17 is one of several studies for his reception-piece, *La Douleur d'Andromaque* (Louvre, Paris). The composition, which is based on an antique sarcophagus, was greeted with enthusiasm by the Académie and one critic wrote: 'Nothing is closer to the beautiful antique.'

David returned to Rome in 1784 to paint the masterpiece of his early career, *The Oath of the Horatii* (1785, Louvre, Paris). The picture caused a sensation when it was exhibited, first in Rome and then in Paris, and it established the artist's reputation as the leader of the Neo-classical school in Europe.

Alongside his large-scale history paintings David painted a number of portraits. Initially these were of close friends and relatives but as his fame and reputation grew during the 1780s he accepted commissions from the aristocracy and the wealthy middle classes.

At the Salon of 1789 David exhibited *The Lictors returning to Brutus the Bodies of his Sons* (Louvre, Paris). Because of its underlying theme of republican virtue this painting eventually became a potent symbol of the Revolution. The artist himself gradually became involved in political life; he played a leading role in a campaign to abolish the Académie Royale and in 1790 he began to plan a monumental composition to commemorate one of the key events of 1789, *The Tennis Court Oath*. His political career began in earnest when he was elected a deputy to the National Convention in 1792. He voted for the death of the King in January 1793 and in the same year he painted his two great canvases of the revolutionary martyrs, *Lepelletier de Saint-Fargeau* (lost) and *Marat Assassinated* (Musées Royaux des Beaux-Arts, Brussels). During the years of the Terror, David was closely associated with Robespierre and he worked on numerous propaganda projects, including several major revolutionary pageants.

After the fall and execution of Robespierre in July 1794,

David narrowly escaped the guillotine. He was imprisoned several times, but was eventually released in October 1795. For several years he worked mainly on portraits (e.g. *Portrait of Jacobus Blauw*, 1795, National Gallery, London) and on a large Neo-classical composition, *The Sabine Women* (Louvre, Paris), exhibited in 1799.

David's enthusiasm for the Revolution was superseded by an admiration for Napoleon. He painted numerous portraits of his new hero ranging from a simple head study from life (Louvre, Paris) to the heroic allegory, *Napoleon at St-Bernard* (1800, Musée National du Château de Malmaison). David was appointed first painter to the Emperor in 1804; he was commissioned to execute several large canvases glorifying the festivals of the Empire but only *The Coronation of Napoleon and Josephine* (1805–8, Louvre, Paris) and *The Distribution of the Eagle Standards* (1808–10, Musée National du Château de Versailles) were completed.

After the Bourbon Restoration David went into exile in Brussels where he remained for the rest of his life. He painted a large number of portraits and several mythological composi-tions. His last major work was *Mars disarmed by Venus* (1824, Musées Royeaux des Beaux-Arts, Brussels).

David had an enormous influence through both his own paintings and the work of his followers. His pupils included Gros, Girodet, Gérard and Isabey. Another of his pupils, Ingres, described David as 'the only master of our century'.

JEAN-HONORE FRAGONARD 1732–1806

Fragonard was born in Grasse (Provence), his father being a glove-maker's assistant and his mother a merchant's daugh-ter. When he was six the family moved to Paris, where, nine years later, Fragonard was apprenticed to a notary, the first person to be convinced of his talent. On the advice of his employer, Fragonard's parents decided on an artistic career for their son. After consultation with Boucher, they settled Fragonard in Chardin's studio for a short time, before he joined the large and active workshop of Boucher in 1748. While there he made copies from works by Watteau and Rembrandt in the Crozat Collection and was employed in creating cartoons for tapestry collections.

In 1752, Fragonard inherited the estate of his deceased uncle. That same year he entered the Prix de Rome competition with the large and melodramatic *Jeroboam sacrificing to the Idols* (Ecole des Beaux-Arts, Paris), winning first prize. This brought sufficient finance to allow him to finish his studies at the Ecole Royale des Elèves Protégés and an award of a four-year stay at the Académie Française in Rome. While attending the Ecole, which was directed by Carle van Loo, recognised by his pupils as 'a good master', Fragonard exhibited two important paintings, *Psyche show-ing her Sisters her Gifts from Cupid* (National Gallery, London) and *The Saviour washing the Feet of the Apostles*

(Cathedral, Grasse). These works demonstrate that he was amassing all the skills of the monumental history painter. In 1755, he undertook the journey to Rome with some fellow students, accompanied by Mme van Loo. There he studied with Charles-Joseph Natoire, and made copies of the Italian Baroque masters in the churches. It was Natoire who recognised in the young Fragonard an ability to work in different styles, and a certain lack of patience with conventional degrees of finish, this perhaps being a result of his great natural facility. With Natoire's encouragement he began to work from nature, making trips into the Roman Campagna. He also received encouragement from the interest shown in landscape painting by Hubert Robert, then his fellow student at the Académie. Both became friendly with the engraver and collector, Jean-Claude Richard, Abbé de Saint-Non, who arrived in Rome in November 1759. They travelled with him to Naples the following year, and stayed with him in Tivoli at the Villa d'Este. During that summer, Fragonard made a justly famous series of red chalk drawings, perhaps the first works in which he achieved his own character. His contemporaneous painting, *The Waterfalls at Tivoli* (Louvre, Paris) is a clear document of the affinity between Robert and himself.

After being granted extensions to his period in Rome, Fragonard travelled with the Abbé through all the major Italian cities for a further six months. Many drawings document the works of art which most impressed him. Contrary to most travelling artists he seemed to have preferred the productions of contemporaries, like Tiepolo, to the antique.

On his return to Paris in 1761, Fragonard's formal period of education was over, and his career began in earnest. In March 1765, he submitted his painting of *Coresus and Callirhoe* (Louvre, Paris) to the Académie as his *morceau de réception*, and was elected by unanimous vote. It was well received by Diderot and consequently shown again at the Salon, and then acquired by the King. He was then commissioned to paint a pendant to the *Coresus*, it being intended that both designs could be woven at Gobelins. In fact, he never completed the second piece. As a form of recognition, however, he was given lodgings in the Louvre, and official commissions. These included the ceiling of the Galerie d'Apollon in the Louvre, a commission which he never carried out.

It was in 1767 that Fragonard painted for M. de Saint-Julien, Receveur du Clergé de France, his famous painting of *The Swing* (Wallace Collecton, London) in which he employed Saint-Julien's mistress as model. The painting signalled his discovery of a genre which suited his temperament and technique. From this point he began to acquire a personal clientele whose tastes were quite different from those who dispensed the official commissions. The attitudes of the latter were mirrored in a press condemnation of Fragonard in 1769, the year of his marriage to a perfumer's daughter from Grasse: 'the lure of profit and the interest in boudoirs have diverted the painter from the quest for glory.'

It was about this time that he painted his fifteen so-called 'imaginary portraits' (eight of them now in the Louvre).

Fragonard's new patrons included Mlle Guimard, the dancer, and Mme du Barry, for whom he painted four scenes depicting *The Progress of Love*, intended for her *pavillon* at Louveciennes built by Ledoux. However, she rejected the paintings (now Frick Collection, New York) when they were strongly criticised by a supporter of the new Neo-classical style.

After a journey through France, Italy and Germany in the company of Bergeret, the brother-in-law of the Abbé de Saint-Non, Fragonard settled to the production of those paintings for which he is now famous – fluidly executed scenes, often treating the subject of love, frequently with erotic overtones. Engravings after the paintings helped to ensure their popularity. Thus, Blot engraved *The Bolt* in 1784 and, seven years later a pendant to it, *The Contract*. Regnault published *The Stolen Kiss* (no. 15) in 1787, and later *The Dream of Love* and *The Fountain of Love*. The latter were made as late as 1791, when the Revolution had got underway and a change in taste was at hand. Despite the evidence of his subject-matter, which reflects the emphasis which the aristocratic class placed on pleasure, Fragonard was an enthusiastic supporter of the new thought, and his wife was one of the women who donated their jewels for the good of the Republic.

In 1790 he moved with his wife and her sister, back to his home town, far from the troubles of Paris. He was to return a year later and enrol his son in the studio of David, the painter of the Revolution. Under David's protection Fragonard was given official status, becoming the first painter to be appointed as a curator of the developing Museum of the Arts, and he occupied himself with this work, and with illustrations to La Fontaine, until his death in 1806.

While Fragonard deserves the epithet 'the cherub of erotic painting', the range of his production now receives greater emphasis. Not only did he create religious works and history paintings; in his secular works the range of emotion encompasses all the aspects of love and, in addition, atmospheres of nostalgia and elegy, which seem to express regret that the world was changing.

PAUL GAUGUIN 1848–1903

Gauguin was born in Paris; his father was a republican journalist and his mother was the daughter of the writer, Flora Tristan. In 1849 his family travelled to Peru but his father died during the voyage. Gauguin stayed with his mother's Spanish-Peruvian family until 1855 when he was sent to school in France. From 1865 he travelled widely, first as a merchant seaman and then with the Navy.

On completion of his naval service in 1871 Gauguin became a stockbroker and for thirteen years he led a comfortable bourgeois existence. He became a 'Sunday' painter in the 1870s; he met Pissarro and he showed in the Impressionist

group exhibitions from 1879. His earliest works are modelled on the work of Realist artists like Courbet and Jongkind but he soon came under the influence of Pissarro and then Cézanne.

In 1883 Gauguin abandoned his job, announcing, 'from now on I will paint every day.' For two years he attempted to establish an artistic career in Paris and Rouen but in 1885 poverty and hardship forced him to take his family to Copenhagen, where they stayed with his wife's parents. After the failure of an exhibition of his work, he separated from his family and returned to Paris.

Gauguin made his first trip to Pont-Aven in Brittany in 1886. Although he was still using Impressionist techniques he was already developing his ideas for a more expressive style and in his letters he spoke of using colours and lines to suggest ideas and moods: 'Colours are still more eloquent than lines . . . There are tones that are noble, others that are common, harmonies that are calm and consoling, others that excite you by their boldness.'

In Brittany, Gauguin felt that he could 'live like a peasant' among a people who were still relatively untouched by modern ideas of progress or by industrialisation. The same ideal of a primitive way of life inspired him to travel to Panama in 1887 with the painter Charles Laval. After a period of work on the Canal project he moved on to Martinique 'to live like a savage'. In his paintings of this island he played down the French civilising influence and concentrated on the lush tropical scenery. He returned to France in November 1887. In October 1888 he stayed at Arles with Van Gogh but their differing artistic temperaments led to conflict and after his friend's breakdown in December he fled back to Paris.

From 1888 to 1890 Gauguin made prolonged visits to Brittany. Influenced by the theories of Emile Bernard he began to use simpler forms with areas of strong colour bounded by heavy outlines. In *The Vision after the Sermon* (1888, National Gallery of Scotland, Edinburgh) and *The Yellow Christ* (1889, Albright-Knox Art Gallery, Buffalo) he used flat areas of colour to express the simple religious beliefs of the Breton peasants. In his attempts to forge a direct and expressive style he borrowed freely from a wide range of sources, including Japanese prints, traditional folk art and medieval stained-glass, as well as the work of contemporaries like Degas.

In 1889 Gauguin and several of his followers showed their work at an exhibition in the Café Volpini. He was now acknowledged as a leading figure in the artistic and literary movement of Symbolism and he found sympathy for his ideas among poets and writers, including Mallarmé, Verlaine and Aurier. In 1890 he held a sale of his work to finance a voyage to Tahiti; before his departure he told a journalist that he was leaving France to make 'simple, very simple art . . . to immerse myself in virgin nature . . .'.

Since its discovery in the eighteenth century the island of Tahiti had been equated with ideals of beauty and sensual pleasure. However, when he arrived there in 1891 Gauguin witnessed the results of over a hundred years of colonial rule and he later recorded his initial discouragement: 'Shall I manage to recover any trace of that past so remote and so mysterious? And the present had nothing worthwhile to say to me.'

By the end of his first year he had come to terms with the contradictions of modern Tahiti. He portrayed the natives as a simple, dignified race, still in touch with their ancient culture, and still dominated by their belief in ancestral spirits. Where the Christian missionaries had all but erased any trace of primitive religions, Gauguin invented his own; several of his works combine elements from a range of religions, Christian, Buddhist and Hindu, and he often made use of a portfolio of photographs and drawings which he had brought from France. In *Her Name is Vairaoumati* (no. 24) he juxtaposed symbols of sensuality and promiscuity (mangoes, a cigarette and nudity) with the ruins of an ancient temple and its enigmatic idols, fusing the reality of contemporary Tahiti with echoes of a mystical past.

Gauguin returned to France in 1893; he worked in Paris and Brittany and the dealer Durand-Ruel put on an exhibition of his work which attracted some attention. When he returned to Tahiti in 1895 his health was in decline; themes of love and death began to dominate his work, culminating in a large allegorical composition, *Where do we come from? What are we? Where are we going?* (1897, Museum of Fine Arts, Boston). This work was intended to be a summary of his beliefs and after its completion he attempted to commit suicide but recovered in hospital.

In 1901 he moved to the island of Hiva Oa in the Marquesas group. His last works are characterised by a renewed vigour and he continued to paint vibrant and lyrical visions of native life. For several years Gauguin had been sending a steady stream of canvases back to France and even before his death in 1903 his self-imposed exile had become something of a legend; his friend Daniel de Monfreid wrote to him: 'You are already as unassailable as all the great dead: you already belong to the history of art.'

VINCENT VAN GOGH 1853–1890

Van Gogh's paintings are often considered to be the visions of a tormented mind, the products of a crazed, fanatical genius. A few well-known incidents during his career have tended to overshadow the appreciation of his work. Yet the true nature of his famous 'illness' has never been determined, although it was probably some form of epilepsy, and in the periods in between his breakdowns he remained lucid and determined. His ideas and artistic ambitions were expressed with great clarity and sensitivity in his frequent letters, mainly to his brother Theo who was a constant source of moral and financial support.

Van Gogh was born at Groot-Zundert in the Netherlands in 1853. His grandfather and father were Protestant clergymen and he grew up in a religious atmosphere. In 1869 he joined Goupil and Co., an art-dealing firm which had once been run by one of his uncles. He worked for this firm in The Hague, London and Paris until he was dismissed after a prolonged period of depression brought on by a failed love affair. He returned to England to work as a teacher in Isleworth and Ramsgate until 1877 when he decided to study theology in Amsterdam; Van Gogh later referred to this period as 'the worst time in my life'. He soon abandoned his studies and went to work among the poor in the mining district of the Borinage in Belgium, where he taught children, gave Bible classes and helped the sick.

By about 1880 he had decided to become an artist and in October he went to Brussels where he took lessons from an amateur artist and taught himself drawing and anatomy. In 1881 he moved to The Hague where he received some instruction and encouragement from his cousin, the painter Anton Mauve. He also studied the work of other artists of The Hague school, including Breitner and Israëls. From 1883 until 1885 he stayed with his family at Neunen. He painted landscapes and peasant themes, including his first major work, *The Potato Eaters* (1885, Rijksmuseum Vincent Van Gogh, Amsterdam). The sombre colours and heavy forms are indebted to the work of Mauve yet the forceful handing of paint looks forward to Van Gogh's own highly individual style.

On a brief trip to Antwerp in 1885 he was profoundly impressed by the work of Rubens, but it was his move to Paris in 1886 that completely transformed his style. He first entered the studio of the academic painter Fernand Cormon, where he met Henri de Toulouse-Lautrec and Louis Anquetin. In the spring of 1887 he had his first contact with the work and theories of Impressionist and Neo-Impressionist circles, and he became particularly friendly with Paul Signac and Emile Bernard. The artist's brother Theo reported to their sister that 'Vincent's paintings are becoming lighter and he is trying very hard to put more sunlight into them'. He had already studied the colour theory of Delacroix but he now began to use more luminous colours and he applied his paint with distinct and varied brushstrokes.

The frenetic pace of life in Paris proved to be a strain on Van Gogh's health and by the end of 1887 he was planning to retreat to the south of France where he hoped to establish an artist's colony. His vision of the south was clearly influenced by the Japanese prints which he had studied since 1885, and when he arrived in Arles in February in 1888 he wrote to Theo: 'This country seems to me as beautiful as Japan as far as the limpidity of the atmosphere and the gay colour effects are concerned.' Away from the conflicting stimuli of Paris, his work developed rapidly and the first months of his stay in Provence were among the most productive of his career. In the countryside around Arles he painted orchards in bloom as well as numerous views of the plain of La Crau and the ruined abbey of Montmajour. He also worked in the town itself, painting the public gardens and the Roman tombs on the Alyscamps.

In his earliest paintings at Arles, he continued to work in an Impressionist manner but he gradually heightened his colour, and using a bold impasto, he began to simplify the forms in his compositions; as he explained to Theo, 'instead of trying to reproduce exactly what I have before my eyes, I use colour more arbitrarily so as to express myself vigorously.' In his letters he explained how, under the influence of Delacroix and Monticelli, he was experimenting with colour symbolism; thus, in his painting of *The Bedroom at Arles* (1888, Rijksmuseum Vincent Van Gogh, Amsterdam), the colour was to be 'suggestive of *rest* or of sleep in general'.

In October 1888 he was joined at Arles by Gauguin. Although Van Gogh had eagerly awaited Gauguin's arrival, artistic and personal differences soon led to conflict between the two artists; Van Gogh's health deteriorated and finally, in December 1888, he severed part of his ear and presented it to a local prostitute. Gauguin left the next day and Van Gogh was sent to the local hospital; he was looked after by the house doctor, Félix Rey, whose portrait he later painted (no. 26).

Van Gogh voluntarily entered the asylum of Saint Paul at the nearby town of Saint-Rémy in May 1889. He continued to suffer from severe attacks but he was able to paint in the intervening periods, at first working in the hospital grounds and later in the surrounding countryside. At Arles, under the supervision of Gauguin, he had experimented with working from his memory and imagination, but at Saint-Rémy, with the exception of a few canvases such as *The Starry Night* (Museum of Modern Art, New York), his paintings were based on a direct observation of nature. He exaggerated and simplified forms in his attempts to capture the 'inner character' of his subjects and he chose motifs like cypress trees and olive groves which he felt could symbolise the Provençal landscape (*A Cornfield, with Cypresses*, National Gallery, London). Often he produced replicas of his own work or copies after other artists in which he explored the decorative and expressive possibilities of colour and pattern (see no. 27). He copied works by Delacroix, Daumier and Doré, but Millet was his principal source of inspiration and he produced over twenty paintings after this artist.

In May 1890, Van Gogh returned to Paris and then moved to Auvers to stay with Dr Paul Gachet, who had earlier supported Pissarro and Cézanne. Van Gogh continued to paint, producing more than seventy paintings in as many days, but his physical and mental condition did not improve. On 27 July 1890 he shot himself and two days later he died. 'Life was such a burden to him', wrote Theo to his mother, 'but now, as so often happens, everyone is full of praise for his talents.'

JEAN-BAPTISTE GREUZE 1725–1805

Greuze was born in 1725, in the small town of Tournus, near Mâcon. Baptised 'Jean', he later styled himself Jean-Baptiste. Similarly, he was to describe his father, a master roofer, as a 'manager-architect'. Between about 1745 and 1750 he was a pupil in Lyons of the painter Charles Grandon. In 1750 he arrived in Paris, where he studied drawing at the Académie with Charles-Joseph Natoire as his teacher. His talent was recognised at this time by Pigalle, who made representations on his behalf to Louis Silvestre, Director of the Académie from 1752. Greuze possessed a combative temperament and this may have contributed to the gossip circulating at this time which hinted that he passed off, as his own, portraits by other artists. In order to scotch these rumours, Greuze painted a portrait of Silvestre, which was seen to be excellent. Greuze presented it to the Académie in 1755, together with other works, including *The Father reading the Bible to his Family* (private collection). It was this work which first demonstrated his ability to render with increased emotional intensity a subject familiar to him from the work of Dutch and Flemish genre painters. Its success led to his being elected as an associate member.

Soon after his election, he left for Italy with Louis Gougenot, Abbé de Chezal-Benoît. They travelled to Turin, Genoa, Parma, Bologna, Florence, Naples, and Rome where Greuze remained. In the summer of 1757, after his return to Paris, Greuze showed a number of paintings at the Salon which displayed the influence of his Italian journey. *La Paresseuse Italienne* [Indolence] (Wadsworth Atheneum, Hartford, Connecticut), for example, took a particularly individual form. Seemingly untouched by classical antiquity or by the landscape painters of the seventeenth century, Greuze continued to create genre paintings which combine precise documentary observation with an overt moral. His next years were extremely productive, although little helped by his wife Anne-Gabrielle Babuti, whom he married in 1759. She was well known for her temper (immortalised in a Greuze composition [*La Femme colère*]) and her extra-marital affairs; she also interfered in Greuze's dealings with his engravers. Eventually they divorced, in 1793, the year in which divorce was legalised.

Despite domestic disruption, Greuze attained great success, painting, in 1761, the Dauphin Louis. At one sitting he insulted the Dauphine by his bluntness. Nevertheless, he continued to gain admiration and attracted the attention of Catherine the Great in Russia, who bought his *Le Paralytique* (no. 11) and who considered inviting the artist to St Petersburg until warned off by Diderot. The latter recommended his art, but not his person: 'une bien mauvaise tête'.

Because of a disagreement with Cochin at the Académie Greuze was prevented from exhibiting at the Salon until he had presented his reception-piece. This he did in 1769, but was mortified when his *Septimius Severus reproaching Caracalla* (Louvre, Paris) gained him full membership not as a history painter, as he had intended, but as a genre painter. Diderot had seen preparatory sketches for the painting and appreciated Greuze's radical change from 'bambochade' to 'la grande peinture', although the final painting disppointed him. The painting was, in fact, badly received by critics and public alike. Greuze said he would refuse to participate in the Académie's future exhibitions and attempted to resign his membership. His painting is now seen as a precursor of the Neo-classicism of David.

Henceforth Greuze exhibited in his quarters at the Louvre at the same time as the Académie exhibitions, and only took to exhibiting at the Salon again in 1800, five years before his death.

During the ensuing years, he became greatly popular with the Russian nobility. In 1782, Catherine the Great's son Paul visited him in Paris, and it was probably on this occasion that he acquired the important collection of drawings now in the Hermitage. Subsequently (1785–9), Greuze sold paintings to Prince Nicolas Yusopov, to whom he also supplied works by Vincent, Fragonard and Mme Vigée Le Brun.

Greuze was generally underestimated throughout the nineteenth century while the twentieth associated him principally with sentimental bust-length studies of children. It is only recently that his more radical innovations, both in subject-matter and style, are being reassessed.

JEAN-AUGUSTE-DOMINIQUE INGRES 1780–1867

Born in Montauban, Ingres was the son of an artist and of a wig-maker's daughter. It was originally his father who taught him drawing, and also music. At the age of ten, Ingres attended the Académie in Toulouse, where, two years later, he took first prize in 'drawing the figure in the round'. His principal teachers were Joseph Roques (who had been taught by the same artist as David, namely, Joseph Vien), and the sculptor Jean-Pierre Vigan. He also had lessons with Jean Briant, a landscape painter, and Lejeune, a violinist. At this time Ingres was also a competent violinist, earning an income by playing in an orchestra. He was always to remain deeply attached to music.

In 1799, after two years spent in David's studio, he was accepted by the Ecole des Beaux-Arts in Paris. In 1800, he won the second Grand Prix de Rome, and in 1801 the first prize, with his painting of *The Envoys of Agamemnon* (Ecole des Beaux-Arts, Paris). However, because there were no funds available to send him to Rome he remained in France for a further five years, living in a former monastery. He had contact with other David pupils like Granet, and Gros, who was achieving recognition as a great colourist. During this period Ingres carried out his first mature works, including *Napoleon I on the Imperial Throne* (Musée de l'Armée, Paris)

and the portraits of three members of the Rivière family (Louvre, Paris). When exhibited at the 1806 Salon, these works attracted severe criticism on account of their lack of warmth and 'gothic' style said to be copied from Van Eyck. Ingres, always hypersensitive to criticism, was deeply hurt by these comments, which he received while on his way to Italy.

Arriving in Rome, via Florence, in October 1806, Ingres began a period of residence which was to last fourteen years rather than the expected four. In 1807 he broke off his engagement with his fiancée (who was still in Paris), resolving to remain at a distance from the French critics; in 1813, he married Madeleine Chapelle, a milliner. The first period spent in Rome (1806–20) is marked initially by fine portraits (*Granet*, 1807, Musée Granet, Aix-en-Provence) and by the development of the nude in his work. *The Valpinçon Bather* (Louvre, Paris) of 1808 was praised at the Salon on account of its sensitive rendering of reflected light. His *Grande Odalisque* (1814, Louvre, Paris) displays the perfection of his use of contour to create expressive rhythms.

Napoleon's defeat in 1815 resulted in the French colony in Rome being unable to patronise artists, and Ingres turned to making ravishing portrait drawings and drawings of family groups of other nationalities, which achieved great vitality through their comparative lack of formal ambition. He also painted a number of small 'historical' works (e.g. *The Death of François I*, Louvre, Paris).

In 1820, the sculptor Lorenzo Bartolini invited Ingres to Florence, resuming an acquaintance forged in France years before. Here, Ingres took up the study of Raphael. He completed several portraits, notably of Count Guryev (no. 18) and spent four years (1820–4) on an official commission from the French government. This was *The Vow of Louis XIII*, which he took to Paris where it achieved a rapturous success at the Salon of 1824, before being installed in the Cathedral at Montauban. As a consequence, Ingres was awarded the Légion d'Honneur, and was elected to the Académie. He now installed himself in a studio in Paris, later being accorded rooms at the Institut. This was the beginning of a brilliant official career, not untinged with problems. His *Martyrdom of Saint Symphorias* (now Autun Cathedral) was a failure at the Salon, and he vowed never to exhibit there again. On the other hand, *The Apotheosis of Homer* (Louvre, Paris) was warmly received by the classicists. Subsequently, Ingres accepted the position of Director of the Académie Française in Rome and spent six years at the Villa Medici, enthusiastically carrying out his official duties, as well as painting.

Returning to Paris in 1841, he painted a series of brilliant society portraits (e.g. *Mme Moitessier*, National Gallery, London) and, in the midst of large official commissions, a number of religious works, including *The Virgin with the Host* (no. 19). Despite advancing years, his artistic control remained undimmed, and it was in the 1850s and 60s that he achieved the famous *La Source* and *Le Bain turc* (both Louvre,

Paris). The latter, the greatest achievement of his late period, was painted only four years before his death in 1871.

Ingres's work is seen to fall into two distinct periods: before and after *The Vow of Louis XIII* in 1824. The early 'expressive' phase was criticised because of his habit of exaggerating certain features of the life model (on which he invariably relied). The later phase is recognised as 'classicist', yet although calmer and more traditional it exhibits a similar tendency to 'purity' of composition, resulting in a geometric flavour which has attracted some twentieth-century artists.

HENRI MATISSE 1869–1954

Matisse trained as a lawyer and did not take up painting until about 1890. He moved to Paris in 1891 to study art, first under Bouguereau at the Académie Julian and subsequently in the more liberal studio of Gustave Moreau. The academic realism of his early work soon gave way to the influence of Impressionism; he met Pissarro who encouraged him to visit London in 1898 to study the works of Turner and, in the same year, his interest in colour and light was confirmed by a visit to the south of France and Corsica. Looking back on this phase in his career he wrote: 'Before long there came to me, like a revelation, a love of the materials of painting for their own sake. Growing within me I felt the passion of colour.'

One of his first exercises in Impressionism, *The Dining-Table* (private collection), was greeted with hostility by his academic supporters when it was first exhibited in 1897, but for the next four years Matisse continued to experiment with a wide range of innovative styles. In his figure paintings he explored the expressive distortions and simplifications of Cézanne's later work, a concern that he developed in his sculpture; in 1899 he purchased *Three Bathers* (Musée du Petit Palais, Paris) by Cézanne, and this work was to be of great significance to him. His still lifes and landscapes, however, were mainly devoted to a study of colour and were painted in a vigorous and spontaneous form of Impressionism.

The dealer, Vollard, gave Matisse his first one-man show in 1904. Later that year he stayed in Saint-Tropez with Signac who encouraged him to adopt Neo-Impressionist techniques. Back in Paris he painted an idealised figure composition, *Luxe, calme et volupté* (1904–5, Musée d'Orsay, Paris), using mosaic-like touches of pure colour to evoke an Arcadian mood.

Matisse returned to the south of France in 1905 and worked with Derain at Collioure. Both artists painted their landscapes in a mixture of styles, derived mainly from Gauguin and Van Gogh, using strong contrasts of colour to recreate the intensity of the Mediterranean light. When they exhibited these works at the Salon d'Automne in 1905 the bright, unnaturalistic colour of their canvases inspired one critic to describe them as 'fauves' (wild beasts).

The major work of this period was *Bonheur de Vivre* (1905–6, Barnes Foundation, Merion, Pennsylvania); painted in areas of pure flat colour bounded by flowing, rhythmic outlines, this was the first in a series of large decorative figure compositions in which Matisse experimented with the expressive potential of line, colour and pattern. In his *Notes of a Painter*, published in 1908, he set out his artistic ambitions; 'We are moving towards serenity by simplification of ideas and means . . . We must learn, perhaps relearn to express ourselves by means of line. Plastic art will inspire the most direct emotion possible through the simplest of means . . .'

These aims were realised in the large decorative panels, *Dance* and *Music*, commissioned by Sergei Shchukin in 1909 and now in the Hermitage Museum in Leningrad. Shchukin had first met Matisse in about 1906 and he had already collected an important group of his works. *Dance* and *Music* were to decorate the staircase of his house in Moscow and when Matisse showed him a large sketch for the *Dance* panel the Russian collector was enthusiastic. But when the completed paintings were shown at the Salon d'Automne in 1910 they caused a furore; the radical simplifications of form and colour were attacked by several critics and Shchukin initially refused to accept the paintings. He soon relented and the panels were installed in his house later that year; 'he no longer regrets his bold step', reported a Moscow journal in 1911.

In 1909 Matisse moved into a new studio at Issy-les-Moulineaux, south-west of Paris. Over the following years he painted a great many still lifes and interiors, many of which were purchased by Shchukin or Morozov. The sketch for *Dance* appears in the background of *Nasturtiums and 'The Dance'* (no. 37), purchased by Shchukin in 1912. The Pushkin Museum's *Goldfish* (no. 36) is one of a series of similar subjects painted during 1911 and 1912.

Matisse continued to travel widely; he visited Germany (1908, 1909, 1910), Spain (1910–11), and in 1911 he went to Moscow and St Petersburg with Shchukin. He travelled to Morocco in 1910–11 and the light and colour of North Africa made a profound impact on his work. No. 38 is one of several elaborate still lifes painted during a second stay in Morocco in 1912–13.

A more austere mood is apparent in his work from about 1913 until the end of the First World War. Many of his paintings reveal an interest in geometric structure and design, a tendency which was stimulated by his contact with Juan Gris, who encouraged him to experiment with some of the principles of Cubism.

From 1916 he spent his winters in Nice and he settled there in 1919, a move which marked his withdrawal from the Parisian avant-garde. Among the most important projects of his later career were the decorative murals for the Barnes Foundation (1932–3) and the design and decoration of the Chapel of the Rosary at Vence (1948–9). From 1944 to 1947 he worked on the book, *Jazz*, preparing the illustrations with cut and coloured papers, and his development of these techniques during the last decade of his life enabled him to overcome the handicaps of age and illness.

CLAUDE-OSCAR MONET 1840–1926

Monet was born in Paris but when he was five his family moved to Le Havre where his father worked as a grocer. He began his artistic career by producing skilful caricatures of local celebrities which he was able to sell for small sums. His earliest artistic mentor was Louis-Eugène Boudin, who introduced him to painting out of doors. In 1859 he went to Paris where he had his first contact with the Realist circle of artists and writers, including Troyon, Courbet and Pissarro.

After a short period of military service in North Africa Monet returned to the capital and in 1862 he entered the studio of Charles Gleyre where he met Renoir, Sisley and Bazille. At the Salon of 1865 he exhibited two seascapes including *The Pointe de la Hève at Low Tide* (Kimbell Art Museum, Fort Worth), a large work executed in clear luminous colours and indebted to the style of Jongkind. His most ambitious project of the 1860s was conceived in response to Manet's famous *Le Déjeuner sur l'herbe* (1863, Musée d'Orsay, Paris). Using the same subject, Monet planned to paint a huge figure composition entirely out of doors. It was never completed and now survives only in fragments and in a sketch in the Pushkin Museum, Moscow.

Monet made a further attempt to combine the directness of open-air painting with the monumental scale of academic art in his *Women in the Garden* (1866–7, Musée d'Orsay, Paris). This work was rejected by the Salon and Monet began instead to concentrate on landscape painting. In 1869 he worked alongside Renoir at La Grenouillère, a bathing place on the Seine; the National Gallery's *Bathers at La Grenouillère* (1869) is one of a number of spontaneous sketches painted with broad brushstrokes and blocks of bright colour. Although these works were intended as studies for a larger painting (now lost) this type of small, informal composition came to dominate Monet's output over the next decade. At the first Impressionist exhibition of 1874 he displayed these sketches as independent works. One of these, entitled *Impression/Sunrise* (1872, formerly Musée Marmottan, Paris), earned the group its derogatory title.

After the outbreak of the Franco-Prussian war in 1870 Monet fled to London where he was in contact with Pissarro and also with Daubigny, who introduced him to his future dealer, Durand-Ruel. On his return to France in the winter of 1871 he settled at Argenteuil, which remained his base until early 1878. In numerous views of the Seine and the activities along its banks, Monet developed his techniques for rendering bright atmosphere and outdoor light, using broken brushwork, contrasts of colour and simplifying his compositions. His interest in the rapid industrial expansion of Paris and its

environs inspired him to paint a series of views of the Gare St-Lazare, one of which is in the National Gallery collection.

The increasingly hostile reception given to his work, together with a series of financial and personal difficulties, including the death of his wife in 1879, contributed to a period of crisis in Monet's art. In 1880 he dropped out of the Impressionist group show and throughout this decade he began to work in isolation, often showing his work in one-man exhibitions. He travelled widely, working in Normandy, Brittany and on the Mediterranean coast; he sought out the extremes in nature, painting gales at Etretat or ice floes on the Seine.

In his attempts to capture ever more fleeting effects of light and atmosphere, Monet began to paint the same motif in groups of pictures, a practice which developed into his series paintings of the 1890s. From about 1890 he worked on a series of paintings depicting haystacks and he exhibited fifteen of these in May 1891. In the following year he began work on a group of paintings showing the façade of Rouen Cathedral (see no. 22). He worked in a systematic way, studying his subject under varying light conditions and at different times of the day. Although many of his works were begun in front of the motif, he appears to have elaborated on them in the studio, refining and enriching the initial colour schemes.

Monet settled at Giverny, about fifty miles north-west of Paris, in 1883. He began to construct his famous water garden in the 1890s and this became the inspiration for much of his late work. In 1900 he exhibited a series of works depicting the pond with its Japanese footbridge (e.g. *The Water-Lily Pond*, National Gallery, London), and after the pond was enlarged in 1901 the surface of the water with its floating water-lilies became his principal motif. In 1914, at the instigation of Clemenceau, Monet began work on a group of large-scale paintings of water-lilies which he planned to present to the French nation. To house these murals, two special rooms were constructed to Monet's design in the Orangerie in Paris and the works were installed in 1927, the year after the artist's death.

PABLO PICASSO 1881–1973

In an artistic career spanning over eighty years, Picasso worked as a painter, sculptor, printmaker and designer. He worked in an unprecedented variety of styles and media, and is widely regarded as the most influential artist of this century.

He was born in Malaga but in 1896 his family moved to Barcelona when his father became a professor at the Academy of Fine Arts. Picasso's exceptional artistic talent was recognised at a very early age and he received some training from his father; by the age of thirteen he was able to paint in an accomplished academic style.

Between 1901 and 1904 he divided his time between Barcelona, Madrid and Paris. He became part of the progressive artistic and literary circle which centred on the *Quatre Gats*, a café in Barcelona. Many of his early Paris paintings are scenes of Bohemian night-life painted in a manner indebted to Toulouse-Lautrec (see no. 33). He also studied the work of Van Gogh, Gauguin and the Nabis group. During 1901 he began to paint more generalised images of poverty and despair using elongated figures and an overall blue tonality; several of his Blue Period works relate to the suicide of his close friend, the poet Carles Casagemas.

In 1904 Picasso settled in Paris. His studio in Montmartre was frequented by a wide circle of writers, poets and artists, including Max Jacob, André Salmon, Juan Gris and later, Guillaume Apollinaire. From about 1905 he began to enjoy a moderate success; his work attracted the attention of a number of collectors, including the Americans Leo and Gertrude Stein, but until 1914 his most important patron was the Russian, Sergei Shchukin.

In 1905 Picasso painted several works depicting travelling circus performers, including *Girl on a Ball* (1905, Pushkin Museum, Moscow). These circus themes gradually gave way to more classical subjects; in 1906 Picasso stayed at Gosol in the Pyrenees where he produced a series of compositions depicting simple statuesque figures which reflect his study of archaic Greek and Iberian sculpture.

Les Demoiselles d'Avignon (1907, Museum of Modern Art, New York) was the key work of Picasso's early career. Although it was conceived as a brothel scene in the style of his work at Gosol, Picasso reworked the painting after he had seen the primitive tribal sculptures at the Trocadéro in Paris. The final image, with its violent distortions of form, arbitrary colour and shallow fragmented space, represented a complete rejection of the naturalist concerns of nineteenth-century art. The radical style of *Les Demoiselles d'Avignon* was developed in a series of landscapes and figure paintings which were influenced by his study of primitive art as well as the late work of Cézanne (see no. 34).

Picasso recognised similar interests in the work of Braque whom he had met in 1907, and working in close collaboration they evolved the style which was later branded as Cubism. Still lifes and interiors were often the starting point for their works but by 1910 their canvases had become flickering surfaces made up of fragmented shapes, lines and patterns; 'I paint things as I think them not as I see them', declared Picasso. Using a form of pictorial shorthand they suggested and alluded to their subjects, often adding typography in a playful and witty manner. Both artists stressed that Cubism was not an abstract style, although Picasso later commented that 'It's not a reality that you can take in your hand. It's more like a perfume . . . The scent is everywhere, but you don't quite know where it comes from.' Even the sitters for the few Cubist portraits had to pose for long periods (see *Portrait of Ambroise Vollard*, no. 35).

The outbreak of war in 1914 ended the partnership between Picasso and Braque. While Picasso continued to work in a

Cubist idiom he also reverted to more conventional styles; when he drew a second portrait of Vollard in 1915 it was in a precise linear manner derived from the work of Ingres. In 1917 he went to Rome with Jean Cocteau to design the costumes, scenery and curtain for the ballet *Parade* for Diaghilev's company. In the following year he married a dancer from the Ballets Russes, Olga Koklova. The period from 1917 until about 1924 is often described as Picasso's 'Neo-Classical' phase; he painted still lifes and figure compositions using muted colours and heavy ponderous forms influenced by classical sculpture (e.g. *The Pipes of Pan*, 1923, Musée Picasso, Paris).

Picasso remained in the forefront of avant-garde art throughout the 1920s and 30s. He was hailed by André Breton as one the initiators of Surrealism and his work was shown in several Surrealist exhibitions. One of his most influential works, *The Three Dancers* (1925, Tate Gallery, London) introduced a mood of violence and tension which eventually culminated in *Guernica* (1936, Museo del Prado, Madrid). Produced for the Spanish Pavilion at the Paris Exposition in 1937 this monumental work was intended to arouse public feelings of 'horror and outrage' after the bombing of the Basque town of Guernica.

During the Second World War he remained in Paris and after the liberation he joined the French Communist party. He travelled to Poland in 1948 and to Sheffield in 1950 as a member of the Communist peace congresses. He continued to revise his vision and means of expression and a prolific output of paintings, sculptures, prints and ceramics continued until his death in 1973.

PIERRE-AUGUSTE RENOIR 1841–1919

The son of a tailor, Renoir was born in Limoges in 1841. He began his artistic career as an apprentice porcelain painter in a Parisian china factory. In 1861 he joined the studio of the academic painter, Charles Gleyre, where he met Monet, Bazille and Sisley, and the following year he enrolled at the Ecole des Beaux-Arts. He later recalled that Gleyre had been 'of no help to his pupils' and had left them 'to their own devices'.

In the 1860s Renoir made frequent trips to the forest of Fontainebleau, often in the company of his friends from Gleyre's studio. He met and was encouraged by Diaz whose influence is apparent in many of his early landscapes.

Renoir experimented with a variety of styles during the 1860s but his output at this period is dominated by a group of life-size figure paintings whose style is indebted to Courbet. Although several of his works were rejected by the jury of the annual Salon, he achieved a modest *succès de scandale* at the 1868 exhibition with a painting of his mistress, *Lise with a Parasol* (Museum Folkwang, Essen).

In 1869 Renoir worked alongside Monet at La Grenouillère, a popular bathing resort on the Seine. He adopted the techniques that his friend had evolved for painting out of doors, using small sketchy brushstrokes and vibrant high-keyed colours (e.g. *La Grenouillère*, 1869, Pushkin Museum, Moscow). The spontaneity of these works set the pattern for Renoir's work of the 1870s. In 1873 he moved into a studio in the rue Saint-Georges, Montmartre, and although he continued to paint portraits and landscapes, he concentrated on scenes of modern life, including *La Loge* (1874, Courtauld Institute, London) and *Bal du Moulin de la Galette* (1876, Musée d'Orsay, Paris).

Renoir participated in the first three Impressionist exhibitions but in 1879 he abandoned these group shows in favour of the Salon, where one of his portraits, *Mme Charpentier and her Children* (1878, Metropolitan Museum of Art, New York), was particularly well received. This success paved the way for further commissions and with the resulting income he was able to travel extensively for the first time. These travels, however, correspond with a period when Renoir was uncertain about the direction of his art. 'I had gone to the end of Impressionism', he later recalled, 'and I had come to the conclusion that I didn't know how either to paint or to draw.' His interest in light and colour attracted him to North Africa in 1881 but his increasing enthusiasm for Ingres and the classical tradition inspired him to visit Italy in the same year. These conflicts are readily apparent in the National Gallery's *Umbrellas* (c.1881–5). Parts of this picture are painted in the soft feathery style of his work of the 1870s while some areas have been reworked in a harder style with crisp outlines and subdued colours. This severe manner was carried over into a number of works during the 1880s (see no. 21), and culminated in *The Bathers* (1887, Philadelphia Museum of Art).

In the 1890s Renoir reverted to a softer, more atmospheric style. His work was now in demand, largely through the efforts of his dealer, Durand-Ruel, and his pictures of children and of women dressed in fashionable costume were especially popular. He continued to travel widely, visiting Madrid (1892), Dresden (1896), Amsterdam (1898) and London.

By 1902 Renoir had settled on the Riviera and in 1907 he purchased a small estate near Cagnes. He continued to paint in spite of an increasingly severe physical handicap caused by arthritis. In response to the Mediterranean light his palette became richer and warmer and he moved away from modern subject-matter, concentrating instead on more timeless themes; he painted idealised visions of peasant life or, as in *The Bathers* (1918–19, Musée d'Orsay, Paris), classical nudes set against luxuriant landscape backgrounds.

HUBERT ROBERT 1733–1808

Robert is principally renowned for landscape paintings which are suffused with an Arcadian or softly elegiac atmosphere.

Often, he treats architecture with great accuracy and yet invests it with an element of fantasy, through the addition of figure groups and foliage.

Born in Paris, he is said to have received his first training from the sculptor Michel-Ange Slodtz. In 1754 he went to Rome as a member of the French Embassy, and it was there that he discovered the foundations of his art. He was fascinated not only by the landscape and architecture which he saw, but also by the ways they were painted by Gian Paolo Panini, of whose works he became an avid collector. He was also deeply impressed by Locatelli and Piranesi.

It was in Rome in 1756 that Robert met Fragonard; three years later, the young art-lover the Abbé de Saint-Non arrived in Rome, and immediately became passionately devoted to the work of Fragonard. Together the trio travelled to Naples and Sicily, moving north again to work at the Villa d'Este in Tivoli.

In 1765, Robert returned to Paris where he was already a *pensionnaire* of the Académie. In 1767, he showed his *morceau de réception* (*Port du Rome*, Ecole des Beaux-Arts, Paris) at the Salon, and achieved great success, being appointed, in 1768, Designer of the King's Gardens, and later, in 1784, Keeper of the King's Paintings. Both positions bred certain problems. In the first case, France was in the grip of a developing passion for English landscaping, which Robert had never seen, and which was contrary to his style. In spite of this competition from abroad, Robert designed part of the King's gardens at Versailles and also the park at Compiègne. But his curatorship of the royal collection was cut short by the Revolution; in fact, Robert spent some time in prison before becoming part of the administration of first the Conservatoire, then the Louvre, under Robespierre.

During his years as an 'official' artist Robert painted many views of Paris, and of famous monuments in the French provinces. While often architecturally precise they are usually infused with at least a sense of fancy, if not always being composed according to the imagination of the artist. They are always elegant and sensitive.

Robert is very well represented in the main Russian public collections, since old families like the Shuvakov, Golitzin and Stroganov collected him (see nos 13 and 14).

ALFRED SISLEY 1839–1899

Sisley was born in Paris of British parents. In 1857 he was sent to London to train for a career in business, but much of his time was spent visiting museums where he developed a particular enthusiasm for the landscapes of Turner and Constable. On his return to Paris in 1862 he obtained his parents' permission to study art and he entered the studio of Charles Gleyre where he met Monet, Bazille and Renoir.

In 1863 Sisley abandoned this academic training to concentrate on painting landscapes out of doors. He often worked in the Fontainebleau area, sometimes in the company of his former colleagues from Gleyre's studio. His early landscapes are painted in sombre, dark colours and are influenced by Corot and Daubigny, but around 1870 he began to adopt the Impressionist techniques of Monet and Renoir, using small, distinct brushmarks and clearer colours to convey atmospheric effects.

During the siege of Paris in 1871 Sisley took refuge in the village of Voisins-Louveciennes and for the next four years he explored motifs around this area, often painting at Argenteuil and at Villeneuve-la-Garenne. Many of his finest works date from this period, including no. 20 in which he combines a sensitive observation of light with a strong sense of pictorial design.

Throughout the 1860s Sisley had been able to lead the life of an amateur, thanks to the support of his family. However, after the premature death of his father in 1871, he was left without an income and he suffered from financial hardship for the rest of his career.

In 1874 Sisley spent four months in England at the invitation of the baritone, J. B. Faure. He painted a series of views of the Thames and of regattas at Hampton Court. From 1874 until 1877, he lived at Marly-le-Roi. Unlike Monet, Sisley was never attracted by dramatic natural effects and even his series of paintings depicting floods at Port-Marly are coolly observed and carefully constructed.

In the 1880s Sisley moved back to the Fontainebleau area, painting around the villages of Marlotte, Moret and Saint-Mammes. He eventually settled in Moret and this village provided the motifs for many of his late paintings. Apart from a tendency towards more decorative effects in some of his later works, Sisley's art never moved far from the principles of his Impressionist pictures of the 1870s. Because of this he has often been described as a minor figure, although his distinct brand of Impressionism was not without influence; in 1898 Pissarro wrote: 'He is a great and beautiful painter, and in my opinion, he is a master equal to the greatest.'

PIERRE SUBLEYRAS 1699–1749

Born in Saint-Gilles-du-Gard in Languedoc, Southern France, Subleyras received his first training in Uzès from this father, who seems to have been a painter of little importance. He then passed some time with Joseph Gabriel Imbert in Villeneuve, although his real training was undertaken in the studio of Antoine Rivalz in Toulouse. His first extant work is a *Consecration of Louis XV* (Musée de Toulouse), which dates from around 1722.

In early 1726, Subleyras moved to Paris, where he drew the live model for the first time, and also studied geometry and perspective. A year later he won the Premier Grand Prix at the Académie with his painting of *The Brazen Serpent* (Musée des Beaux-Arts, Nîmes, on deposit from the Louvre, Paris).

Arriving in Rome in October 1728, he became a pupil at the Académie de France; he was to study there for seven years, as well as undertake commissions, principally for portraits. During this period Subleyras was supported both by Nicolas Vleughels, the Director, and by the Duc d'Antin. They secured commissions for him, and also living accommodation in the Palazzo Mancini, the location of the Académie. In 1735 he elected not to return to Toulouse where he might have taken over the workshop of Rivalz, who died late in the year. The reason for Subleyras' refusal to return to France was perhaps based partly on his delicate health but, more precisely, on his developing clientele and his relationship with Maria Felice Tibaldi, daughter of the well-known musician and a miniaturist in her own right, whom he married in 1739. Her sister was the wife of Charles Trémollières, the painter. (Subleyras' portrait of his wife is in the Worcester Art Museum, Massachussets.) A year later he became a member of the Accademia di San Luca, his reception-piece being a partial study for his huge *Supper in the House of Simon Levi* (painted for Santa Maria Nuova in Asti), a picture which attracted immense admiration. A small but highly finished sketch for it (now also in the Louvre) was engraved and thus gained great popularity. Subsequently, Subleyras became the painter most sought after by the religious establishment in Rome, painting for the Pope and his cardinals, as well as for Roman noble society and the French community there. He painted Pope Benedict XIV (now in Versailles), and made several other portraits during a sojourn in Naples where the climate was better attuned to his health. Returning to Rome, his condition worsened and he died there on 28 May 1749.

Subleyras painted many altarpieces for a variety of locations, including Asti, Milan, Grasse and Toulouse. He also developed a genre style and made small paintings illustrating some of the fables of La Fontaine. Among his religious works, his *Mass of Saint Basil* (no. 3) was particularly admired, and several versions exist.

Subleyras prolonged the classicism of the French seventeenth century into the eighteenth, in a dignified but lively style enlivened by light colour and a great gift for narrative composition. He was the only French artist in the eighteenth century to receive a commission for St Peter's, a fact which shows that he was thought equal to Poussin and other important seventeenth-century French artists.

CLAUDE-JOSEPH VERNET 1714–1789

Born in Avignon, Vernet received his first training at home, his father being a minor decorative painter. He then followed local tradition by moving, when aged about fourteen or fifteen, into the workshop of a local artist, in this case Philippe Sauvan, mainly a history painter, but also known to have made decorative works for houses in the area. Vernet then studied in nearby Aix with Jacques Viali, a painter of landscape and marine subjects.

The earliest extant works by Vernet are two overdoors at the Hôtel de Simiane in Aix, showing local topographical features. These were doubtless inspired by the preferences of the Marquis de Caumont, who recommended the seventeen-year-old artist to his friend the Marquise de Simiane. It was Caumont, together with the Comte de Quinson, who sponsored Vernet's move to Rome in 1734. Quinson also patronised Subleyras, whom Vernet was later to befriend. In Rome, Vernet was later recommended to Adrien Manglard, who, like Viali, painted landscapes and marines. He was also introduced to Nicolas Vleughels, the head of the French Académie, who made facilities available to the young artist and advised him to concentrate on marine painting.

In addition to having commissions from Caumont and Quinson, Vernet attracted the notice of the Duc de Saint-Aignan. Within a few years he had established himself as a specialist in marines and landscapes, which he conceived according to his imagination, although basing them on careful study of the coast as far south as Naples and on the area around Rome. In 1743, he was elected a member of the Accademia di San Luca.

His style, now fully formed, was seen as a continuation of that of the great landscapists of a hundred years before, Claude Lorrain and Salvator Rosa, and indeed he self-consciously imitated these artists. Some critics preferred his works, commenting in particular on his realism in the depiction of shipping and on the greater variety of weather conditions. This struck a responsive chord with French collectors who were developing a taste for nature, and in a well-known review of the Paris Salon in 1767, Diderot talked of Vernet's paintings as if they were real sites. This attitude is mirrored in that of collectors like the Marquis de Villette who commissioned a number of pictures from Vernet, including the pair of Roman 'jardins avec des figurines habillées à la mode' (nos 8 and 9).

While Vernet clearly benefited from the interest in nature aroused by Dutch art, his topographical tendency was stimulated by the work of his contemporaries in Italy, like Vanvitelli and Locatelli. He surpassed these painters, however, in the sentiment with which he infused his views, and is the painter who best evoked the coast and port of Naples, a city which was undergoing something of a 'discovery' – excavations were being carried out at Herculaneum and King Charles III was building his Villa Reale at Partici – with the result that Naples became part of the Grand Tour, and Vernet became a favourite with British patrons of the 1750s.

Vernet exhibited four views of Naples and Italy at the Paris Salon of 1746, which were well received. His art was accepted as being true to nature, especially to the effects of light.

In 1750, Vernet was visited in Rome by the brother of Mme de Pompadour (who became Directeur des Bâtiments de la

France, as Marquis de Marigny). This led to the commission of a major series of the *Ports de France* (Musée de la Marine, Paris), the largest commission of paintings to be made in the reign of Louis XV. Accordingly, Vernet returned to France in 1753, with his English wife (Cecilia Virginia Parker) and their family. He completed the series of more than fifteen large pictures of ports, which brilliantly reconcile topography with atmosphere and decoration.

Taking up residence in Paris in 1762, Vernet was to remain an important and respected artist until his death. He was fairly consistently supported by Diderot, as his art appealed both to Diderot's eye for a well-made object and to his naturalistic aesthetic, and accorded well with Diderot's efforts to elevate genre to the level of great art. Diderot compared Vernet's marines in their effect to Poussin's *Seven Sacraments*. Towards the end of the 1760s, however, Diderot began to see a slackening in the quality of Vernet's art, which he now thought to have lost the warmth of its contact with nature.

From the viewpoint of the twentieth century, Vernet seems to have been the perfect, if repetitious, exponent of a limited genre. His death in the first year of the Revolution was perfectly timed.

ELIZABETH LOUISE VIGEE LE BRUN 1755–1842

Born in Paris, she was the daughter of a minor portrait painter, Louis Vigée, and of Jeanne Maissin, a hairdresser. Her father died when she was no more than twelve, and she was therefore left to train herself, which she did by making numerous copies of Old Masters in the salons. She made portraits of her family (*Etienne Vigée, the Artist's Brother*, St Louis Art Museum), and then was able to undertake further portrait commissions, with considerable success. She was registered as a master painter at the Académie de Saint Luc when only nineteen.

A year later she married the well-known dealer and collector, Jean-Baptiste Le Brun, who guided her career by introducing her to the literary and artistic salons of Paris. It is also said that he exploited her talent for his own devices; in any case, the marriage was eventually dissolved during the Revolution. After a time working for aristocratic sitters, in 1778 she was commissioned to paint Marie Antoinette. This resulted in her being admitted to the Académie Royale at royal command, and ushered in a period of great activity. She exhibited more than forty portraits and history paintings at the Salon in the 1780s. These brought her great fame, and cemented her place within the highest level of society. Her most important painting during the period is the large *Portrait of Marie Antoinette and her Children* (Musée National du Château de Versailles), an image which displays the sitter with the dignity of a monarch, the affections of a mother and the glamour of a woman of society. Although the painting created a satisfactorily attractive, and yet traditionalist image

for the Queen, and met with a favourable reception when shown at the Salon in 1787, it resulted in Vigée Le Brun attracting the animosity of the Queen's opponents. The press accused her of low morals, and, as the political situation was becoming ever more violent, she fled France in search of safety.

In the following years, she travelled and worked in Italy, Austria, Germany and Russia (from 1795 to 1801), becoming, everywhere she went, the painter of the aristocracy, and attracting adulation from her sitters as well as jealousy from the local artists.

After a time in Britain, she returned to France where she was able to live on the fortune she had amassed from her painting. Thereafter, however, her work became less fashionable and declined in quality, for she was never able to cope, socially or intellectually, with the new Romanticism. She spent much of her last years writing her *Souvenirs*, which constitute an important document for the sociology of art in the late eighteenth century.

It is her work as a portraitist that is important. Endowed with great facility, she perfected her technique while still young. Basing her imagery on famous French portraitists of the past (Rigaud, van Loo), she developed more daring contrasts in colour and a high tone which accorded well with the invariably optimistic emotional tenor of the sitter. She created an ideal image particularly suited to the fashionable women of her time.

JEAN-ANTOINE WATTEAU 1684–1721

Watteau was born in Valenciennes, which had just become part of France, ceding from Belgium. After a life plagued by illness, he died of tuberculosis at the age of thirty-seven. His major achievement was virtually to invent, and perfect, a type of subject-matter (the *fête galante*) and, implicitly, to revitalise French painting by leading it away from the classical style towards more everyday themes.

Watteau was the son of a well-to-do carpenter and master builder. He is known to have shown artistic ability at an early age and was apprenticed to the first of his teachers, Jean-Pierre Gérin, in 1699. By 1702, when Gérin died, Watteau seems to have been attached to another (unknown) artist who specialised in décor for the theatre, and travelled with him to Paris when he went to work for the Opéra. Watteau was restless by temperament and his associations were constantly interrupted and renewed. Consequently, he was attached for a time to one A. Métayer (whose actual work is unknown), to Claude Gillot (who worked in a style opposed to the grand style of the Versailles court) and, eventually, to Gabriel Audran III. In this early period of his life, he met the men who would remain his friends until his death. They included Gillot's nephew, Jean Mariette (the collector), Sirois (an art-dealer) and Nicolas Vleughels (the painter), as well as the dealer Gersaint.

The most influential of his early contacts were perhaps Gillot, whose paintings of theatrical characters were to prove decisive, and Gabriel Audran III. The latter was *concierge* of the Palais de Luxembourg, and through him Watteau gained access to Rubens's Marie de' Medici series (now Louvre, Paris) and other, smaller, works by the master. Audran was an 'arabesque' painter and employed Watteau as his assistant while decorating the Château de Meudon with a series of *The Months*.

The chronology of Watteau's life is extremely vague, but it seems likely that around 1710 he returned to Valenciennes and painted military scenes there. On his return to Paris he took lodgings with the dealer Sirois, who was the father-in-law of Gersaint. Around 1711, he is known to have become engaged in painting 'masquerades' in the style of Gillot, the type of painting for which he was to become famous. His 'Proposition embarassante' (no. 2) is a version of a composition originating around this time.

1712 was a year of conspicuous success. The paintings Watteau submitted for the Prix de Rome competition surpassed the expectations of the judges, who offered him the greater honour of election to the Académie Royale, this albeit dependent upon his submission of an adequate *morceau de réception*. Watteau, always as critical of others as he was of himself, was not greatly impressed by this recognition and submitted the required work only in 1717, on receiving a written reminder. The painting, which gained him admittance as a 'painter of *fêtes galantes*', was the famous *Pilgrimage to the Island of Cythera* (Louvre, Paris), which deals primarily with the power of love, bringing the mellowed, nostalgic atmosphere of a distant Golden Age up to date.

It was probably before his reception into the Académie that Watteau spent a period in the house of Pierre Crozat, the Chancellor of France, and one of Europe's major collectors. He had large holdings of both paintings and drawings, particularly of the Venetian sixteenth and Flemish seventeenth centuries, with which Watteau grew familiar and from which Crozat commissioned several copies. While *chez* Crozat, Watteau could well have participated in his weekly meetings of art-lovers (including Mariette and de Piles) which were to have a decisive influence on the taste of the day. Reputedly, he left Crozat's house to avoid the fashionable collectors who centred on it; later, he was to reside with his painter friend, Nicolas Vleughels.

In 1719, Watteau made the journey to London where he received several commissions. The aim of his visit seems to have been only partly professional, however, for now continually ill, he consulted the well-known doctor, Richard Mead. Returning to Paris in the summer of 1720, he went to live with his friend Gersaint for whom he painted a shop-sign, now known as *L'Enseigne de Gersaint* (Charlottenburg, Berlin).

With his illness intensifying, and able to work only for brief periods, Watteau removed to Nugent-sur-Maine, where his friends continued to visit him until his death in July 1721.

Watteau's unique development of the *fête galante* into a rich language of both narrative and pastoral complexity was crucial to the development of French painting in the eighteenth century. In particular, his style was continued by Pater (whom he taught) and Lancret, who concentrated on the decorative aspects of life in society. They never achieved Watteau's moods of gentle melancholy, nor the sometimes trenchant psychology which clearly was part of his own character. Like all great artists Watteau transcended the genre which he inherited, infusing the masquerades of Gillot and the simple genre scenes of his Flemish precursors with something of the heroism and tragedy which he saw in the works of Rubens and the Venetians owned by Crozat. His reputation waned with the rise of Neo-classicism, and it fell to French commentators of the mid-nineteenth century (including Baudelaire and Verlaine) to rediscover him. In England, Lord Hertford bought several paintings, now in the Wallace Collection.

The Catalogue

Catalogue entries by
A. A. Babin [AB] M. A. Bessonova [MB] E. V. Deryabina [ED]
E. B. Georgievskaya [EG] A. G. Kostenevich [AK] I. A. Kuznetsova [IK]

The dimensions of the paintings are in centimetres followed by inches.

ANTOINE WATTEAU (1684–1721)

'La Boudeuse' (Woman Sulking)

Oil on canvas, 42 × 34 (16½ × 13½)
Hermitage, Leningrad (4120)

The picture is among the best *scènes galantes* of Watteau's late period, around 1717–18. However, because it was not included in the *Recueil Julienne* (the most complete list of Watteau's works, compiled by his friend Julienne), and because it had been engraved by Philippe Mercier, some art historians erroneously ascribed the painting itself to Mercier. The clarification of the picture's history undertaken by Eidelberg and by Rosenberg (1984–5 exhibition catalogue) has removed any doubts about its being painted by Watteau. The title *'La Boudeuse'* is of dubious authenticity, as is the case with many other Watteau paintings. The woman is listening to her interlocutor with indifference rather than with anger or irritation. The black silk dress she is wearing suggests to some historians that this is a picture of a young widow not yet ready to accept the attentions of her bold admirer. Interestingly, in the eighteenth century, such long, slashed sleeves and such berets were to be seen only on the stage. Thus Watteau leaves it to the viewer to guess the true subject of the picture.

Parker and Mathey consider that Watteau used the drawing of a man in a beret now in the Louvre for this painting.

E.D.

PROVENANCE

From 1725: probably in England;
1736–48: Robert Walpole collection; Horace Walpole and heirs' collection,
Strawberry Hill Manor, Great Britain, whence sold in 1842;
later: Duc de Marny collection in France;
1852: sale in Paris; Didier collection; Ferrole collection;
1856: sale in Paris; at this sale or a little later acquired by Count Stroganov;
1923: transferred to the Hermitage from the Stroganov palace museum in Leningrad

EXHIBITIONS

1922–5 Petrograd (no catalogue); 1955 Moscow, p. 25; 1956 Leningrad, p. 25;
1965 Bordeaux, no. 98; 1969 Budapest, no. 25; 1972 Dresden, no. 48;
1972 Leningrad, no. 8; 1979–80 Melbourne–Sydney, no. 39; 1984 Leningrad, no. 2;
1984–5 Paris, no. 46, pp. 354–5; 1987–8 Delhi, no. 57

BIBLIOGRAPHY

Hermitage catalogues: 1958, p. 270; 1976, p. 189;
Nemilova 1982, no. 51; Nemilova 1985, no. 354
*A Description of the Villa of Horace Walpole, Youngest Son of Sir Robert Walpole,
Earl of Orford, at Strawberry Hill, near Twickenham*, Strawberry Hill 1774, p. 98
L. de Fourcaud, 'Antoine Watteau', *Revue de l'Art ancien et moderne*, 1904, p. 356
E. H. Zimmermann, *Watteau, Klassiker der Kunst*, Stuttgart, Leipzig, 1912, p. 189, pl. 84.
Ernst 1928, p. 172
Réau 1929, no. 411
H. Adhémar, *Watteau, Sa Vie, son oeuvre*. Précéde de 'L'univers de Watteau' par R. Huyghe, Paris 1950, no. 220
K. T. Parker, J. Mathey, *Antoine Watteau: Catalogue complet de son oeuvre dessiné*, Paris 1957–8, vol. 2, no. 749
I. S. Nemilova, *A. Watteau and his Paintings in the Hermitage*, Leningrad 1964, cat. 7, pp. 146–51
M. P. Eidelberg, 'Watteau's "La Boudeuse"', *Burlington Magazine*, May 1969, vol. 111, no. 794, pp. 275–8
E. Camesasca, P. Rosenberg, *Tout l'Oeuvre peint de Watteau*, Paris 1970 (2nd edn 1983), no. 116
J. Cailleux, ' "Watteau and his Times" at the Hermitage', *Burlington Magazine*, October 1972, vol. 114, no. 835, p. 734
Y. Zolotov, *Antoine Watteau*, captions by I. Nemilova, I. Kuznetsova, T. Kamenskaya, V. Alexeeva, Leningrad 1973, pp. 144–5
R. Raines, 'Watteau and "Watteaus" in England before 1760', *Gazette des Beaux-Arts*, February 1977, pp. 51, 59, 63
M. Guerman, *Antoine Watteau*, Leningrad 1980, pp. 52, 169–71, 183
M. Roland-Michel, *Tout Watteau*, Paris 1982, no. 163

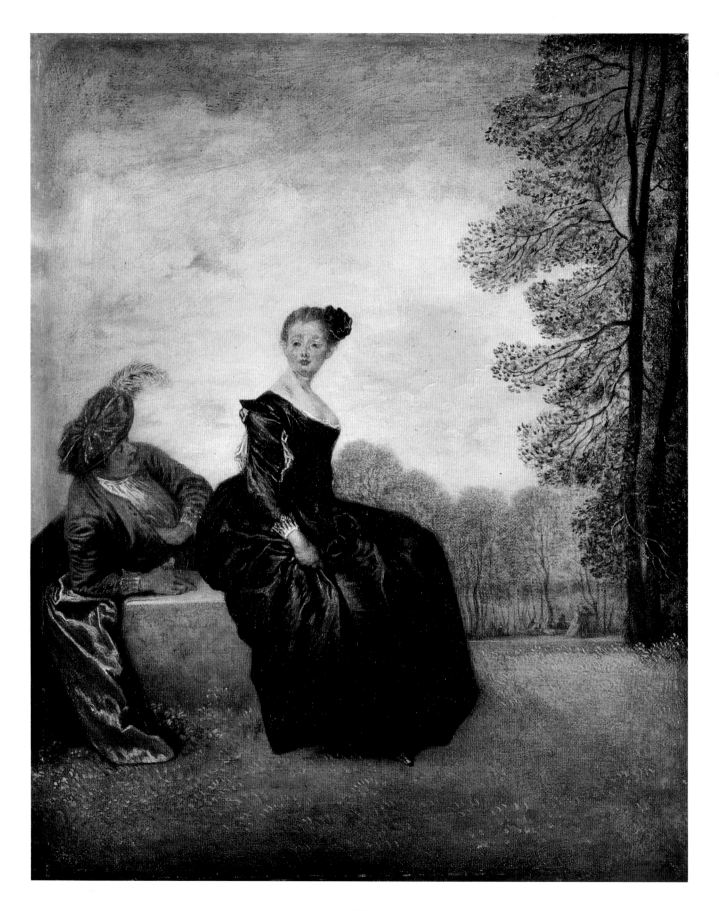

JEAN-ANTOINE WATTEAU (1684–1721)

'La Proposition embarrassante'
(The Embarassing Proposal)

Oil on canvas, 65 × 84.5 (25½ × 33½)
Hermitage, Leningrad (1150)

X-radiograph analysis has revealed that Watteau altered the original version substantially some considerable time after its completion.

The uneven surface of the painting is visible to the naked eye: straight pleats are clearly discernible beneath the deep folds of the draped skirt worn by the standing figure. Stray brushstrokes are visible through the terracotta dress of the seated girl, and also in the background near the guitar player. All these are shown by the X-radiographs to be traces left by the removal of original paint. In some places the removal had been very thorough, right down to the ground colour, while in others it is still possible to discern figures painted earlier.

The X-radiographs have, further, shown that the guitar player has undergone great changes: earlier she was seen not from the back but almost in profile, with a clear view of the décolletage of the tight long-waisted bodice and the full, gathered skirt; her right hand was on the guitar strings while the left hand supported the neck of the guitar. Above the guitarist there is a suggestion of the outline of a man's head, and the girl in the terracotta dress is painted over the figure of a lady playing a musical instrument. Slight changes have been made to the figures and the garments of the standing couple, but the background landscape has not been altered. The composition and the delicacy of its painting are highly praised by Rosenberg (1984–5 exhibition catalogue): 'The picture owes more to the quality of the landscape, especially the trees on the left, than to the protagonists of the scene . . . This composition already demonstrates the rhythm which became so characteristic of Watteau's *scènes galantes*.'

A drawing (dated *c.* 1712) exists for the guitarist in the original composition (Parker, Mathey, no. 78). The original version of the painting probably dates from the same time. Watteau evidently returned to his canvas some three or four years later. This would support the dating of the painting as 1715 or 1716, which is accepted by most scholars.

A drawing for the final version of the guitarist is in the Louvre (Parker, Mathey, no. 825) and a drawing for the standing man is in a private collection in New York (Parker, Mathey, no. 643); there exists a counter-proof of the figure of the seated girl in the terracotta dress in the Rijksmuseum, Amsterdam (Parker, Mathey, no. 636). The title of the picture, *'La Proposition embarrassante'*, emerged when the painting was in the collection of Count von Brühl and is used in the engraving of it by Nicolas-Henri Tardieu. Rosenberg notes that the painting was often called 'Couple Dancing a Minuet to the Strains of a Guitar'.

E.D.

PROVENANCE

Before 1746: acquired by von Brühl; 1769: acquired for the Hermitage from the Count von Brühl collection

EXHIBITIONS

1955 Moscow, p. 24; 1956 Leningrad, p. 12; 1972 Leningrad, no. 4; 1984 Leningrad, no. 1; 1984–5 Paris, no. 39

BIBLIOGRAPHY

Hermitage catalogues: 1774, no. 345; 1863, no. 1501 ('Minuet'); 1908 and 1916, no. 1501;
1958, p. 266; 1976, p. 189; Nemilova 1982, no. 50; Nemilova 1985, no. 353
Recueil d'estampes gravées d'après les tableaux de la Galerie et du Cabinet de S.E.M. le Comte de Brühl, Dresden 1754, part 1, no. 34
Georgi 1794, p. 478; P. Lacroix, 'Musée du palais de l'Ermitage sous le règne de Catherine II',
Revue Universelle des Arts, 1861, vol. 13, p. 176, no. 345
G. F. Waagen, *Die Gemäldesammlung in der Kaiserlichen Ermitage zu St Petersburg*, Munich 1864, p. 304
E. de Goncourt, *Catalogue raisonné de l'oeuvre peint, dessiné et gravé d'Antoine Watteau*, Paris 1875, no. 158
L. Clément de Ris, 'Les Musées du Nord: Le Musée Impérial de l'Ermitage à Saint-Pétersbourg, *Gazette des Beaux-Arts*, 1880, vol. 21, p. 269
E. Staley, *Watteau and His School*, London 1902, p. 143 V. Josz, *Watteau: Moeurs du XVIIIe siècle*, Paris 1903, pp. 320–1

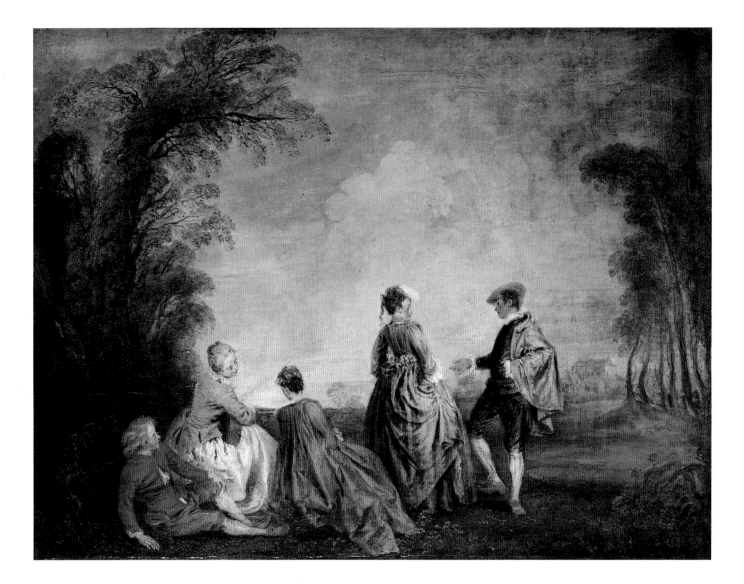

E. Pilon, *Watteau et son école*, Paris 1912, p. 201; E. Hildebrand, *Antoine Watteau*, Berlin 1922, p. 99, fig. 46

Réau 1929, no. 415; V. N. Volskaya, *A. Watteau*, Moscow 1933, p. 32

H. Adhémar, *Watteau, Sa Vie, son oeuvre*. Précéde de 'L'univers de Watteau' par Huyghe, Paris, 1950, no. 142, pl. 73

K. T. Parker, J. Mathey, *Antoine Watteau: Catalogue complet de son oeuvre dessiné*, Paris 1957–8, vol. 2, nos. 636, 643, 825

Sterling 1957, pp. 40–1, pl. 25; J. Mathey, *Antoine Watteau, peintures réapparues*, Paris 1959, p. 68

A. P. de Mirimonde, 'Les sujets musicaux chez Antoine Watteau', *Gazette des Beaux-Arts*, November 1961, vol. 58, p. 250

I. S. Nemilova, *A. Watteau and his work in the Hermitage*, Leningrad 1964, pl. 17; *Baroque and Rococo Masters* 1965, nos. 67–8

E. Camesasca, P. Rosenberg, *Tout l'Oeuvre peint de Watteau*, Paris 1970 (2nd edn 1983), no. 146

I. S. Nemilova, 'The question of the creative process in the work of Watteau' in *Western Art*, Moscow 1971

Y. Boerlin-Brodbeck, *Antoine Watteau und das Theater*, Basel 1973, pp. 209, 330, 331

Y. Zolotov, *Antoine Watteau*, captions by I. Nemilova, I. Kuznetsova, T. Kamenskaya, V. Alexeeva, Leningrad 1973, pp. 143–4

I. S. Nemilova, *Mysteries of Old Paintings*, Moscow 1974, pp. 19–44; Nemilova 1975, p. 434

M. Guerman, *Antoine Watteau*, Leningrad 1980, p. 106; M. Roland-Michel, *Tout Watteau*, Paris 1982, no. 189

D. Posner, *Antoine Watteau*, London 1984, p. 285, no. 74

M. Roland-Michel, *Watteau: Gloire et mystère d'un artiste du XVIIIème siècle*, London–Paris 1984

PIERRE SUBLEYRAS (1699–1749)

The Mass of Saint Basil

Oil on canvas, 133.5 × 80 (52½ × 31½)
Hermitage, Leningrad (1169)

The painting has an unusual subject. Its literary derivation is ascribed, in the catalogue of the 1987 Paris exhibition, to the funeral oration for Saint Basil the Great included in the works of Saint Gregory of Nazianzus (c. 329–c. 389, also known as Theologus), Basil's fellow student, friend and co-author.

Saint Basil the Great (329–379) was the founder of monastic institutions and a prolific author. He is now principally remembered for the improvements he made to the liturgy (still used in the Eastern Church). The Hermitage painting depicts another important event in his life, much of which was spent countering the arguments of the Arians, who denied that Father and Son were of one substance, and consequently rejected the sanctity of Holy Communion. One powerful supporter of Arianism was the Eastern Roman Emperor, Valens (364–378). The painting shows the bearded Basil (as Bishop of Caesarea) receiving the chalice from a deacon during his celebration of the Mass. At the sight of the chalice, the Emperor faints. This legend symbolises the weakening of Arianism in the face of Saint Basil's opposition. In 381, the Nicene creed was recognised as the orthodox one, and the influence of Arianism was to decrease thereafter.

The Hermitage picture is a finished study for the large composition executed by Subleyras in 1743–7 for St Peter's in Rome. It was moved in 1752 to Santa Maria degli Angeli in Rome, a mosaic copy made by Vatican craftsmen under the direction of P. L. Ghezzi in 1748–51 taking its place in St Peter's.

Subleyras had started work on the studies at the request of Pope Benedict XIV some years before the contract commissioning the painting was signed in 1743. Several preliminary works are extant: the Louvre study differing somewhat from the final version of the composition and therefore probably the earliest; the Hermitage study, almost identical to the large canvas and the artist's copy of the Hermitage composition, belonging to a French private collection. There are preliminary drawings of the composition in Besançon and in the Louvre (Cabinet des Dessins). Several studies exist for individual figures. The Musée des Beaux-Arts, Orléans, has two of these: the figure with a candlestick, and the figure with a chalice. Another study for the figure of a deacon with a chalice (3515) is in the Hermitage. A study for a group of three figures is in the Musée des Beaux-Arts, Agen. There are also some versions of the composition which are regarded as studio replicas or as copies (1987 Paris exhibition catalogue, pp. 336–7). According to the catalogue the Hermitage picture belonged to La Curne de Sainte-Palaye (c. 1753) before coming into the collection of Crozat, Baron de Thiers; it had not been in the collections of Mme de Bossette or of the court banker, Beaujon, as stated in the Hermitage catalogues. E.D.

PROVENANCE

Collection of La Curne de Sainte Palaye; 1772: acquired from the collection of Crozat, Baron de Thiers, for the Hermitage

EXHIBITION

1987 Paris, no. 116

BIBLIOGRAPHY

Hermitage catalogues: 1774, no. 1020; 1908 and 1916, no. 1477; 1958, p. 341; 1976, p. 299;
Nemilova 1982, no. 317; Nemilova 1985, no. 245; Observation sur les ouvrages de M. M. de l'Académie, Paris 1753, pp. 141–3
La Curne le Sainte Palaye, Paris 1755, p. 56; Memorie par le Belle Arti, February 1786, p. xxxv; Georgi 1794, p. 480
F. Labensky, Livret de la Galerie impériale de l'Ermitage de Saint-Pétersbourg, St Petersburg 1838, vol. XIX, p. 184, no. 56; Dussieux 1856, no. 961
Blanc 1862, vol. 2, p. 8; T. Lejeune, Guide Théorique et pratique de l'amateur de tableaux, Paris 1865, vol. 3, p. 319
E. Dacier, Catalogue de ventes et livrets de salons illustrés par Gabriel de Saint-Aubin, Paris 1913, vol. VIII, pp. 62–3, 56
L. Réau, 'Une biographie italienne de Pierre Subleyras', Bulletin de la Société de l'Histoire de l'Art Français, 1924, p. 198; Réau 1929, no. 334
O. Arnould, 'Subleyras' in Ed. M. Louis Dimier, Paris–Brussels 1928–30, vol. 2, p. 77, no. 46
M. Stuffmann, 'Les tableaux de la collection de Pierre Crozat', Gazette des Beaux-Arts, July–September 1968, p. 134, no. 173
N. Volle, De Watteau à David: Peintures et dessins des musées de province français, Brussels 1975, p. 74
H. R. Hutter, 'Zur Genese von Pierre Subleyras, Messe des Hl. Basilius',
Römische historische Mitteilungen, vol. XXVII, 1985, pp. 505–10

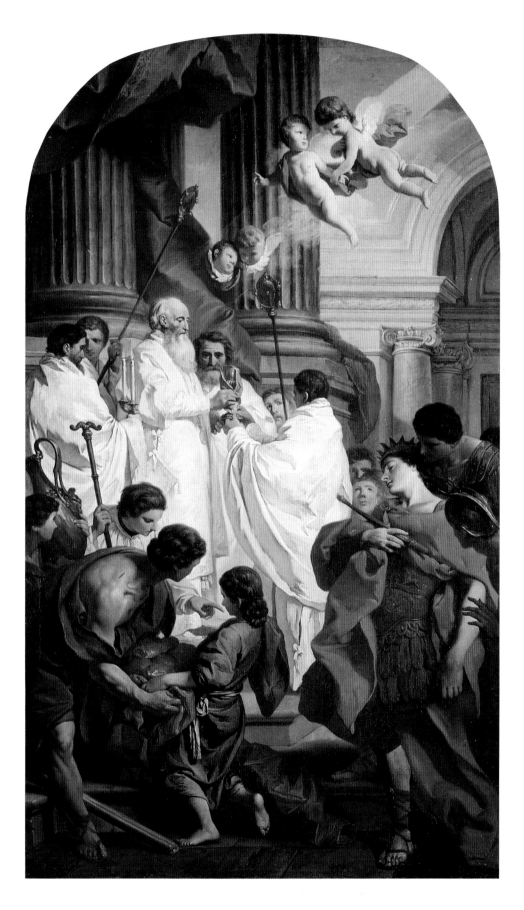

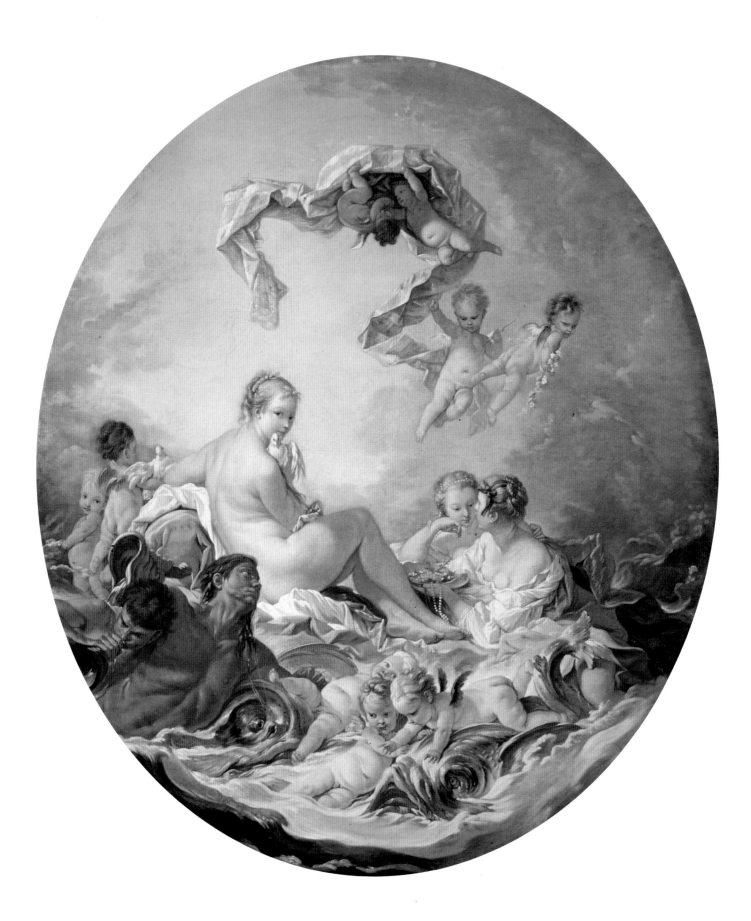

FRANÇOIS BOUCHER (1703–1770)

The Birth and Triumph of Venus

Oil on canvas, oval, 103 × 87 (40½ × 34¼)
Hermitage, Leningrad (7656)

X-radiograph analysis has revealed that minor changes in the contours of the figures were made in the course of painting the picture. The painting and its pendant, *The Toilet of Venus* (no. 5), are datable to the early 1740s through comparison with a pair of ovals showing *The Birth of Venus* and *The Toilet of Venus* which were exhibited at the 1743 Paris Salon (now New York, private collection).

A large number of variants by Boucher and his workshop are known. The compositions, and the drawings for them, were extremely popular and several engravings of the group exist, by J. Daullé and C. Duflos. There is a whole series of preliminary drawings for both pictures. A drawing of the figure of Venus for the present picture is in the Hermitage (382). E.D.

PROVENANCE

Prince Yusupov collection, St Petersburg; 1920: the Yusupov palace museum, Petrograd;
1925: transferred to the Hermitage

EXHIBITIONS

1956 Leningrad, p. 10; 1970 Leningrad, no. 3; 1987–8 Delhi, no. 64

BIBLIOGRAPHY

Hermitage catalogues: 1958, p. 263; 1976, p. 187; Nemilova 1982, no. 15; Nemilova 1985, no. 10
Youssoupoff 1839, no. 309
A. Prakhov, 'Provenance of Prince Yusupov's art treasures', *Russian Art Treasures*, 1906, p. 210, no. 7
State Museum Fond, *Catalogue of Art Treasures from the former Yusupov Collection*, St Petersburg 1920, p. 6, no. 56
S. P. Ernst, *Yusupov collection: The French School*, Leningrad 1924, no. 38
Réau 1929, no. 440; Ananoff 1976, p. 361
P. Jean-Richard, *L'Oeuvre gravé de François Boucher dans la collection Edmond de Rothschild*, Paris 1978, nos. 550, 900
J. P. Marandel, 'Boucher et l'Europe' in *François Boucher: 1703–1770*, exhibition catalogue,
Paris 1986, p. 91

FRANÇOIS BOUCHER (1703–1770)

The Toilet of Venus

Oil on canvas, oval, 101 × 86.7 (39¾ × 34¼)
Hermitage, Leningrad (7655)

She had always before been accustomed to idle in the shade, devoting all her attention to enhancing her beauty . . . (Ovid, *Metamorphoses*, X, 533–4). This painting and its pendant, *The Birth and Triumph of Venus* (no. 4), may be dated to the early 1740s since a comparable version, which was presumably their precursor, was exhibited at the 1743 Salon. This version is thought to be identifiable with one of a number of canvases in a private collection in New York. A series of variations on this composition exists, some ascribed to Boucher and some to his studio (Wallace Collection, London; Nationalmuseum, Stockholm).

Some scholars, for example Marandel (1986), suggest that the Hermitage paintings may be copies made in Boucher's studio. E.D.

PROVENANCE

Prince Yusupov collection, St Petersburg; 1920: the Yusupov palace museum, Petrograd;
1925: transferred to the Hermitage

EXHIBITIONS

1956 Leningrad, p. 10; 1970 Leningrad, no. 4; 1972 Dresden, no. 3;
1985 Sapporo–Fukuoka, no. 21, p. 144; 1987–8 Delhi, no. 63

BIBLIOGRAPHY

Hermitage catalogues: 1958, p. 263; 1976, p. 187; Nemilova 1982, no. 16; Nemilova 1985, no. 11
A. Prakhov, 'Provenance of Prince Yusupov's art treasures', *Russian Art Treasures*, 1906, p. 210
State Museum Fond, *Catalogue of Art Treasures from the former Yusupov collection*, St Petersburg 1920 p. 5, no. 48
S. P. Ernst, *Yusupov collection: The French School*, Leningrad 1924, no. 39
Réau 1929, no. 441; Ananoff 1976, nos. 245–5
P. Jean-Richard, *L'Oeuvre gravé de François Boucher dans la collection Edmond de Rothschild*, Paris 1978, nos. 550, 899
J. P. Marandel, 'Boucher et l'Europe', in *François Boucher, 1703–1770*, exhibition catalogue, Paris 1986, p. 91

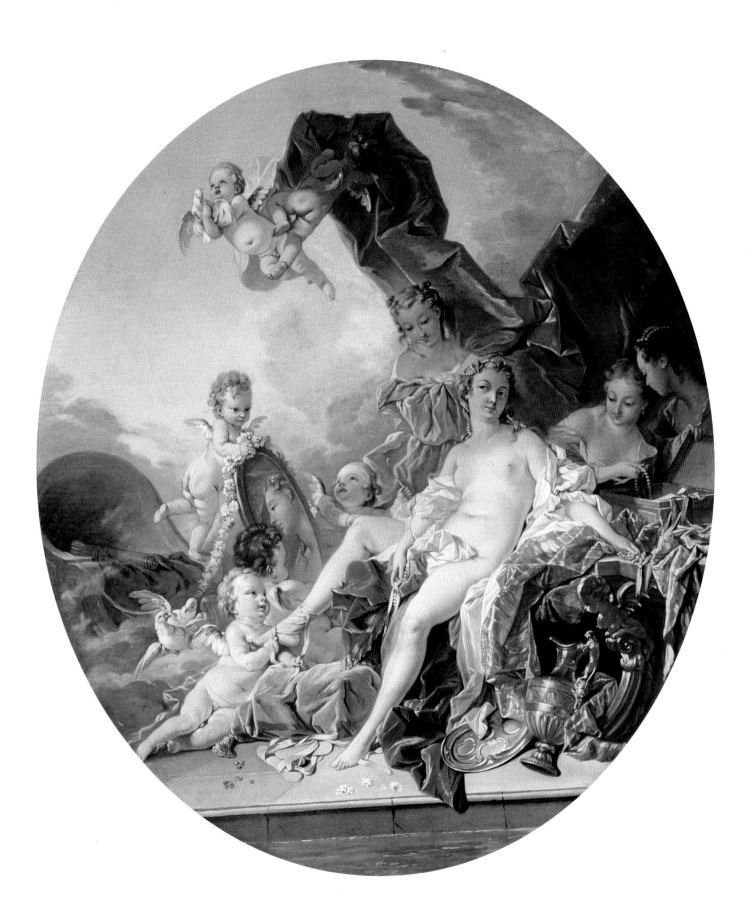

41

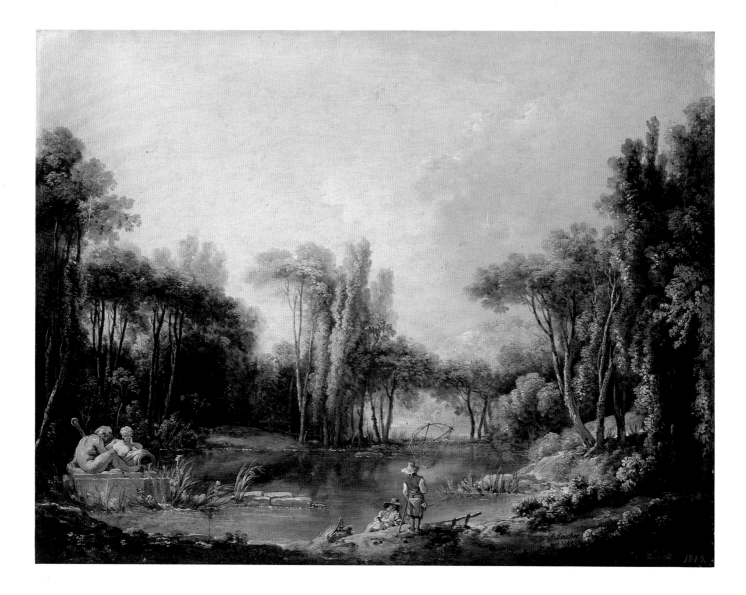

6

FRANÇOIS BOUCHER (1703–1770)

Landscape with a Pond

Oil on canvas, 51 × 65 (20 × 25½)
Signed and dated bottom right: f. Boucher, 1746
Hermitage, Leningrad (1137)

At the time of painting this landscape in the 1740s, Boucher was much involved with work for the theatre, designing scenery for the Paris Opéra. His decorative gifts are vividly expressed in his landscapes. Virtuoso paintings like this one, with a predominance of bluish-greens, are far removed from a realistic representation of nature, and resemble theatrical scenery.

Another landscape, in the Nationalmuseum in Stockholm, comes closest in composition to the Hermitage picture, reproducing the same statue. The same standing figure of a fisherman, wearing a hat, appears in the 1761 *Landscape with a Pond* (private collection, Bielefeld). The same drawing evidently served for both pictures. E.D.

PROVENANCE

1772: acquired from Crozat, Baron de Thiers collection in Paris; 1860–82: Gatchina Palace

EXHIBITIONS

1955 Moscow, p. 23; 1956 Leningrad, p. 10; 1968 Göteborg, no. 21; 1970 Leningrad, no. 2;
1972 Dresden, no. 2; 1977 Tokyo–Kyoto, no. 33; 1982 Tokyo–Kumamoto, no. 40

BIBLIOGRAPHY

Hermitage catalogues: 1774, no. 1149; 1908 and 1916, no. 1797; 1958, p. 261; 1976, p. 186;
Nemilova 1982, no. 14; Nemilova 1985, no. 9
A. Benoit, *History of Painting*, St Petersburg 1912, vol. 4, p. 332
I. S. Nemilova, 'A New Painting by François Boucher', in *Transactions of the State Hermitage*, 1961, vol. 6, p. 306
Baroque and Rococo Masters 1965, no. 72
M. Stuffmann, 'Les Tableaux de la collection de Pierre Crozat: Historique et destinée
d'un ensemble célèbre établis en partant d'un inventaire après décès inédits (1740)',
Gazette des Beaux-Arts, July–September 1968, p. 126
Nemilova 1975, p. 436; Ananoff 1976, p. 409, no. 300

FRANÇOIS BOUCHER (1703–1770)

'Le Sommeil de l'enfant Jésus' (The Virgin and Child with the Infant John the Baptist)

Oil on canvas, 118 × 90 (46½ × 35½)
Signed and dated bottom left: f. Boucher 1758
Pushkin Museum, Moscow (730)

The painting was executed for the Marquise de Pompadour in 1758, i.e. a year after the *Rest on the Flight into Egypt* in the Hermitage. It appeared at the 1759 Salon with no catalogue entry, under the title 'La Nativité' and was widely noted in the press. Diderot, who was later to become fiercely critical of Boucher's work, could not resist writing at this, his first, Salon: 'I consider that its colours are false . . . that there is nothing more ridiculous in such a context than the grand bed with its canopy, but . . . I wouldn't mind owning this painting' (*'J'avoue que le coloris en est faux . . . qu'il n'est rien de si ridicule qu'un lit galant à baldaquin dans un sujet pareil mais . . . je ne serais pas fâché d'avoir ce tableau'*). All the critics admired the quality of the painting, but some remarked that the Virgin was more like one of the Graces or even a theatrical dancer.

At the exhibition of French painting at the Hermitage in 1922–5 this canvas was called 'Le Rêve de l'enfant Jésus'. Until 1918 it was part of the collection of the Counts Vorontsov-Dashkov. It is not known how or when it arrived in Russia.

I.K.

PROVENANCE

1759–64: Marquise de Pompadour collection; until 1918: Counts Vorontsov-Dashkov collection; 1918–25: the Hermitage; 1925: transferred to the Pushkin Museum

EXHIBITIONS

1759 Paris, Salon; 1922–5 Petrograd

BIBLIOGRAPHY

Pushkin Museum Catalogues: 1948, p. 14; 1957, p. 21; 1961, p. 20; 1986; p. 37
Diderot, 1875–7, vol. 10, p. 102; Ernst 1928, p. 180; Réau 1929, p. 437
J. Cordey, *Inventaire des biens de Madame de Pompadour rédigé après son décès*, Paris 1939, p. 1242
Sterling 1957, p. 218; Ananoff 1976, vol. II, p. 173, no. 498
Kuznetsova 1982, p. 81

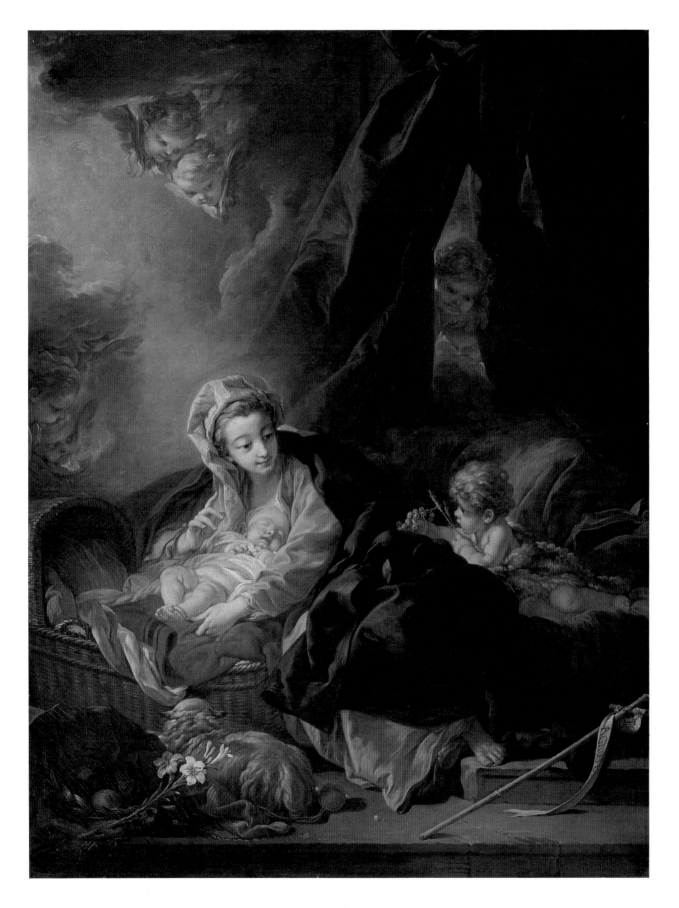

CLAUDE-JOSEPH VERNET (1714–1789)

'Rome: La Villa Ludovisi dans le moment où les eaux jouent' (The Villa Ludovisi, Rome)

Oil on canvas, 74.5 × 99.5 (29¼ × 39¼)
Signed and dated on the right, on an album held by the artist: Joseph Vernet, f. Roma 1749
Hermitage, Leningrad (3684)

Both *The Villa Ludovisi* and its pendant *The Villa Pamphili, Rome* (no. 9), were in the Hermitage until 1930, when *The Villa Pamphili* was transferred to the Pushkin Museum in Moscow.

The picture shows motifs peculiar to the estate: the topiary in the park, the fountains screened by the greenery, the structure of the walls and of the portico. However, it is impossible to identify the location topographically with the plans and engravings of the villa, since the artist has altered the interrelationship of the building and the park.

The artist himself is seen in the foreground, holding an album and a pencil in his hand, with his wife Virginia Parker and his son Livio with a governess. This group is encountered in several later compositions by Vernet; the artist's son grows visibly older in each one. The Vernet family appears again in another Hermitage painting, *The Italian Harbour* of 1750 (1273).

In 1746, the Marquis de Villette commissioned eight pictures from Vernet, as was recorded by the artist himself. It is clear from his notes that the paintings were to be completed in pairs, two pictures a year. *The Villa Ludovisi* and *The Villa Pamphili* were completed in 1749, and were the last pair of the commission. Vernet referred to them as: 'Two other (views) of the gardens, with figures dressed in the latest fashion' (Lagrange 1864, Commandes, 60); and 'For M. de Villette, two views of the gardens' (Lagrange 1864, Reçus, 26).

Both paintings were auctioned on 8 April 1765 in Paris. They were acquired by Catherine the Great between 1765 and 1768, and presented to the St Petersburg Academy of Arts in 1768. E.D.

PROVENANCE

Until 1765: Marquis de Villette collection; from 1768: St Petersburg Academy of Arts;
1922: transferred to the Hermitage from the Academy of Arts Museum in Petrograd

EXHIBITIONS

1955 Moscow, p. 25; 1956 Leningrad, p. 13

BIBLIOGRAPHY

Hermitage catalogues: 1958, p. 271–3; 1976, p. 190; Nemilova 1982, no. 60; Nemilova 1985, no. 290
Lagrange 1864, pp. 185, 327, no. 60
A. Somov, *Picture Gallery of the Imperial Academy of Painting*, II,
Catalogue of Foreign Paintings (originals and copies), St Petersburg 1874, no. 585
Ingersoll-Smouse 1926, vol. 1, no. 213; Réau 1929, no. 393 bis; Nemilova 1975, p. 440

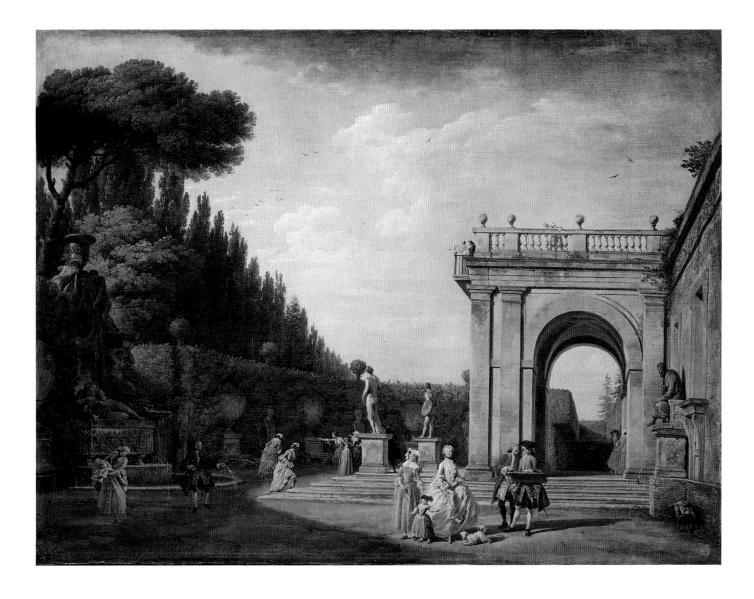

CLAUDE-JOSEPH VERNET (1714–1789)

The Villa Pamphili, Rome

Oil on canvas, 76 × 101 (30 × 39¾)
Signed and dated bottom right: Joseph Vernet f. Romae 1749
Pushkin Museum, Moscow (2769)

This painting and its pendant, *The Villa Ludovisi, Rome* (no. 8), belong to the artist's best period. Vernet went to Italy at the age of twenty, and by 1749 had spent fifteen years in Rome, painting chiefly picturesque Italian landscapes. His reputation stretched throughout Europe.

The Villa Pamphili, Rome, together with its pair, was commissioned by his devoted patron, the Marquis de Villette, in May–June 1746 as two of a total of eight canvases which were to be delivered to the Marquis at the rate of two per year.

The pair of paintings included in the present exhibition was described as depicting 'garden fêtes with fashionably dressed figures', in other words scenes of contemporary life. The setting is not an imaginary one; instead the artist leads the viewer into the luxurious gardens of two well-known Roman villas.

The Villa Pamphili, Rome shows festively dressed figures promenading up and down an 'avenue of fountains', with a semicircular amphitheatre in the background. In the further distance is a merry circle of dancers. In this picture, but not in its pair, it is difficult to distinguish the faces in the foreground, although the two central figures, facing the viewer, are most probably portraits.

The lively spontaneity of the whole scene, the pale and harmonious colours and the splendidly represented light of a clear summer's day already declining into dusk lend this landscape a special charm. I.K.

PROVENANCE

Until 1765: Marquis de Villette collection; acquired by Catherine the Great; 1768: presented to the Academy of Arts in St Petersburg; 1922: The Hermitage; 1930: transferred to the Pushkin Museum

EXHIBITIONS

1955 Moscow, p. 25; 1958 Leningrad, p. 13; 1965 Bordeaux, no. 37; 1965–6 Paris, no. 36; 1976 Paris, no. 21

BIBLIOGRAPHY

Pushkin Museum catalogues: 1948, p. 18; 1957, p. 26; 1961, p. 36; 1986, p. 44
Lagrange 1864, p. 327
A. Somov, *Catalogue of the Academy of Arts: Foreign Paintings*, St Petersburg 1874, p. 149, no. 586
Ingersoll-Smouse 1926, vol. 1, p. 53, no. 212
Réau 1929, no. 393; Sterling 1957, p. 58; Kuznetsova 1982, p. 95

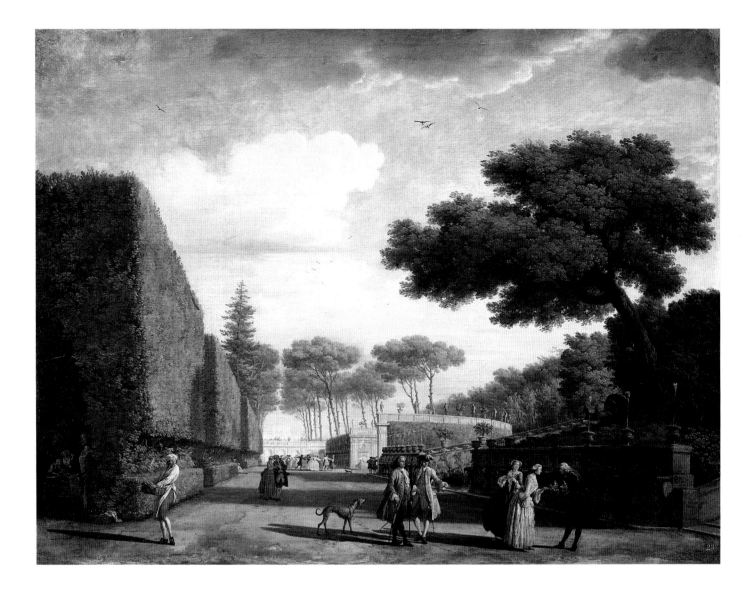

JEAN-SIMEON CHARDIN (1699–1779)

Still Life with the Attributes of the Arts

Oil on canvas, 112 × 140.5 (44 × 55¼)
Signed and dated bottom left, along the edge of the table: Chardin 1766
Hermitage, Leningrad (5627)

This painting was commissioned in 1766 from the artist by Catherine the Great. It was intended to decorate the conference hall at the St Petersburg Academy of Arts. The picture arrived in Russia in the same year, but was in fact not given to the Academy and remained in the Hermitage collection until the mid-nineteenth century. In 1854 it was sold at auction to an anonymous buyer, and subsequently was employed as an overdoor at the country residence of Greig in Oranienbaum. The original shape of the picture, which was altered to fit into the available space, has been restored by ornamental corner attachments.

In his maturity Chardin painted several allegorical still lifes of the attributes of the arts. The Hermitage painting represents the master's attitude to the principles of 'high art' and symbolically links the St Petersburg and the French Academies (Yakimovich 1981).

The still life is dominated by the sculpture of Mercury, patron of the arts. A variant of the figure in marble (Louvre, Paris) was Jean-Baptiste Pigalle's entry in 1744 for membership of the Académie, and confirmed his reputation as an important sculptor. He placed French sculpture on a par with examples from antiquity and from the Italian Renaissance (Conisbee 1986) and became the first sculptor to be awarded the Order of St Michael, in 1769. The honour was officially bestowed on him by Louis XV for the monument placed in the Place Royale in Rheims in 1765, the year before Chardin painted his still life. The insignia of the Order, on a black ribbon, may be seen in the foreground of Chardin's picture.

The statue of Mercury also appears in works by Chardin of 1748. The artist had a plaster cast of it, made numerous drawings of it and included it in his painting *The Drawing Lesson* (London art market). Thus, almost twenty years before Pigalle's achievements received royal recognition, Chardin put Pigalle's sculpture in his picture to serve as a model for the instruction of young artists. Other accessories include architectural tools, drawings and commemorative medals of the type issued on the occasion of the laying of corner stones or the completion of a building.

There are three extant versions of the *Still Life with the Attributes of the Arts*. The first, painted in 1765 (Louvre, Paris) (i.e. before the Hermitage version), was commissioned by the Marquis de Marigny for the Château de Choisy. These paintings are very similar in composition, but instead of the Pigalle sculpture the earlier one depicts a less expressive seated female figure. After painting the *Still Life* for Catherine the Great, Chardin painted a replica of it for Pigalle (possibly the painting today in the Minneapolis Arts Institute). Another painting, listed in the catalogue as 'Reproduction with minor alterations of the painting commissioned by the Russian Empress' and belonging to Abbé Pommyer was shown at the 1769 Salon. The painting is known only from the drawing by Gabriel de Saint-Aubin, and is often mistakenly identified with the still life in Minneapolis. E.D.

PROVENANCE

1766: acquired from the artist's studio; 1854: private collection, St Petersburg;
second half of 19th century: country residence of Greig in Oranienbaum (now Lomonosov);
H. van der Palei collection near Oranienbaum; 1926: re-acquired by the Hermitage
from the Commission for the Amelioration of the Living Conditions of Children, Leningrad

EXHIBITIONS

1937 Paris, no. 142; 1955 Moscow, p. 61; 1956 Leningrad, p. 61; 1972 Dresden, no. 19;
1975–6 USA–Mexico–Canada, no. 12; 1979 Cleveland–Boston, no. 125; 1979 Paris, no. 125;
1986–7 Paris, no. 327; 1987 Leningrad, no. 427

BIBLIOGRAPHY

Hermitage catalogues: 1774, no. 378; 1958, p. 355; 1976, p. 233; Nemilova 1982, no. 363; Nemilova 1985, no. 25
Georgi 1794, p. 478; Dussieux 1856, no. 893; Blanc 1862, vol. 2, p. 16

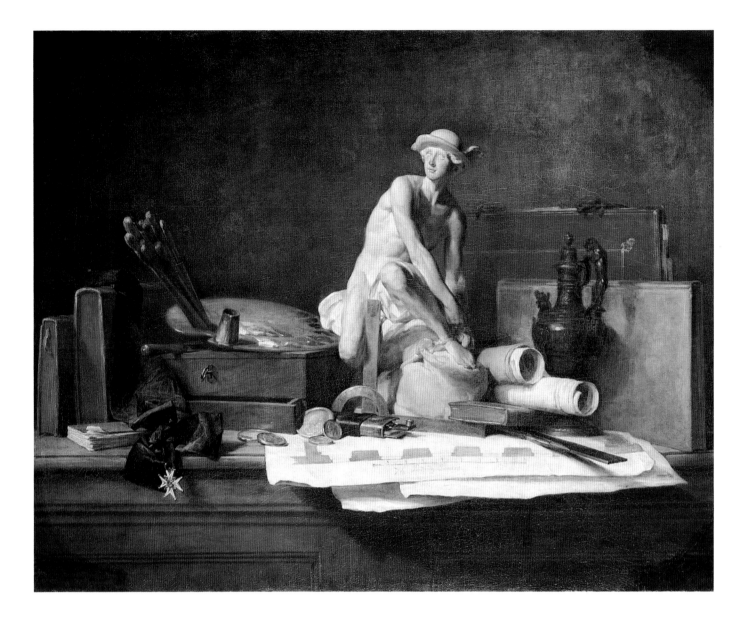

G. F. Waagen, *Die Gemäldesammlung in der Kaiserlichen Ermitage zu St Petersburg, nebst Bemerkungen über andere dortige Kunstsammlungen*, Munich 1864, p. 305

J. Guiffery, *Catalogue raisonné de l'oeuvre peint et dessiné de J-B. S. Chardin, suivi de la liste des gravures executées d'après ses ouvrages*, Paris 1908, pp. 77, 91; E. Pilon, *Chardin*, Paris 1909, p. 170

N. N. Wrangel, 'Art and the Emperor Nicholas Pavlovich', *Starye Gody* (*The Old Years*), July–September 1913, pp. 89–90

Réau 1929, no. 34; G. Wildenstein, *Chardin*, Paris 1933, no. 1134

E. G. Nothaft, 'Attributes of art and problems in the allegorical still life by Chardin', *Ezhegodnik Gosudarstvennogo Ermitazha* (*Yearbook of the State Hermitage*), Leningrad 1937, vol. 1, no. 2, pp. 1–17

Sterling 1957, p. 43; I. S. Nemilova, *A. Watteau*, Moscow–Leningrad 1961, pp. 13–14

M. Faré, *La Nature morte en France, son histoire et son évolution du 17ᵉ siècle au 20ᵉ siècle*, Geneva 1962, vol. 1, p. 164

G. Wildenstein, *Chardin*, Paris 1963, no. 343; *Baroque and Rococo Masters* 1965, no. 79.

D. Diderot, *Salons: Texte établi par J. Adhémar et J. Seznec*, Oxford 1957–67, vol. 4, p. 23

R. Charmet, *French Paintings in Russian Museums*, New York 1970, pp. 9–20

P. Rosenberg, *Tout l'oeuvre peint de Chardin*, 1983, no. 180; Nemilova 1975, p. 434

M. Faré, *La Vie silencieuse en France*, (*La nature morte au 18ᵉ siècle*), Fribourg 1976, p. 168

A. K. Yakimovich, *Chardin and the Enlightenment in France*, Moscow 1981, pp. 19, 94–6, 102, 105, 107, footnotes 138, 139

P. Conisbee, *Chardin*, Oxford 1986, p. 29

JEAN-BAPTISTE GREUZE (1725–1805)

'Le Paralytique' (The Paralysed Man)

Oil on canvas, 115 × 146 (45¼ × 57½)
Scarcely legible monogram on right, on the tablecloth: JG
Hermitage, Leningrad (1168)

This picture was exhibited in the 1763 Salon and is one of the pivotal paintings in the oeuvre of Greuze, comparable to *A Father's Curse* (Louvre, Paris). Diderot wrote of it: 'Greuze is truly my kind of painter. Leaving aside his small compositions, which merit praise, I now turn to his painting *Filial Love*, which would be better named *Reward for Good Upbringing*.' ('Filial Love' is the alternative title of the Hermitage picture.) The pathos of paintings like 'Le Paralytique' stems from the artist's assertion, according to Diderot, that a family drama may be as noble as a heroic tragedy, since it arouses thoughts and feelings in the beholder which are closer to him, and is more comprehensible.

The existence of numerous drawings bears witness to the artist's careful development of the composition. Nine drawings in the Hermitage are studies for individual figures (14727, 14770, 14784, 14785, 14792, 14794, 14798, 14802, 14808). A signed study, in ink, for the painting is in the Musée des Beaux-Arts, Le Havre.

Tradition has it that Diderot acted as mediator in the acquisition of the painting from the artist by Catherine the Great. The 1767 engraving of this picture by J.-J. Flipard was dedicated to Catherine. E.D.

PROVENANCE

1766: acquired from the studio of Greuze

EXHIBITIONS

1763 Paris Salon, no. 140; 1955 Moscow, p. 28; 1956 Leningrad, p. 18; 1986–7 Paris, no. 318;
1987 Leningrad–Moscow, no. 382; 1987–8 Belgrade–Ljubliana–Zagreb, no. 9

BIBLIOGRAPHY

Hermitage catalogues: 1774, no. 22; 1908 and 1916, no. 1520; 1958, p. 281;
1976, p. 197, Nemilova 1982, no. 123, Nemilova 1985, no. 59
Georgi 1794, p. 479
F. Labensky, *Livret de la Galerie impériale de l'Ermitage de Saint-Pétersbourg*, St Petersburg 1838, p. 180, no. 60
Dussieux 1856, no. 961; Blanc 1862, vol. 2, p. 15; Diderot 1875–7, vol. 9, p. 143; vol. 10, p. 347
M. Tourneaux, *Diderot et Catherine II*, Paris 1899, pp. 57–8
E. and J. de Goncourt, *L'Art du 18ᵉ siècle*, Paris 1914, vol. 2, p. 89
C. Mauclair, M. J. Martin, C. Masson, *Jean-Baptiste Greuze, avec catalogue raisonné de l'oeuvre peint et dessiné de Jean-Baptiste Greuze suivi de la liste des gravures exécutées d'après ses ouvrages*,
Paris, [1920], p. 49, no. 186
Réau 1924, pp. 197, 199; Réau 1929, no. 115; V. K. Gerz, *Le Paralytique*, Leningrad 1949
A. Brookner, *Greuze*, London 1972, pp. 62–3, 86, 103, 106–7, 118
I. N. Novoselskaya, *Jean-Baptiste Greuze: Drawings in the Hermitage Collection*,
exhibition catalogue, Leningrad 1977, pp. 6–8, 14, nos 57–65

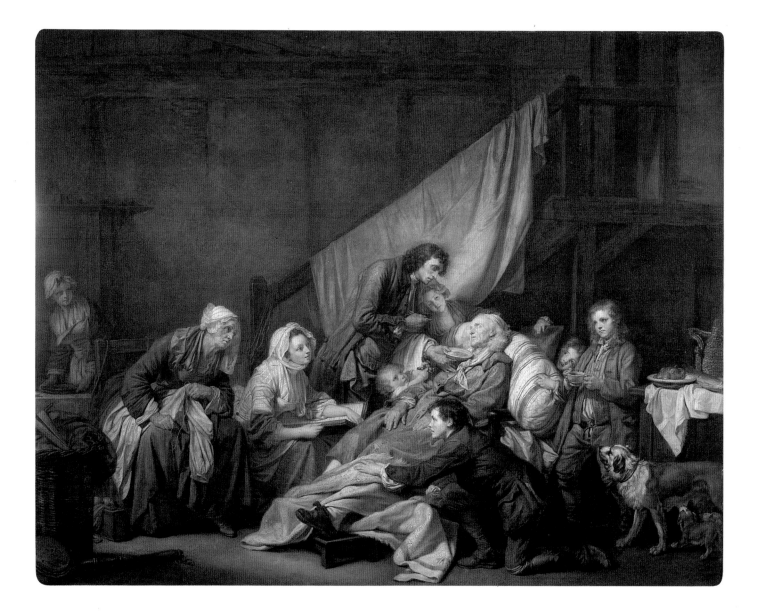

JEAN-BAPTISTE GREUZE (1725–1805)

'L'Enfant gâté' (The Spoiled Child)

Oil on canvas, 66.5 × 56 (26¼ × 22)
Hermitage, Leningrad (5725)

This picture was received reasonably favourably by the critics when it was exhibited at the 1765 Salon, but it had considerably less success than did other works of Greuze, possibly on account of its subject-matter rather than because of any artistic shortcomings. An article in the *Mercure de France*, for example, gave this view: 'This small picture is very beautiful, combining all the qualities which have brought renown to M. Greuze, but we do not know what motivated him to choose this subject, rather than some other, to portray the excessive indulgence of parents towards their children.' Diderot was not pleased with the subject either, and he made a formal artistic judgement which expressed the prevailing tastes of his time: '(The picture) is agitated, the dim light flickering from all directions and irritating the eye . . . There are too many details, too much is contrived. The composition is heavy and disorganised.' In the course of time, however, the painting came to be considered as a characteristic example of the artist's work.

It is probable that Greuze intended to paint a picture as a pair for 'L'Enfant gâté'. There exists a drawing, possibly of the proposed work (Sterling and Clark Institute, Williamstown, Massachusetts), as well as a compositional study (Louvre, Paris; Mauclair 1920, no. 319).

There exists a series of preliminary drawings for the present picture and several sketches of the composition. Two drawings for the figure of the mother and a study of the boy's head are in the Hermitage (14773, 14787, 14493). The Albertina in Vienna has a finished study drawing, and the Boymans-van Beuningen Museum in Rotterdam has a number of drawings connected in one way or another with the Hermitage picture.

'L'Enfant gâté' was probably painted in the early 1760s. Miller (1923) believed that it was painted before 1763, since it was, it seems, sold that year to the Desmarest collection from the collection of Duc de Choiseul-Praslin. However, other information suggests that the sale took place in 1793. It is certain that in 1798 'L'Enfant gâté' was already in Prince Bezborodko's collection, where it came through Melissino, the Ober-Prokurist of the Most Holy Synod. In a letter dated 9 February 1798, Bezborodko writes to the architect Lvov: 'Milissino has foisted on me a very considerable Greuze, "L'Enfant gâté".' The number 107, in white in the bottom left-hand corner of the front of the picture, refers to the Bezborodko collection; such numbers are to be seen on paintings by Vernet, Pompeo Batoni and others. They refer to a manuscript catalogue (untraceable), in French, which, according to van Reimers (1805, p. 357), was compiled by the restorer Ivan Gauf.

E.D.

PROVENANCE

Before 1793: Duc de Choiseul-Praslin collection; 1793: Desmarest collection; 1797: Darnay collection;
possibly 1798: Melissino collection; 1798: Prince Bezborodko collection, St Petersburg;
mid-19th century: Prince F. Paskevich collection, St Petersburg, until 1923: Princess I. Paskevich collection;
1923: transferred to the Hermitage from the collection of Princess Paskevich in Petrograd through the State Museums Fond.

EXHIBITIONS

1765 Paris Salon, no. 111; 1967–8 Dresden (no number); 1968 Göteborg, no. 26

BIBLIOGRAPHY

Hermitage catalogues: 1958, p. 281; 1976, p. 197; Nemilova 1982, no. 122; Nemilova 1985, no. 58
Mercure de France, October 1765, vol. 1, p. 168; Blanc 1862, vol. 2, p. 16; Diderot 1875–7, vol. 10, pp. 347–8 (Salon 1765)
Van Reimers, *Petersburg am Ende seines ersten Jahrhunderts*, St Petersburg 1805, vol. 2
E. and J. de Goncourt, *L'Art du 18e siècle*, Paris 1914, vol. 2, pp. 77, 87
C. Mauclair, M. J. Martin, C. Masson, *Jean-Baptiste Greuze, avec catalogue raisonné de l'oeuvre peint
et dessiné de Jean-Baptiste Greuze suivi de la liste des gravures exécutées d'après ses ouvrages*, Paris [1920], p. 89, no. 136
M. F. Miller, 'French Paintings of the 17th-18th Centuries in the New Rooms at the Hermitage', *Gorod (The City)*, 1923, no. 1, p. 71
M. Dobroklonsky, *Dessins des maîtres anciens*, Leningrad 1926, p. 78, no. 210
Ernst 1928, pp. 238–9; Réau 1929, no. 116; A. Brookner, *Greuze*, London 1972, pp. 64, 98
I. N. Novosleskaya, *Jean-Baptiste Greuze: Drawings in the Hermitage Collection*, exhibition catalogue, Leningrad 1977, p. 14, nos 76–8

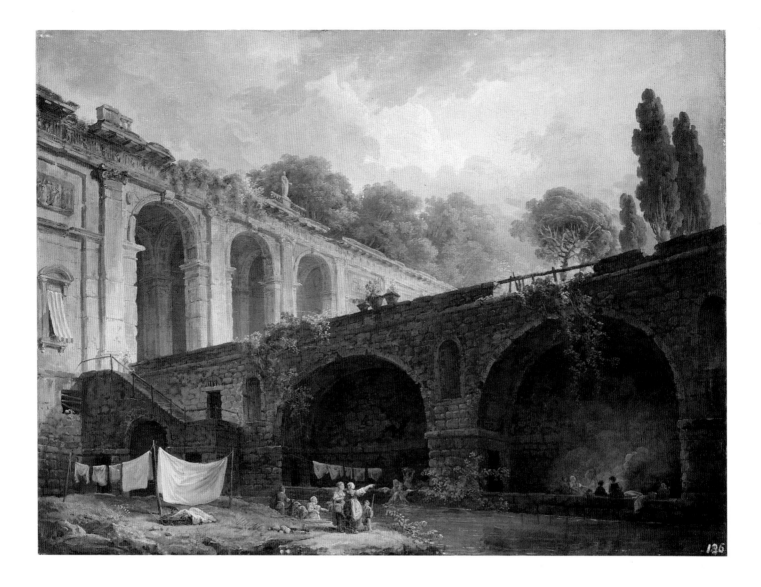

HUBERT ROBERT (1733–1808)

The Villa Madama, Rome

Oil on canvas, 52 × 69.5 (20½ × 27¼)
Hermitage, Leningrad (7593)

The Villa Madama, situated on Monte Mario south of Rome, was the country property of Cardinal Giulio de' Medici, who in 1523 became Pope Clement VII. Its construction was started in 1517 to the design of Raphael, Giulio Romano and Antonio da Sangallo the Younger. Subsequently the villa became the property of Margaret of Austria, the daughter of Emperor Charles V and wife of Ottavio Farnese, Duke of Parma. The name of the villa derives from the title 'Madame' given to the eldest daughter of the king. The loggia of the villa was decorated by Giovanni da Udine and painted by Giulio Romano. The arcade depicted in the picture leads to the villa. The building remained unfinished, and in the eighteenth century was in semi-ruined state.

The picture served as the subject for many of Robert's works. Many drawings of the buildings were made on site. In the Veyrens collection (Musée de Valence) alone there are nine. The Hermitage has a painting (5649) and a watercolour (14307), both compositions being close to that of the present picture. A splendid preliminary drawing for the present picture, dated 1760, is in the Albertina in Vienna.

The present painting was shown, with its pendant *Pavilion with Waterfall* (Hermitage no. 7594) at the Paris Salon in 1767. E.D.

PROVENANCE

Repnin collection, Yagotina, Poltava region; 1935: acquired by the Hermitage

EXHIBITIONS

1767 Paris Salon, no. 110; 1967–8 Dresden (no number);
1969 Budapest, no. 21; 1973 Warsaw, no. 10; 1985 Leningrad, no. 6

BIBLIOGRAPHY

Hermitage catalogues: 1958, p. 334; 1976, p. 225; Nemilova 1982, no. 265; Nemilova 1985, no. 188
Diderot 1875–7, vol. II, pp. 235–6; Ernst 1928, p. 242; T. D. Kamenskaya, *Hubert Robert*, Leningrad 1939, p. 19
J. de Cayeux, *Les Hubert Robert de la Collection Veyrenc au Musée de Valence*,
catalogue, Valence 1985, pp. 151–2

HUBERT ROBERT (1733–1808)

A Ruined Terrace

Oil on canvas, 59 × 87 (23¼ × 34¼)
Hermitage, Leningrad (5647)

The sculptural group shown in the painting is *The Tamer of Horses* by Guillaume Coustou. In the eighteenth century it stood, with a companion piece, on the terrace of the royal park at Marly. Today the sculptures crown the pylons at the entrance to the Champs-Elysées from the Place de la Concorde in Paris. The architecture of the terrace and the surrounding landscape as depicted in the painting do not, however, correspond to those of the park at Marly. Thus the formerly accepted title of 'The Terrace at Marly' is now regarded as dubious. The painting, in fact, exemplifies the free decorative imagination of the artist, showing him using motifs taken from life sketches in his characteristic manner.

An approximate date of 1780 is suggested since Robert painted another picture on a closely related subject, the *View in the Environs of Marly*, which was shown in the 1777 Salon. He also exhibited two paintings from life in the Marly gardens at the 1783 Salon (no. 66). These pictures belonged to the Courmont collection, but one of them was wrongly identified by Sterling (1957) with the Hermitage painting. E.D.

PROVENANCE

Prince Yusupov collection in St Petersburg; from 1920: Yusupov palace museum in Petrograd;
1925: transferred to the Hermitage

EXHIBITIONS

1908 St Petersburg, no. 80; 1955 Moscow, p. 54; 1985 Leningrad, no. 30

BIBLIOGRAPHY

Hermitage catalogues: 1958, p. 336; 1976, p. 226; Nemilova 1982, no. 288; Nemilova 1985, no. 212
Youssoupoff 1839, no. 322
L. Réau, 'Catalogue de l'oeuvre d'Hubert Robert en Russie',
Bulletin de la Société de l'Histoire de l'Art Français, 1913, p. 306
S. Ernst, *State Museum Fond: Yusupov Collection: French School*, Leningrad 1924, p. 130
Réau 1924, pp. 187, 205; Réau 1929, no. 303; T. D. Kamenskaya, *Hubert Robert*, Leningrad 1939, pp. 37–40
Sterling 1957, p. 58;
Nemilova 1975, p. 442; J. de Cayeux (preface M. Serres), *Hubert Robert et les jardins*, Paris 1987, p. 138, no. 107

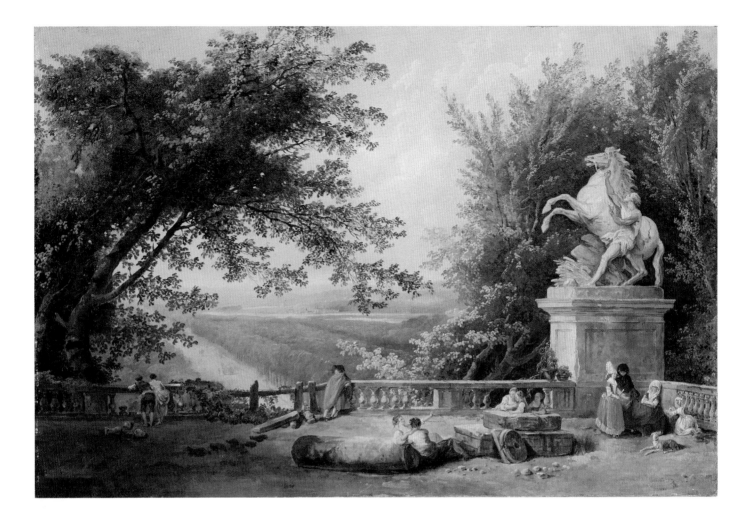

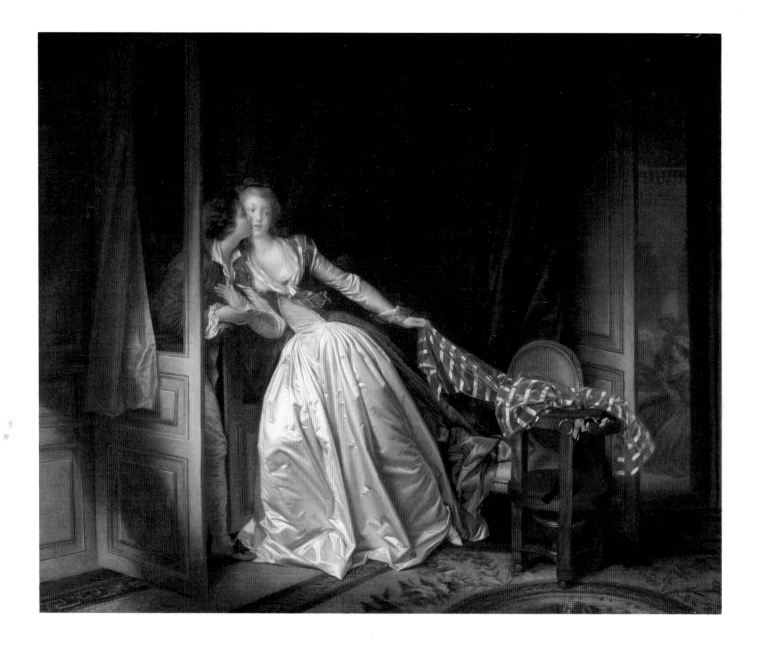

JEAN-HONORE FRAGONARD (1732–1806)

'Le Baiser à la dérobée' (The Stolen Kiss)

Oil on canvas, 45 × 55 (17¾ × 21¾)
Hermitage, Leningrad (1300)

This painting was engraved in 1788 by Nicolas-François Regnault as a pair with *The Bolt* (Louvre, Paris). However, it seems doubtful that the artist conceived them as a pair since there are disparities not only in the size but also in the manner of painting of the two pictures. Nemilova (Cat. 1982; Cat. 1985) finds *The Marriage Contract* (lost, but known from an engraving by Blot) much closer to the Hermitage painting.

The enamel-like technique employed in the '*Le Baiser à la dérobée*' is unusual for Fragonard, and this has led some art historians to doubt whether it was painted by him, and to attribute it to Marguerite Gérard (Ananoff 1979, and others). Whether Fragonard changed his technique and style in the 1780s, when the seventeenth-century Dutch masters were popular, or whether a whole series of paintings like '*Le Baiser à la dérobée*' was indeed painted by him in collaboration with his sister-in-law remains an open question (Rosenberg, 1987 exhibition catalogue). Nonetheless, it is noteworthy that the caption on the engraving by Regnault which reads '"*Le Baiser à la dérobée*". Gravé par N. F. Regnault d'après le Tableau d'H. Fragonard, Peintre du Roi' was executed in the artist's lifetime. E.D.

PROVENANCE

From the end of 18th century: collection of the Polish king Stanislav Augustus Ponyatovski in the Royal Palace of Lazienki, Warsaw; 1895: transferred from the Lazienki Palace to the Hermitage

EXHIBITIONS

1937 Paris, no. 165; 1955 Moscow, p. 60; 1956 Leningrad, p. 60; 1965 Bordeaux, no. 21; 1965–6 Paris, no. 19; 1969 Budapest, p. 10; 1972 Dresden, no. 15; 1974–5 Paris, no. 60; 1975–6 USA–Mexico–Canada, no. 11; 1979–80 Melbourne–Sydney, no. 44; 1980 Tokyo–Kyoto, no. 89; 1987–8 Paris, no. 304

BIBLIOGRAPHY

Hermitage catalogues: 1958, p. 346; 1976, p. 232; Nemilova 1982, no. 350; Nemilova 1985, no. 48
Journal de Paris, June 1788, p. 666; *Journal général de France*, 1788, p. 274; *Mercure de France*, June 1788, p. 95
Ch.-P. Landon, *Salon de 1808: Recueil de pièces choisies parmi les ouvrages de peinture et de sculpture exposés au Louvre le 14 octobre 1808*, Paris 1808, p. 9
'Catalogue des tableaux du Palais de Lazienki à Varsovie', *Revue universelle des arts*, April–September 1856, p. 58
Dussieux 1856, p. 533; Blanc 1862, vol. 2, p. 10; R. Portalis, *Honoré Fragonard, sa vie, son oeuvre*, Paris 1889, pp. 72, 271
V. Josz, *Fragonard*, Paris 1901, p. 119; R. Nevill, 'J. H. Fragonard', *Burlington Magazine*, 1903, 3, p. 290
A. Dayot, 'Chardin et Fragonard', *L'Art et les Artistes*, 1907, p. 151, no. 27; P. de Nolhac, 'J. H. Fragonard', *Revue de l'Art*, 1907, 21, p. 300
A. Dayot, *La Peinture française au 18ᵉ siècle*, Paris 1911, p. 216; L. Réau, 'La Galerie de Tableaux de l'Ermitage et la collection Semenov', *Gazette des Beaux-Arts*, 1912, p. 396; M. Conway, *Art Treasures in Soviet Russia*, London 1925, p. 169
G. Grappe, *La Vie et l'oeuvre de Fragonard*, Paris 1929, vol. 2, pp. 28, 86; Réau 1929, no. 102
R. Wilenski, *French Painting*, Boston 1936, pp. 155–60
G. Mihan, 'Masterpieces collected for the Hermitage by Catherine II and her successors', *Apollo*, April 1944, p. 111
L. Guimbaud, *Fragonard*, Paris 1947, p. 53; L. Réau, *Fragonard*, Brussels 1956, pp. 52, 70, 108, 157, pl. 59
Sterling 1957, p. 52; Y. K. Zolotov, *Fragonard*, Moscow 1959, p. 17
G. Wildenstein, *The Paintings of Fragonard*, Aylesbury 1960, p. 523, pl. 124; *Baroque and Rococo Masters* 1965, nos 82–3
A. Watt, 'From Russia with Love for Art', *Studio International*, November 1965, p. 205; J. Thuillier, *Fragonard*. Geneva 1967, pp. 12, 54, 72–4
R. Charmet, *French Paintings in Russian Museums*, New York 1970, p. 25; N. A. Livshits, *J.-H. Fragonard*, Moscow 1970, p. 88
D. Wildenstein, *L'Opera completa di Fragonard*, Milan 1972
P. Rosenberg, I. Compin, 'Quatre nouveaux Fragonard au Louvre', *La Revue du Louvre*, 1974, nos. 4–5, pp. 263–78
T. Gaehtgens, 'De David à Delacroix: La peinture française de 1774 à 1830', *Kunst Chronik*, February 1975, p. 46
A. Ananoff, 'Propos sur les peintures de Marguerite Gérard', *Gazette des Beaux-Arts*, December 1979, pp. 215–16, 218
S. Wells-Robertson, 'Marguerite Gérard et les Fragonard', *Bulletin de la Société de l'Histoire de l'Art Français*, 1977, p. 187

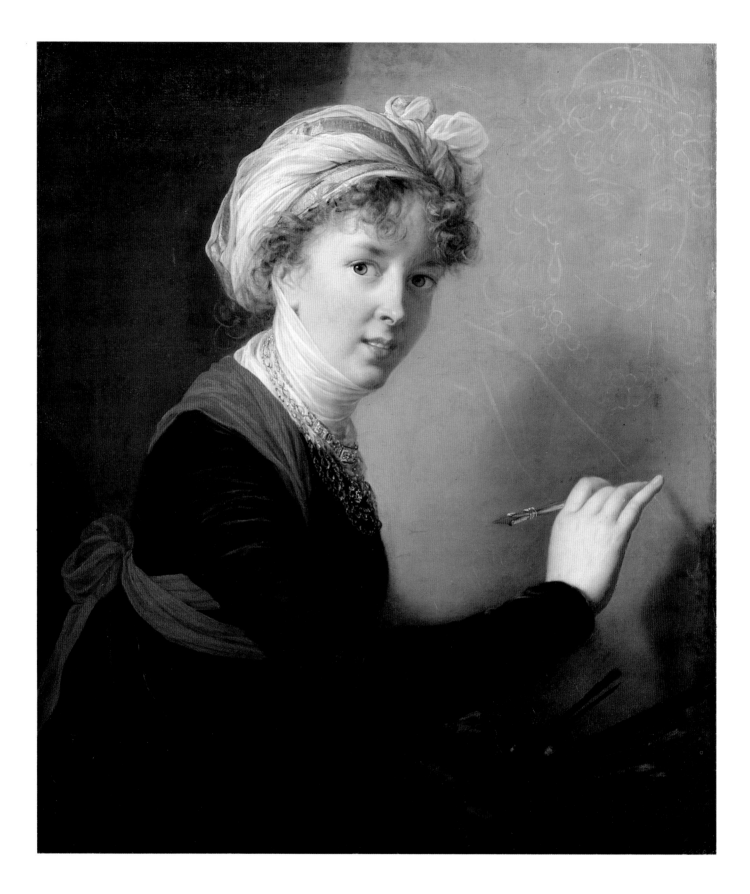

ELIZABETH LOUISE VIGEE LE BRUN (1755–1842)

Self Portrait

Oil on canvas, 78.5 × 68 (31 × 26¾)
Signed and dated, bottom left: Vigée Le Brun à Pétersbourg 1800
Hermitage, Leningrad (7586)

The artist is depicted working on a portrait of the Empress Maria Feodorovna (1759–1828), the wife of Paul I, the sitter dressed in semi-formal imperial court attire. It is the full-length portrait of the empress which Vigée Le Brun painted in 1799 (Hermitage; 1272), in response to a commission from Tsar Paul.

Vigée Le Brun was working in Russia between 1795 and 1801. Her portraits enjoyed great success and were recognised by the St Petersburg Academy of Arts. In 1880 the artist presented the *Self Portrait* to the Academy, where it was displayed among other portraits in the Council Hall. For this painting she was awarded the title of 'Membre d'Honneur' of the Academy of Arts. E.D.

PROVENANCE

1922: transferred to the Hermitage from the Academy of Arts Museum in Petrograd

EXHIBITIONS

1870 St Petersburg, no. 729; 1905 St Petersburg, no. 256; 1956 Leningrad, p. 14; 1965 Bordeaux, no. 38; 1965–6 Paris, no. 38; 1967–8 Dresden (no number); 1972 Leningrad, Portraiture, no. 319; 1979–80 Melbourne–Sydney, no. 45; 1986–7 Paris, no. 313; 1987 Leningrad, no. 378

BIBLIOGRAPHY

Hermitage catalogues: 1958, p. 276; 1976, p. 194; Nemilova 1982, no. 93; Nemilova 1985, no. 326
Souvenirs de Mme Louise-Elisabeth Vigée-Lebrun, Paris 1835, vol. 2, p. 472; vol. 3, pp. 39, 348
Dussieux 1856, no. 909; Réau 1924, p. 299; Réau 1929, no. 180

JACQUES-LOUIS DAVID (1748–1825)

'La Douleur d'Andromaque' (Andromache mourning Hector)

Oil on canvas, 58 × 43 (22¾ × 17)
Signed and dated bottom left: L. David 1783
Pushkin Museum, Moscow (843)

The subject is taken from Homer's *Iliad* (XXIV, 720–45). This picture is a finished study for the large painting of the same title now in the Louvre. For this painting David was unanimously elected to the membership of the Académie Royale on 22 August 1783, and the canvas itself was immediately exhibited at the Salon.

The subject of the burial and mourning of a hero was one of the leading themes in David's work. As early as 1780, while in Rome, he made a large frieze-like oil sketch depicting *The Funeral of Patroclus* (National Gallery of Ireland, Dublin). David's concept of *La Douleur d'Andromaque* evolved over the following two years.

The preliminary sketch for the painting is in the Municipal Library at Mulhouse. This small pen and black chalk drawing shows Hector's body on a couch, and Andromache seated next to it, with the child Astyanax, weeping, on her lap. There are no details of their surroundings, but the sketch already reveals the nucleus of the future composition.

The next stage is represented in a black chalk and wash drawing dated 1782 from the former collections of N. Revil and B. Fillon, now in the Musée du Petit-Palais in Paris. This is a completed composition very similar to the painting, with drapery covering the wall, Hector's armour, and a couch embellished with bas-reliefs. An important change has been made to Astyanax, who is no longer weeping but standing next to his mother and stretching up to her, trying to console her.

The Moscow oil study dated 1783 is even closer to the Louvre painting, completed the same year. Its format has been extended upwards; the wall drapery is now surmounted by a cornice, above which are the bases of some columns. On the right is a monumental pedestal supporting a lamp (or incense burner), whose vertical line emphasises the perpendicular elements which are important to the composition.

The position of Hector's body upon the funerary couch may well reflect the influence of the Scottish artist Gavin Hamilton's canvas on the same theme, painted in Rome in 1761 and engraved by Cunego in 1764. However, the austere and majestic composition of David's painting shows no trace of the theatrical gesturing and agitation of the multitude of figures depicted by his predecessor. Only the image of Andromache, her face distorted by grief, displays the striving after expression which is concealed and restrained in the finished work, in accordance with the classical ideal. The study differs in some small details from the finished painting, but the principal elements are the same. This suggests that it was this particular study which was submitted for consideration to the Académie on 29 March 1783. I.K.

PROVENANCE

1805: acquired in Paris by the Russian ambassador to Florence, Nikolai Demidov;
later in the collection of the architect Auguste de Montferrand in St Petersburg;
early 1860s: acquired by P. Ushakov; 1900: purchased for the Hermitage from I. Vasiliev for 900 roubles;
1927: transferred to the Pushkin Museum

EXHIBITIONS

1861 St Petersburg, *Exhibition of paintings belonging to Members of the Imperial family and to Private Owners*, no. 152;
1955 Moscow, p. 29; 1956 Leningrad, p. 19; 1964 Leningrad, *Western European Painting from Soviet Museums.*
Exhibition marking the 200th Jubilee of the Hermitage, p. 14

BIBLIOGRAPHY

Pushkin Museum catalogues: 1948, p. 24; 1957, p. 45; 1961, p. 65; 1986, p. 64; Dussieux 1856, p. 444
A. Somov, *Imperial Hermitage. Catalogue of the Picture Gallery, III, English and French Painting*, St Petersburg 1900, pp. 42–3, no. 1883
Réau 1929, p. 75, no. 485; R. Cantinelli, *J-L. David*, Paris 1930, p. 102; K. Holma, *David, son évolution et son style*, Paris 1940, p. 42
L. Hautecoeur, *Louis David*, Paris 1954, p. 66; Sterling 1957, p. 65; A. Schnapper, *David, témoin de son temps*, Fribourg 1980, p. 70
I. Kuznetsova, *French Painting of the 16th-First Half 19th Centuries*, Pushkin Museum Publications, Moscow 1982, pp. 111–12

JEAN-AUGUSTE-DOMINIQUE INGRES (1780–1867)

Portrait of Count Guryev

Oil on canvas, 107 × 86 (42 × 33¾)
Signed and dated bottom left, on the parapet: Ingres, Flor. 1821.
Hermitage, Leningrad (5678)

Nicholas Guryev (1792–1849) was the son of the Minister of Finance, Dmitri Guryev. He took part in the Napoleonic war of 1812 and in the campaigns of 1813 and 1814. In 1816 he was promoted to the rank of colonel, but retired at the end of that year with the civilian rank of councillor. In 1818 he rejoined the service as an aide-de-camp to Tsar Alexander I. He retired in November 1818, transferred to the diplomatic service and served as Russian ambassador to The Hague, Rome and Naples. He was later Secretary of State at the Ministry of Foreign Affairs, and in 1834 became a Privy Councillor.

In the autumn of 1820 Guryev and his young wife travelled to Italy on their honeymoon. Judging from the letter which Ingres sent from Florence to his friend J. P. G. Gilibert in France, dated 20 April 1821, the portrait had been completed by that time (Boyer d'Agen p. 69).

The composition of the painting follows the direction taken by Ingres in such portraits as those of Granet (1807, Musée Granet, Aix-en-Provence) and of Bartolini (1820, Louvre, Paris), which reflect the artist's interest in the work of the Italian Mannerists of the sixteenth century, particularly Pontormo and Bronzino.

Also in 1821, Ingres' friend Lorenzo Bartolini made a full-length sculpture of Guryev's wife, Marina, née Naryshkin (1798–1871). This sculpture is in the Hermitage.

The portrait of Count Guryev remained almost continuously in the Guryev–Naryshkin family collection. According to Réau (1929, p. 32, no. 134), in the first few years of Soviet rule the portrait was in the possession of Arnold Seligmann.

A.B.

PROVENANCE

1889: property of E. D. Naryshkin; 1922: transferred from the A. N. Naryshkin collection, through the State Museums Fond, to the Hermitage

EXHIBITIONS

1889 St Petersburg, no. 77; 1923 Petrograd, room 1; 1938 Leningrad, no. 322, p. 44; 1955 Moscow, p. 62; 1956 Leningrad, p. 62; 1965 Bordeaux, no. 53; 1967–8 Paris, pp. 172–3, no. 120; 1972 Leningrad, Portraiture, no. 402; 1974–5 Paris, no. 109

BIBLIOGRAPHY

Hermitage catalogues: 1958, p. 458; 1976, p. 303; Berezina 1983, no. 241
H. Delaborde, *Ingres, sa vie et ses travaux, sa doctrine d'après les notes manuscrites et lettres du maître*, Paris 1870, p. 249, no. 123
H. Lapauze, *J. A. D. Ingres: Les cahiers de Montauban*, Montauban 1898, p. 214
H. Lapauze, *Les dessins*, Montauban 1901, vols 9 and 10; *Russian Portraits of the 18th–19th Centuries*, published by Grand Duke Nikolai Mikhailovich, St Petersburg 1907, vol. 3, no. 4, pl. 201
Boyer d'Agen, *Ingres d'après une correspondance inédite*, Paris 1909; H. Lapause, *Ingres, sa vie et son oeuvre*, Paris 1911, p. 214
H. Lapause, *Sur un portrait inédit d'Ingres: Renaissance de l'art français moderne*, Paris 1923, p. 446; Réau 1924, p. 344; Réau 1929, p. 32, no. 134
S. Joubert, *Une correspondance romantique: Madame d'Agoult Liszt*, Paris 1947
G. Wildenstein, *Ingres*, London 1956, p. 193, no. 148, pl. 55; Sterling 1957, p. 74, pl. 55
T. Kamenskaya, 'Les oeuvres d'Ingres au Musée de l'Ermitage', *Bulletin du Musée Ingres*, 1959, no. 6
V. N. Berezina, *Ingres: Portrait of N. D. Guryev*, Leningrad 1960; G. Boudaille, *Le Musée de l'Ermitage*, Paris 1961, p. 32
V. N. Berezina, 'Ingres: Portrait of Guryev', in *Hermitage 1764–1964*, no. 149
V. N. Berezina, *Jean-Auguste-Dominique Ingres: Album*, Leningrad 1967, p. 10; R. Rosenblum, *Ingres*, Geneva 1967, pp. 15, 73
E. Camesasca, *L'opera completa di Ingres, apparati critici e filologici*, Milan 1968, no. 106
French 19th Century Masters 1968, no. 1; A. Izergina, *French Painting in the Hermitage (first half of and mid-19th century)*, Leningrad 1969, p. 278
278
J. Whiteley, *Ingres*, London 1977, p. 62; V. N. Berezina, *Jean-Auguste-Dominique Ingres*, Moscow 1977, pp. 114–18, nos 61, 62
V. N. Berezina, *French Painting of the 19th century in the Hermitage Collection*, Moscow 1980, p. 10, no. 68
Kostenevich 1987, nos 32, 33

JEAN-AUGUSTE-DOMINIQUE INGRES (1780–1867)

The Virgin with the Host

Oil on canvas, 116 × 84 (45¾ × 33)
Signed bottom left: A.D. Ingres pinx; dated bottom right: Rome 1841
Pushkin Museum, Moscow (2761)

Ingres was in Rome when he was given the commission for this picture by the heir to the Russian throne, the future Emperor Alexander II, who was in Italy at the time. Saints Alexander Nevskii and Nicholas, depicted with the Virgin, were the patron saints of the Crown Prince and of his father, Tsar Nicholas I, respectively.

Ingres received 10,000 francs for the work; when it was completed it was sent to St Petersburg and exhibited at the Academy of Arts (see Lapauze, p. 352). The Crown Prince did not like the representation of the Virgin, and after three years gave the picture to the Academy Museum, where it was later exhibited with Western European works from the collection of Count Kushelev-Bezborodko.

The Virgin with the Host served as a prototype for a series of later versions, the best known of which is a tondo in the Musée d'Orsay, Paris, which was finished in 1854. In it the saints are replaced by two angels, one holding a light, the other a censer. I.K.

PROVENANCE

1845: given by its owner, Crown Prince Alexander, to the Museum of the Academy of Arts, St Petersburg; 1922: the Hermitage; 1930: transferred to the Pushkin Museum

EXHIBITIONS

1842 St Petersburg, Academy of Arts; 1861 St Petersburg, *Exhibition of Paintings belonging to Members of the Imperial Family and to Private Owners*, no. 297; 1953 Moscow, p. 62; 1956 Leningrad, p. 62; 1979 Dresden, *100th Anniversary of the Birth of Gottfried Semper*, no. 34

BIBLIOGRAPHY

Pushkin Museum catalogues: 1948, p. 87; 1957, p. 149; 1961, p. 157; 1986, p. 191
Ch. Lonormant, 'La Vierge adorant l'Eucharistie, tableau de M. Ingres', *L'Artiste*, 1841, p. 194
L. Vernier, 'De la Madonne exécutée pour le Grand Duc héritier de toutes les Russies par M. Ingres', *L'Artiste*, 1841, p. 1
Dussieux 1856, p. 430; H. Delaborde, *Ingres, sa vie et ses travaux, sa doctrine d'après les notes manuscrites et lettres du maître*, Paris 1870, p. 181, no. 11
A. Somov, *Picture Gallery of the Imperial Academy of Arts, II, Catalogue of Foreign Paintings*, St Petersburg 1874, p. 175–6, no. 639
H. Lapauze, *Ingres, sa vie et son oeuvre*, Paris 1911, p. 344
Réau 1929, p. 32, no. 135; G. Wildenstein, *Ingres*, London 1956, p. 212, no. 234; Sterling 1957, p. 74
D. Ternois, E. Camesasca, *Ingres*, Paris 1971, no. 132; V. N. Berezina, *Jean-Auguste-Dominique Ingres*, Moscow 1977, p. 174
I. Kuznetsova, *French Painting of the 16th-First Half 19th Centuries*, Pushkin Museum Publications, Moscow 1982, pp. 283–4

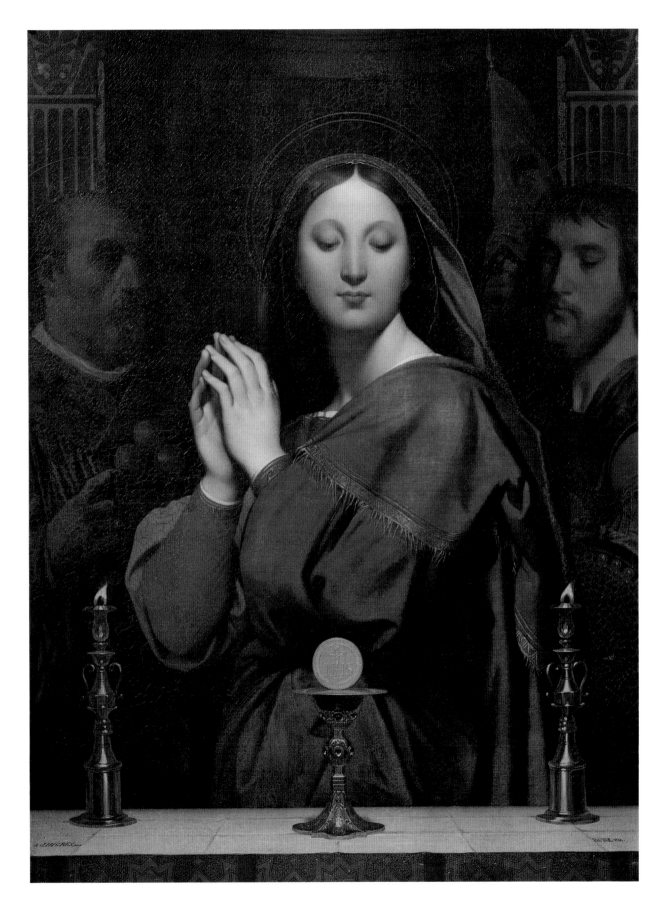

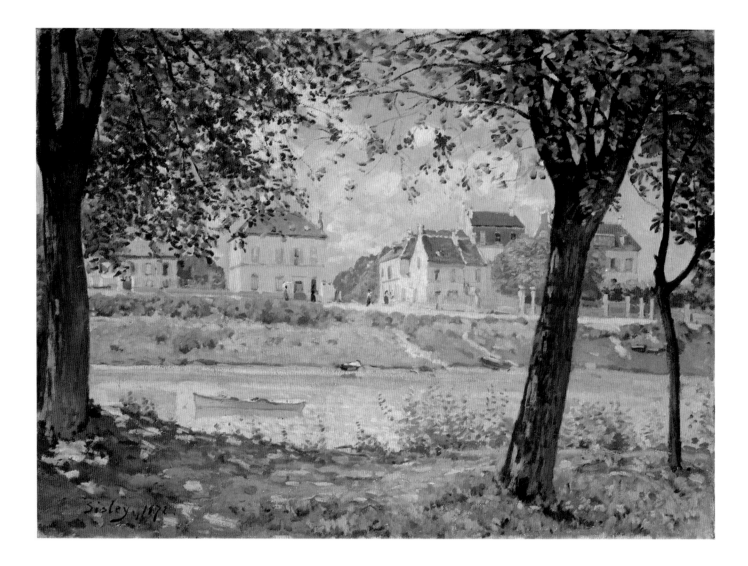

ALFRED SISLEY (1839–1899)

A Village on the Seine (Villeneuve-la-Garenne)

Oil on canvas, 59 × 80.5 (23¼ × 31¾)
Signed and dated bottom left: Sisley 1872
Hermitage, Leningrad (9005)

The small town of Villeneuve-la-Garenne, which Sisley visited from nearby Louveciennes at various times, has now become a suburb of Paris. In 1872 Sisley painted three landscapes there, two of them depicting the bridge across the Seine. The part of Villeneuve seen in the Hermitage picture is also near the bridge. The two houses on the left of the painting are shown on the right of the landscape *Bridge at Villeneuve-la-Garenne* (Metropolitan Museum, New York), as though continuing the panorama.

The picture is unusual in Sisley's oeuvre, using a frontal composition with a natural frame formed by the trunks of trees, the foliage, and the shadowed foreground. A.K.

PROVENANCE

1872: Durand–Ruel gallery, Paris (acquired from the artist on 24 August 1872);
1898: P. I. Shchukin collection, Moscow; 1912: S. I. Shchukin collection, Moscow;
1918: Museum of Modern Western Painting (I), Moscow;
1923: State Museum of Modern Western Art, Moscow; 1948: transferred to the Hermitage

EXHIBITIONS

1939 Moscow, p. 46; 1955 Moscow, p. 57; 1956 Leningrad, p. 56; 1960 Moscow, p. 35; 1965 Bordeaux, no. 72;
1965–6 Paris, no. 71; 1972 Otterlo, no. 55; 1973 Washington–New York–Los Angeles–Chicago–Fort Worth–Detroit, no. 40;
1974 Leningrad, no. 60; 1975 Moscow, no. 48; 1975–6 USA–Mexico–Canada, no. 40; 1976 Dresden, no. 1; 1976 Prague

BIBLIOGRAPHY

Hermitage catalogues: 1958, p. 446; 1976, p. 293; Shchukin catalogue 1913, no. 214
State Museum of Modern Western Art catalogue 1928, no. 578; Réau 1929, no. 1106; Sterling 1957, p. 99
F. Daulte, *Alfred Sisley*, Lausanne 1959, no. 40; *French 19th-Century Masters* 1968, no. 31; Kostenevich 1987, no. 81

21

PIERRE-AUGUSTE RENOIR (1841–1919)

Girls in Black

Oil on canvas, 81.3 × 65.2 (32 × 25¾)
Signed bottom right: A.R.
Pushkin Museum, Moscow (3329)

Renoir continually painted scenes of modern life, showing his contemporaries promenading, at leisure, in cafés. He particularly enjoyed painting young women; this image of two attractive young Parisiennes embodies Renoir's concept of beauty.

In the 1880s he gradually moved away from the Impressionist manner of painting, his draughtsmanship and contours becoming well defined, and the small vibrant dots of paint coalescing into large areas of colour. All these features are present in this painting.

The picture was probably painted in the early 1880s (Feist dates it 1880–2, which would appear to be correct). A study for the left-hand figure exists in the F. Hirschland collection, New York. Feist notes a resemblance between the model in Renoir's pastel, *Portrait d'une Dame*, in the Pushkin Museum (no. 10309) with the left-hand figure in this oil. E.G.

PROVENANCE

Until 1918: Shchukin collection, Moscow; 1918–28: Museum of Modern Western Painting (I), Moscow; 1928–48: State Museum of Modern Western Art, Moscow; 1948: transferred to the Pushkin Museum

EXHIBITIONS

1966 Moscow, p. 54; 1956 Leningrad, p. 51; 1960 Moscow, p. 32; 1974 Leningrad, no. 42; 1974–5 Moscow, no. 40; 1981 Odessa

BIBLIOGRAPHY

Pushkin Museum catalogues: 1957, p. 118; 1961, p. 157, 1986, p. 150, fig. 162
Shchukin catalogue 1913, no. 193; Pertsov 1921, no. 193
State Museum of Modern Western Art, 1928, no. 501; Réau 1929, no. 1071
Sterling 1957, p. 104, no. 81 (erroneously included in the Hermitage collection, Leningrad)
Feist 1961, p. 64; Fosca 1961, p. 84; *Art*, 1962, no. 3, p. 55 (illustrated)
Musée de Moscou, 1963; Charmet 1970, p. 41, no. 17
Renoir 1970, no. 8, p. 118 (illustrated); Daulte 1971, no. 375; Fezzi 1972, no. 454, pp. 108–9 (illustrated)
Georgievskaya, Kuznetsova 1980, no. 468; *Museum 3*, 1982, p. 175 (illustrated)

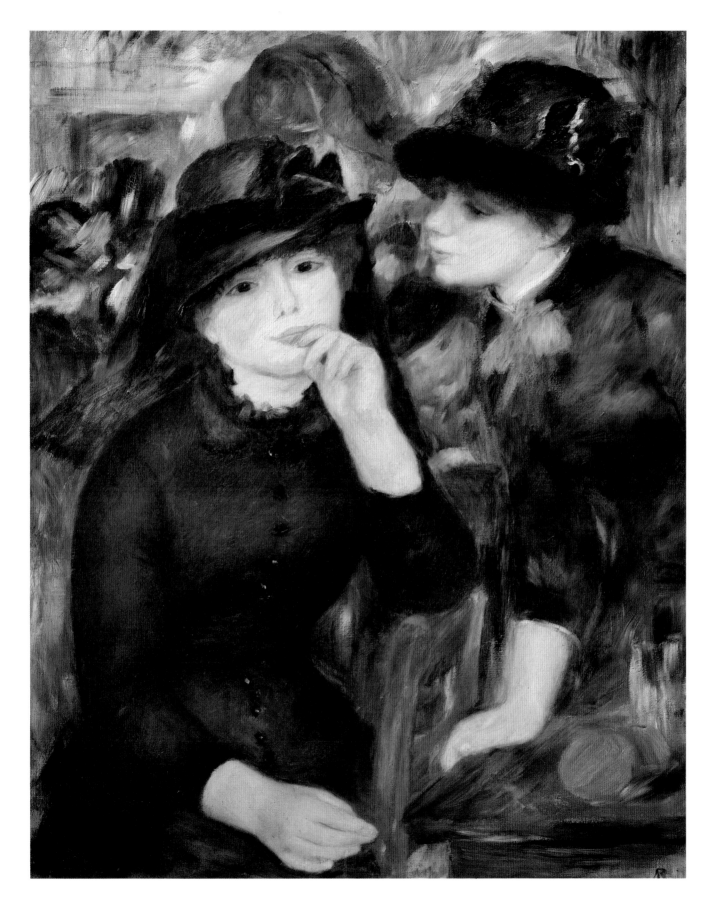

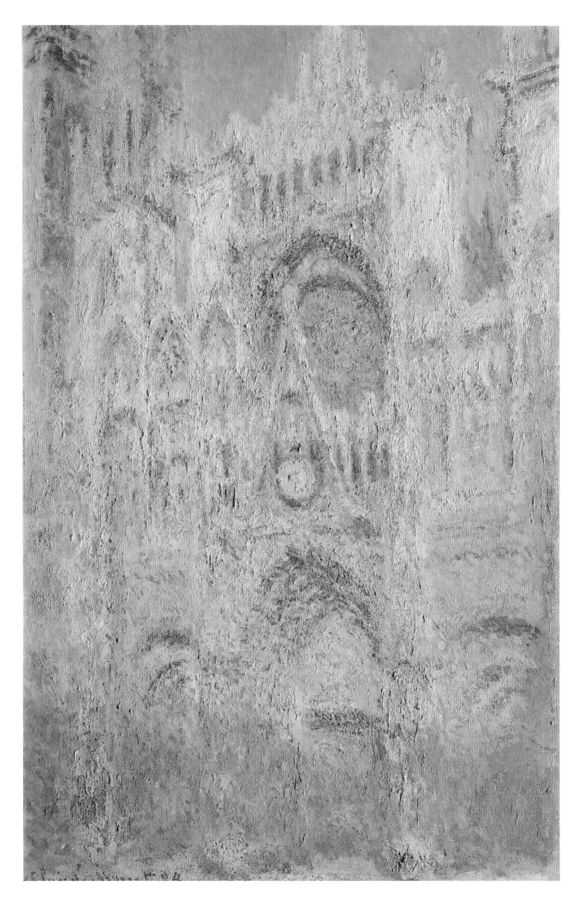

CLAUDE-OSCAR MONET (1840–1926)

Rouen Cathedral

Oil on canvas, 100 × 65 (39½ × 25½)
Signed and dated bottom left: Claude Monet 94
Pushkin Museum, Moscow (3312)

Monet began a series of pictures of Rouen cathedral in February 1892. It was completed in 1895 and shown at an exhibition of Monet's work at the Durand-Ruel gallery in Paris.

The Rouen Cathedral series belongs to the late period of Monet's work, and indeed of the whole Impressionist movement. At this stage Monet was particularly interested in decorative effects.

The Pushkin Museum has another painting from the series: *Rouen Cathedral, Evening* (inv. no. 331). Five paintings from the series are in the Musée d'Orsay in Paris. Wildenstein and Chesnokov have concluded that the cathedral in this painting is shown in the evening, although earlier it had been known as *Rouen Cathedral at Noon.* E.G.

PROVENANCE

Until 1898: property of Claude Monet; 25 February 1898: purchased from Monet by Durand-Ruel in Paris; 1898–1902: Durand-Ruel gallery, Paris; 22 October 1902: purchased by Shchukin from Durand-Ruel in Paris; 1902–18: Shchukin collection, Moscow; 1918–23: Museum of Modern Western Painting (I), Moscow; 1923–48: State Museum of Modern Western Art, Moscow (inv. no. 138); 1948: transferred to the Pushkin Museum

EXHIBITIONS

1895 Paris, *Claude Monet*, Durand-Ruel gallery; 1955 Moscow, p. 47; 1960 Moscow, no. 28; 1974–5 Moscow, no. 20; 1974 Leningrad, no. 26; 1976 Dresden, no. 6; 1976 Prague, no. 21 (under title of *Rouen Cathedral at Noon*)

BIBLIOGRAPHY

Pushkin Museum catalogues: 1957, p. 95; 1961, p. 129; 1986, p. 124, no. 165
Art, 1905, no. 2, p. 18 (illustrated); Shchukin catalogue 1913, no. 138
Tugendhold 1914, p. 9; Pertsov 1921, no. 138, pp. 41, 112; Tugendhold 1923, p. 25
Ternovetz 1925, p. 459; State Museum of Modern Western Art 1928, no. 374; Réau 1929, no. 981
Reuterswärd 1948, p. 278; Reuterswärd 1965, no. 2, p. 27; Monet 1969, no. 13
Georgievskaya, *Monet*, 1973, fig. 11; idem, 1974, fig. 11
D. Wildenstein, *Claude Monet: Biographie et catalogue raisonné*, Lausanne and Paris (3 vols) 1974–9, vol. 3 1979, no. 1326
Barskaya, *Monet*, Leningrad 1980, p. 10 (illustrated); E. Georgievskaya, I. Kusnetsova 1980, no. 151
Seiberling 1981, p. 368, no. 23; V. Chesnokov, ' "Rouen Cathedrals" by Claude Monet' in *The Painter*, 1983, no. 2

PAUL GAUGUIN (1848–1903)

Self Portrait

Oil on canvas, 46 × 37.5 (18 × 14¾)
Signed bottom left: P.Go
Pushkin Museum, Moscow (3264)

In April 1903 Gauguin sent three paintings for sale to the collector Louis Fayet in Paris. These included a self portrait. He informed his friend de Monfreid about this by letter. Two paintings, *Rupe Rupe* and *The Ford*, subsequently found their way from Fayet to the Shchukin collection. At the time Shchukin bought a self portrait from Fayet, which suggests that it had been sent from Tahiti in 1903. There is, however, no certainty that it is this particular self portrait.

Since it is not dated by the artist, the question of the date of the Pushkin picture is highly controversial. Rewald and Sterling dated it 1888–90, i.e. the period when Gauguin was working in Arles and in Brittany. Wildenstein shared Sterling's view and listed this *Self Portrait* in his catalogue under 1888. Sterling had based his dating on the rounded shape of the moustache, which Gauguin began to depict as drooping from the time of the *Self Portrait with the Yellow Christ* (private collection, France)

Wildenstein also assumed that in his letter to his brother, dated 9 January 1889, Van Gogh referred to this particular picture by Gauguin, just finished at Arles. Recently, Cooper has concurred with this view. Nevertheless, the bright yellow band on the left resembles the yellow background of many of the paintings from the Tahitian period. A similar yellow band occurs in the background of the *Self Portrait with a Hat* (Wildenstein 506, Musée d'Orsay, Paris), painted during the

visit to Paris from Tahiti in 1893–4; also noteworthy are the identical format of the canvases in both these self portraits and the signature 'P.Go' on the back of the *Self Portrait with a Hat*. This suggests that the early dating of the Pushkin picture is not indisputable. On the right, the background shows an outline of a pink hut with red foliage hanging from the roof. Unfortunately the paint has been damaged by the application of wax to the surface, so it is difficult to identify a number of details in the background and to form a full view of the style of this canvas. Nevertheless, the Tahitian features that can be discerned in the background suggest a Polynesian origin. This was the view of Pertsov, and Shchukin evidently inclined towards it too.

The question of dating the Pushkin *Self Portrait* should thus be left open. Some authorities have attempted to place it in the last period of the artist's life; they identify it with the self portrait sent to Fayet in 1903, and also note that the canvas is of the rough type used by Gauguin in the Marquesas Islands (see 1983 Lugano exhibition catalogue, p. 58). But such arguments are easy to invalidate since Gauguin often painted on rough canvas at different periods of his life, including during his time in Arles in 1888. It would seem more appropriate to date the *Self Portrait* to 1890–3, the period of the artist's first stay in Tahiti. M.B.

PROVENANCE

Purchased by Shchukin from Fayet (?) in Paris after 1906; 1918–23: Museum of Modern Western Painting (I), Moscow; 1923–48: State Museum of Modern Western Art, Moscow; 1948: transferred to the Pushkin Museum

EXHIBITIONS

1906 Paris, Salon d'Automne, p. 191 (it is likely that the exhibit was this particular self portrait); 1926 Moscow, no. 2; 1966–7 Tokyo–Kyoto, no. 61; 1983 Lugano, no. 15; 1985 Venice–Rome, no. 22; 1986 Washington–Los Angeles–New York, no. 15

BIBLIOGRAPHY

Pushkin Museum catalogue: 1961, p. 54; Cat. Shchukin 1913, no. 18; Tugendhold 1914, p. 38 (ill.)
Pertsov 1921, pp. 77, 108; Tugendhold 1923, p. 138, fig. 49; Ternovets 1925, p. 472
State Museum of Modern Western Art catalogue 1928, no. 88; Réau 1929, no. 830;
Cahiers d'art, 1950, no. 88, p. 341; Lee van Dovski, 1950, no. 206; Sterling 1957, p. 126, notes 101 and 102, pl. 102
Wildenstein 1964, no. 297; K. Mitteistädt, *Die Selbstbildnisse Paul Gauguin*, Berlin 1968, no. 19, pp. 18, 70
F. Cachin, *Paul Gauguin*, Paris 1968, p. 364; G. M. Sugana, *L'opera completa di Gauguin*, Milan 1972, no. 132, pp. 94–5
Fezzi 1979, vol. I., no. 291, pp. 76–7 (ill.); Georgievskaya, Kuznetsova 1980, no. 192; Cooper 1983, p. 576, no. 15
Barskaya, Bessonova 1985, no. 121

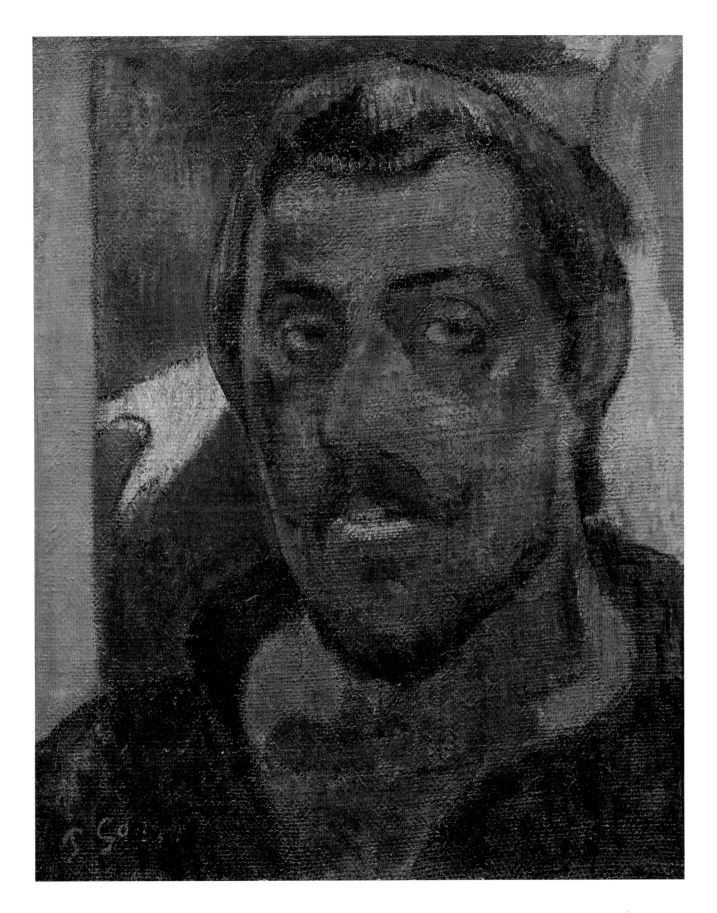

PAUL GAUGUIN (1848–1903)

'Vairaoumati Tei Oa'
(Her Name is Vairaoumati)

Oil on canvas, 91 × 68 (36 × 26¾)
Signed and dated bottom left: Paul Gauguin/92/Tahiti; inscribed bottom centre: Vairaoumati/tei oa.
Pushkin Museum, Moscow (3266)

This was painted during Gauguin's first voyage to Tahiti and reflects the influence of ancient Maori legends.

The painting shows the heroine of a Tahitian legend, the beautiful Vairaoumati, who became the proto-mother of the legendary Areois race and hence of humankind. Gauguin came across the myth of the origin of mankind in Moerenhout's book *Voyage aux îles du Grand Océan*, and in the stories told him by his Tahitian lover, Tehura. He described it in his own book *Noa Noa*. According to the legend, Oro, the son of the greatest of the gods, spent a long time searching the earth for a consort. Eventually, catching sight of a beautiful girl from the Bora-Bora tribe, he was captivated and made her his wife.

In Gauguin's picture Vairaoumati is shown awaiting the appearance of Oro. She has spread a feast on a table for her divine guest and put a rich cloth upon a couch. Beside her is the enigmatic figure of a Tahitian man in a red *pareo*. Perhaps it is Oro himself, reflecting on the destiny of mankind.

Interestingly, the meeting of Oro and Vairaoumati is represented twice: in the figures in the foreground, and in the two Tahitian idols in the far distance. The idols embody the legendary Vairaoumati and Oro, who had never been seen by anyone; the Vairaoumati in the foreground is a modern Tahitian girl with a cigarette in her hand. The contemporary Tahitian woman is compared to the goddess who, according to the legend, ascended to heaven at the end of her days.

The pose of Vairaoumati was borrowed by Gauguin from an ancient Egyptian frieze and from paintings in the British Museum, photographs of which he took with him to Oceania. Another possible source is a work by Puvis de Chavannes entitled *'L'Espérance'* (1872, Musée d'Orsay, Paris). Inspired by these, he painted *'Ta Matete'* (Wildenstein 476) in which several female figures are shown in the same pose as that of Vairaoumati. A sketch for the Pushkin picture was included in Gauguin's letter to Sérusier, dated 23 March 1892, in which he wrote: 'What a religion, this old Oceanic religion! What a marvel! My brain is bursting with it and all the things it suggests to me will frighten everybody.' A variation on the Pushkin picture, *'Te aa no Areois'*, is in New York (Wildenstein 451). In it Vairaoumati is shown sitting on a green hillside, holding in her hand a flowering stem – a symbol of eternal life; both the stone idols and the figure of a Tahitian man are absent.

M.B.

PROVENANCE

1895, 18 February: sale of Gauguin's pictures prior to his second journey to Tahiti, the Hôtel Drouot, Paris, no. 15 (bought in by the artist); Shchukin collection, Moscow; 1918: Museum of Modern Western Painting (I), Moscow; 1923: State Museum of Modern Western Art, Moscow; 1948: transferred to the Pushkin Museum

EXHIBITIONS

1893 Paris, Durand-Ruel gallery, no. 13; 1926 Moscow, Gauguin, no. 6; 1955 Moscow, p. 27; 1956 Leningrad, p. 16; 1960 Moscow, p. 13; 1976 Rotterdam–Brussels–Baden Baden–Paris, 'Symbolism in Europe', no. 56; 1983 Lugano, no. 17; 1985 Venice-Rome, no. 23; 1986 Washington–Los Angeles–New York, no. 17

BIBLIOGRAPHY

Pushkin Museum catalogue: 1961, p. 54; J. de Rotonchamp, *Paul Gauguin*, Paris 1906, pp. 119, 135
Cat. Shchukin 1913, no. 21; Tugendhold 1914, pp. 19, 20, 38; P. Gauguin, *Noa Noa*, 1914, pp. 106–9
P. Gauguin, *Noa Noa*, Paris 1924, pp. 127, 129, 132; State Museum of Modern Western Art catalogue 1928, no. 89
Réau 1929, no. 831; Lee van Dovski 1950, no. 346; P. Sérusier, *A.B.C. de la peinture: Correspondance*, Paris 1950, pp. 56–60, 144
B. Dorival, *Carnet de Tahiti*, 1954, p. 2R; L. J. Bouge, 'Traduction et interprétation des titres en langue tahitienne inscrits sur les oeuvres océaniennes de Paul Gauguin', *Gazette des Beaux-Arts*, 1956, p. 164, no. 66
Sterling 1957, p. 129; Wildenstein 1964, no. 450; Danielsson 1967, p. 233, no. 83 (erroneously stated to be in the Hermitage)
Gachin 1968, p. 364; G. M. Sugana, *L'opera completa di Gauguin*, Milan 1972, no. 284; Georgievskaya, Kuznetsova 1979, no. 195
Barskaya, Bessonova 1985, no. 125

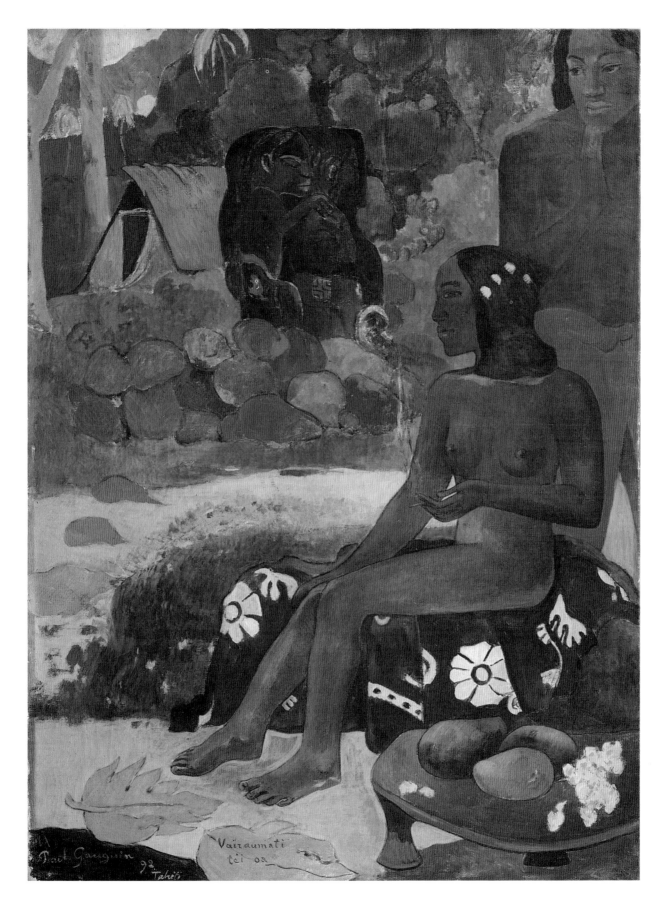

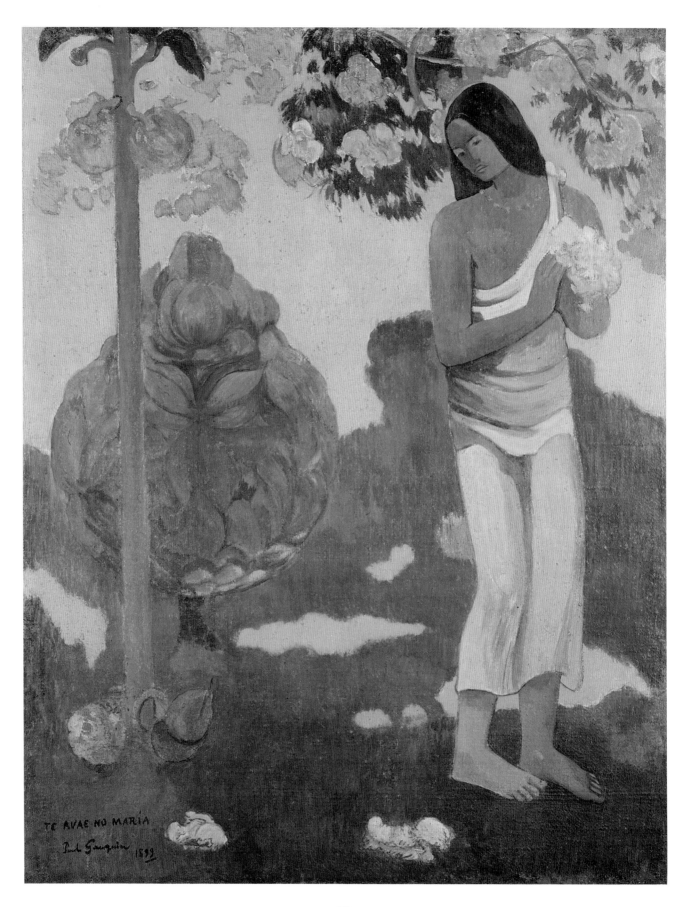

PAUL GAUGUIN (1848–1903)

'Te Avae no Maria'
(Woman holding Flowers)

Oil on canvas, 96 × 74.5 (37¾ × 29½)
Inscribed, signed and dated bottom left: Te Avae no Maria/Paul Gauguin/1899.
Hermitage, Leningrad (6515)

This painting, also known as *Woman holding Flowers*, was painted in 1899 and described in the list of canvases sent by Gauguin to Vollard in 1903: '. . . 9/Te Avae no Maria. Woman with flowers against a golden-yellow background. On the left, a fruit tree and an exotic plant' (de Rotonchamp, p. 221).

The Tahitian title of the picture has been translated by Danielsson and others as 'The Month of Mary' (meaning May, the month dedicated by the Catholic Church to worship of the Virgin Mary). The beginning of May has also long been associated in Europe with the originally pagan celebration of the rebirth of nature; and it is the flowering of nature that forms the main motif of the painting. The white colour of the woman's garment combines the European and Tahitian religious concepts of purity and sanctity.

This is one of the most 'oriental' of Gauguin's works, with the particular tone of the yellow background and the pose of the woman both contributing to the effect. Her gesture is based on a relief of the *Ablutions of Bodhisattva* (c. 800 AD) from the Javanese temple of Borobudur. Gauguin had taken a photograph of this relief to Tahiti and frequently reused the pose of the carved stone figure. The 'exotic plant' also has a prototype in the Borobudur relief.

The main elements of the painting are already present in *'Faa Iheihe'* (1898, Tate Gallery, London). The left side of that composition was incorporated, with some stylistic changes, into *'Rupe Rupe'* (1899, Pushkin Museum), while in *Woman holding Flowers* it forms the entire composition. Gauguin also used the woman's pose in other works of 1899: *Three Tahitian Women against a Yellow Background* (Hermitage); two versions of *Maternity* (Hermitage, and David Rockefeller collection, New York); and *'Te tiai na oe ite rata'* (*Are you waiting for a letter?*, Wildenstein 587). A.K.

PROVENANCE

From 1903: Vollard gallery, Paris (sent to Vollard by Gauguin from Atuona); before 1910: Shchukin collection, Moscow; 1918: Museum of Modern Western Painting (I), Moscow; 1923: State Museum of Modern Western Art, Moscow; 1930: transferred to the Hermitage

EXHIBITIONS

1926 Moscow, Gauguin, no. 23; 1971 Tokyo–Kyoto, no. 65; 1973 Washington–New York–Los Angeles–Chicago–Fort Worth–Detroit, no. 14; 1983 Lugano, no. 23; 1985 Venice–Rome, no. 29; 1987 Tokyo–Nagoya, no. 122

BIBLIOGRAPHY

Hermitage catalogues: 1958, p. 373; 1976, p. 248; J. de Rotonchamp, *Paul Gauguin*, Weimar 1906, p. 189, no. 9
Apollon, 1910, nos 8–9 (ill.); Cat. Shchukin 1913, no. 29; J. de Rotonchamp, *Paul Gauguin*, Paris 1925, p. 221
State Museum of Modern Western Art catalogue 1928, no. 100; Réau 1929, no. 842; Lee van Dovski 1950, no. 361
L. J. Bouge, 'Traduction et interprétation des titres en langue tahitienne inscrits sur les oeuvres océaniennes de Paul Gauguin', *Gazette des Beaux-Arts*, 1956, p. 163; P. Descargues, *Le Musée de l'Ermitage*, Paris 1961, pp. 210–11
Wildenstein 1964, no. 586; B. Danielsson, 'Gauguin's Tahitian Titles', *Burlington Magazine*, April 1967, pp. 228–33, no. 60

VINCENT VAN GOGH (1853–1890)

Portrait of Dr Rey

Oil on canvas, 64 × 53 (25 × 21)
Signed, inscribed and dated bottom right: Vincent/Arles/89
Pushkin Museum, Moscow (3272)

It appears from Van Gogh's letters to his brother Theo (nos 568–71) that the portrait of Dr Rey was finished between 9 and 17 January 1889, and that it was at once presented to Dr Rey: '. . . I have resumed work and have already made three studies, as well as a portrait of M. Rey, which I have given to him as a souvenir' (letter no. 571).

Dr Félix Rey (1865–1932) practised at the Arles Hospital to which Van Gogh was admitted late in 1888 after his first mental breakdown. On the advice of the artist Charles Camoin, Rey sold the portrait to Vollard in 1900, for 150 francs. For some years the sitter was unknown and the painting was simply called 'Portrait of a Man'; it was identified as a portrait of Dr Rey by Sidorova in 1926.

E.G.

PROVENANCE

1889–1900: Dr Rey, Arles; 1900: Vollard gallery, Paris; Cassiere gallery, Berlin (no. 3487); until 1908: Druet gallery, Paris (no. 4285); 1908–18: Shchukin collection, Moscow, purchased from the Druet gallery in Paris in 1908 for 4,600 francs; 1918–23: Museum of Modern Western Painting (I), Moscow; 1923–48: State Museum of Modern Western Art, Moscow; 1948: transferred to the Pushkin Museum

EXHIBITIONS

1909 Paris ('Tête d'homme'); 1926 Moscow, no. 7; 1956 Leningrad, p. 11; 1960 Paris, Musée Jacquemart-André, no. 49a; 1965 Bordeaux, no. 64; 1965–6 Paris, no. 61; 1966–7 Tokyo–Kyoto, no. 63; 1972 Moscow, Portraiture, pp. 109–10, 113; 1972 Otterlo, no. 22; 1973 Washington–New York–Los Angeles–Chicago–Fort Worth–Detroit, no. 17; 1974 Kiev (no cat); 1976 Dresden, no. 9; 1976 Prague, no. 12; 1978 Budapest, p. 7; 1979 Kyoto–Tokyo–Kamakura, no. 22; 1983 Lugano, no. 25; 1985 Venice–Rome, no. 30; 1986 Washington–Los Angeles–New York, no. 25

BIBLIOGRAPHY

Pushkin Museum catalogues: 1961, p. 53; 1986, p. 55: 1988, p. 55; Cat. Shchukin 1913, no. 33; Tugendhold 1914, nos 1–2, p. 39
Tugendhold 1923, p. 42; Ternovets 1925, no. 12, pp. 473, 479 (ill.); V. Sidorova, *Vincent van Gogh*, 1926, pp. 6–7
Ettinger 1926, vol. 4, pp. 112 (ill.), 117; State Museum of Modern Western Art catalogue 1928, no. 80. p. 31
De la Faille 1928, vol. I, p. 143; vol. II, no. 500, fig. 87; Réau 1929, no. 1143, p. 136; Scherjon, Gruyter 1937, no. 144
Choix de lettres de Van Gogh à son frère Théo, 1937, no. 568, p. 265, no. 571, p. 269; De la Faille 1939, no. 526, p. 373
V. Doiteau, E. Leroy, *Aesculape*, 1939, pp. 42–7, 50–5; Perruchot 1950, pp. 285, 286, 290, 293–4, 371–2, 380
Leymarie 1951, no. 109, pp. 122, 123; Sterling 1957, p. 145, fig. 117, p. 221 (126); Prokofiev 1962, fig. 149
Rewald 1962, p. 196, fig. 200; Kuznetsova 1966, no. 568, p. 432, no. 571, pp. 435, 368 (ill.); N. Smirnov, *Van Gogh*, 1968, pp. 22–3, fig. 4
De la Faille 1970, no. 500, p. 223; Perruchot, *The Life of Van Gogh*, 1973, pp. 258–9, fig. 102;
Georgievskaya, Kuznetsova 1980, no. 188; R. Pickvance, *Van Gogh in Arles*, exhibition catalogue, Metropolitan Museum of Art, New York 1984, no. 144; Barskaya, Bessonova 1985, no. 115, p. 358

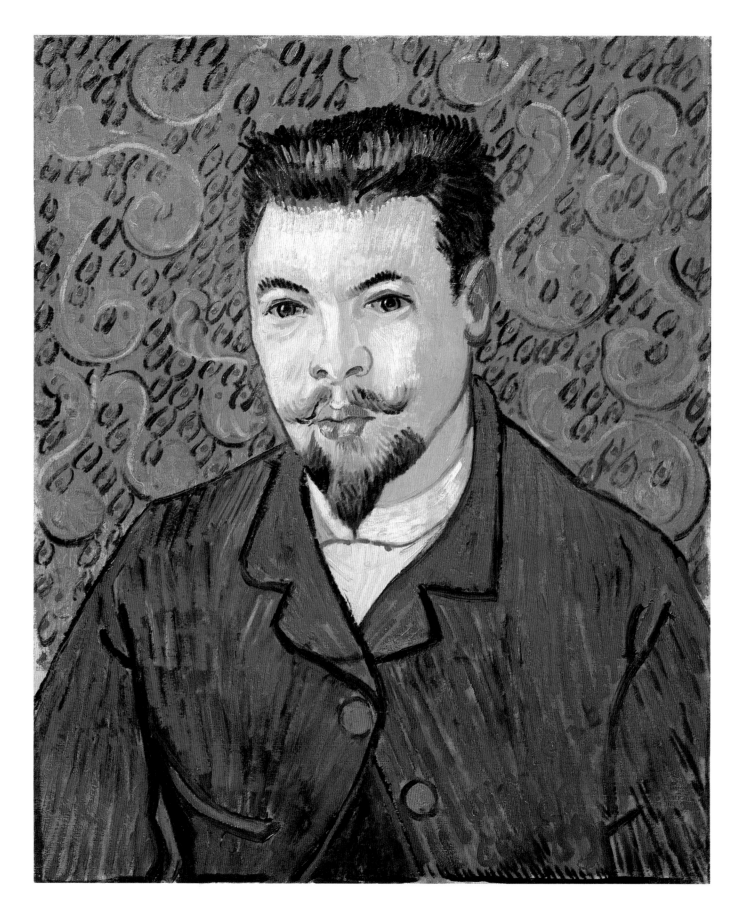

VINCENT VAN GOGH (1853–1890)

The Prison Courtyard

Oil on canvas, 80 × 64 (31½ × 25¼)
Pushkin Museum, Moscow (3373)

The painting is taken from a drawing by Gustave Doré which appeared, engraved by H. Pisan, in the book *London*. Van Gogh has greatly dramatised the subject, so making it more expressive. He painted it in February 1890 while a patient at the Institute for Psychiatric Diseases at Saint-Rémy. At that time he made many oil copies of pictures or illustrations from the books sent to him by his brother Theo.

Van Gogh is known to have had great admiration for Doré long before painting this picture. His interest focused on Doré's *London* illustrations, which were republished several times from 1872. It is also known that Van Gogh owned a print by Doré, *Hard Labour*, and he ruled it into squares for easier copying.

The figure of the convict facing the viewer is often thought to be a self portrait of the artist (see Tralbaut, Leymarie and Dmitrieva). Leymarie considers that the mood of the picture may have been influenced by Van Gogh's reading of an article on Dostoevsky's *Notes from the House of the Dead*.

The picture was bought by Morozov from the Druet gallery in Paris in 1909 for 17,000 francs. E.G.

PROVENANCE

Collection of Mme I. van Gogh-Bonger (wife of the artist's brother Theo van Gogh), Amsterdam; Mme Slavonat collection, Paris; Fabre collection, Paris; 1906: Druet gallery, Paris (no. 542); Prince de Wagram collection; 1909: Druet gallery, Paris; 1909–18: Morozov collection, Moscow; 1918–28: Museum of Modern Western Painting (II), Moscow; 1928–48: State Museum of Modern Western Art, Moscow; 1948: transferred to the Pushkin Museum

EXHIBITIONS

1905 Paris, no. 14; 1908 Munich, no. 7; 1909 Paris; 1926 Moscow, no. 8; 1956 Leningrad, p. 11; 1958 Brussels, no. 108; 1960 Paris, Musée Jacquemart-André, no. 6; 1972 Otterlo, no. 23; 1983 Lugano, no. 26; 1986 Washington–Los Angeles–New York, no. 26

BIBLIOGRAPHY

Pushkin Museum catalogues: 1957, p. 57; 1961, p. 53; 1986, p. 55 fig. 171; *Art*, 1905, nos 5–7 (ill.) Makovskii 1912, pp. 15, 19; Ternovets, *Among the Collectors*, 1922, no. 3; State Museum of Modern Western Art catalogue 1928, no. 83, p. 32 (ill.) De la Faille 1939, no. 690: Prokofiev 1962, no. 148; Rewald 1962, fig. 137; Ternovets 1963, pp. 309–10; N. Smirnov, 'A document of human suffering (Van Gogh's "Convicts in the Exercise Yard", 1890, Pushkin Museum collection)', *Khusozhnik* ('The Artist'), 1967, no. 2, pp. 48–50; N. Smirnov, *Van Gogh*, 1968, pp. 24–5; Tralbaut 1969, p. 290 Perruchot, *The Life of Van Gogh*, 1973, p. 298, fig. 120; N. Smirnov, *Van Gogh*, Moscow 1976, figs 11–12; Leymarie 1977, p. 163 Dmitrieva 1980, pp. 305–6, 317; R. Pickvance, *Van Gogh in Saint-Rémy and Auvers*, exhibition catalogue, Metropolitan Museum of Art, New York 1986, pp. 64–5 (ill.)

PAUL CEZANNE (1839–1906)

'Le Fumeur' (Man smoking a Pipe)

Oil on canvas, 91 × 72 (35¼ × 28½)
Pushkin Museum, Moscow (3336)

It is often difficult to establish the dates of Cézanne's later works: Ternovets and Yavorskaya date this painting to 1890; Barskaya and Venturi to 1895–1900. Hoog points out that the same model posed for the right-hand figure in Cézanne's *Card Players* (Venturi 558, Louvre, Paris), while Rewald believes that the partly visible painting on the wall of the Pushkin canvas may be the *Portrait of Mme Cézanne* of 1885–90 (Venturi 528), slightly altered, or that it may represent a picture by Cézanne which is now lost.

Several paintings and drawings depicting a man seated by a table and smoking a pipe (e.g. Venturi 684, 1087) are known, for which Cézanne used different models. The Hermitage, for example, has a canvas of the same subject and of the same period (inv. no. 6561). E.G.

PROVENANCE

Vollard collection, Paris; until 1918: Shchukin collection, Moscow; 1918–23: Museum of Modern Western Painting (I), Moscow; 1923–48: State Museum of Modern Western Art, Moscow (inv. no. 205); 1948: transferred to the Pushkin Museum

EXHIBITIONS

1926 Moscow, no. 17; 1955 Moscow, p. 57; 1956 Leningrad, p. 56; 1956 Leningrad, Cézanne, no. 19; 1965 Bordeaux, no. 56; 1965–6 Paris, no. 48; 1976 Dresden, no. 13; 1976 Prague, no. 2; 1978 Paris, no. 5; 1984 Tokyo–Nara, no. 3

BIBLIOGRAPHY

Pushkin Museum catalogues: 1957, p. 128; 1961, p. 169; 1986, p. 162; Cat. Shchukin 1913, no. 205
Apollon, 1914, I, pp. 38–9; Pertsov 1921, no. 205; Tugendhold 1923, pp. 86 (ill.), 147; Nurenberg 1926 (ill.)
State Museum of Modern Western Art catalogue 1928, p. 97, no. 551; Yavorskaya 1935, fig. 29; Venturi 1936, no. 688
Rusakova 1970, figs 13, 14 (erroneously stated to be in State Museum of Modern Western Art)
Cézanne, 1975 no. 18 (ill.) (erroneously stated to be in the Hermitage)
J. Rewald in *Cézanne: The Late Work*, exhibition catalogue, Museum of Modern Art, New York 1977, p. 18

PAUL CEZANNE (1839–1906)

Still Life with Curtain

Oil on canvas, 55 × 74.5 (21½ × 29½)
Hermitage, Leningrad (6514)

This still life is one of the most outstanding examples of Cézanne's work in the genre, but art historians have been unable to determine its date: Sterling placed it in the period 1895–1900; Gowing and, subsequently, Rewald and Barskaya thought it was painted in 1899 when Cézanne was in Paris. Barskaya's view depended on the fact that the leaf-decorated curtain belonged to the artist's Paris apartment. However, even if this supposition were correct, it would not be sufficient to establish the date of the painting. Cézanne frequently moved objects from one place to another: for example, the pottery milk-jug depicted in various compositions of the 1890s, including the *Still Life with Curtain*, was kept at his house in Aix.

Venturi dated the picture to around 1895. Cooper inclined towards 1894–5: the decisive argument for him was the absence of deep shadows in the folds of the fabric and of the accentuated outlines which were typical of the paintings of the late 1890s. The composition is developed from that of the *Still Life* in the Barnes Foundation, Merion (Venturi 745), which is now thought to have been painted in 1892–4; the two pictures would not seem to have been separated by a long interval of time.

Although the *Still Life with Curtain* is much more detailed than the Barnes Foundation *Still Life*, the picture is nonetheless unfinished, especially the napkin on the right. However, while the representation of various details may be unfinished in the material sense, it may not be so in the artistic sense. Many of the works which Cézanne may have regarded as unfinished are now perceived as finished. Whether intuitively or consciously, Cézanne stopped working on this picture at the moment when any further brushstrokes, particularly on the napkin, though adding a superficial polish, would have detracted from the overall structure. A.K.

PROVENANCE

Vollard gallery, Paris; 1907: Morozov collection, Moscow; 1918: Museum of Modern Western Painting (II), Moscow; 1923: State Museum of Modern Western Art, Moscow; 1930: transferred to the Hermitage

EXHIBITIONS

1926 Moscow, no. 14; 1956 Leningrad, p. 56; 1956 Leningrad, Cézanne, no. 22; 1971 Tokyo–Kyoto, no. 54; 1972 Otterlo, no. 4; 1974 Leningrad, no. 54; 1977 New York–Houston, no. 27; 1978 Paris, no. 23; 1983 Dresden, no. 27; 1983 Lugano, no. 6; 1984 Leningrad–Moscow, no. 91; 1985 Venice–Rome, no. 9

BIBLIOGRAPHY

Hermitage catalogues: 1958, p. 444; 1976, p. 292; Makovskii 1912, nos 3–4, p. 23; A. Vollard, *Paul Cézanne*, Paris 1914, pl. 48
E. Bernard, *Souvenirs sur Paul Cézanne*, Paris 1925, p. 92; State Museum of Modern Western Art catalogue 1928, no. 561
Réau 1929, no. 743; Venturi 1936, no. 731; Sterling 1957, pp. 113–14; French 19th-Century Masters 1968, no. 56
Cézanne 1975, no. 20; D. Cooper, 'Lugano: French paintings from Russia', *Burlington Magazine*, December 1983, p. 576; Kostenevich 1987, no. 95

PAUL CEZANNE (1839–1906)

Lady in Blue

Oil on canvas, 90 × 73.5 (35½ × 29)
Hermitage, Leningrad (8990)

There are considerable differences of opinion among art historians as to the date of Cézanne's *Lady in Blue*. Venturi placed the picture within a group dated on iconographic and stylistic evidence to 1900–4. This group includes the *Italian Woman leaning on a Table* (Venturi 701, Rosenthal collection, New York), the *Old Woman with a Rosary* (Venturi 702, National Gallery, London), the *Woman with a Book* (Venturi 703, Phillips collection, Washington) and the *Portrait of Mme Cézanne* (Venturi 704, Barnes Foundation, Merion).

However, these paintings are no longer considered to be a group, and instead each canvas is individually dated. The Hermitage picture in the present exhibition is usually bracketed with the *Woman with a Book*, in which the sitter is wearing the same dress and the same hat. In the catalogue of the 1977 exhibition of Cézanne's late work Rewald even identifies the sitters as one and the same woman, though this is incorrect. The date ascribed by Rewald to the *Lady in Blue* is 1902–6. Gowing, one of the organisers of the same exhibition, proposes an earlier date, 1892–6, for the Hermitage picture, and 1902–3 for the *Woman with a Book*. Gowing believes that the *Lady in Blue* was painted in Aix in the Rue Boulegon studio. In Rewald's opinion the cramped interior in the composition also points to the Rue Boulegon. These considerations are not, of course, sufficient to place the painting with certainty either in Aix or in Paris since Cézanne repeatedly used the same studio props, sometimes over several years.

Another detail in the *Lady in Blue*, the patterned cloth, is also seen in the *Italian Woman leaning on a Table*, and in the still life *Apples and Oranges* usually dated 1895–1900 (Venturi 732, Musée d'Orsay, Paris). In the 1977 exhibition the *Italian Woman* was considered to have been painted around 1900. The *Old Woman with a Rosary* clearly belongs to the same period. Of the group mentioned by Venturi, these two canvases are closest in style to the *Lady in Blue*, so it seems reasonable to accept this date – around 1900 – for the Hermitage picture.

A.K.

PROVENANCE

Shchukin collection, Moscow; 1918: Museum of Modern Western Painting (II), Moscow; 1923: State Museum of Modern Western Art, Moscow; 1948: transferred to the Hermitage

EXHIBITIONS

1926 Moscow, no. 20; 1956 Leningrad, p. 56; 1956 Leningrad, Cézanne, no. 21; 1965 Bordeaux, no. 57; 1965–6 Paris, no. 59; 1972 Leningrad, no. 391; 1974 Leningrad, no. 55; 1977 New York–Houston, no. 54; 1978 Paris, no. 11; 1984 Tokyo–Nara, no. 2; 1986 Washington–Los Angeles–New York, no. 7; 1986 Quebec, no. 7; 1987 Lugano, no. 19

BIBLIOGRAPHY

Hermitage catalogue: 1976, p. 292; Cat. Shchukin 1913, no. 203; State Museum of Modern Western Art catalogue 1928, no. 550
Réau 1929, no. 732; Venturi 1936, no. 705; Sterling 1957, pp. 121–2
French 19th-Century Masters 1968, no. 59; Cézanne 1975, no. 21; Izerghina, Barskaya 1975, no. 45
L. Gowing, 'The Logic of Organized Sensations', in *Cézanne: The Late Work*, exhibition catalogue, Museum of Modern Art, New York 1977, pp. 64–5

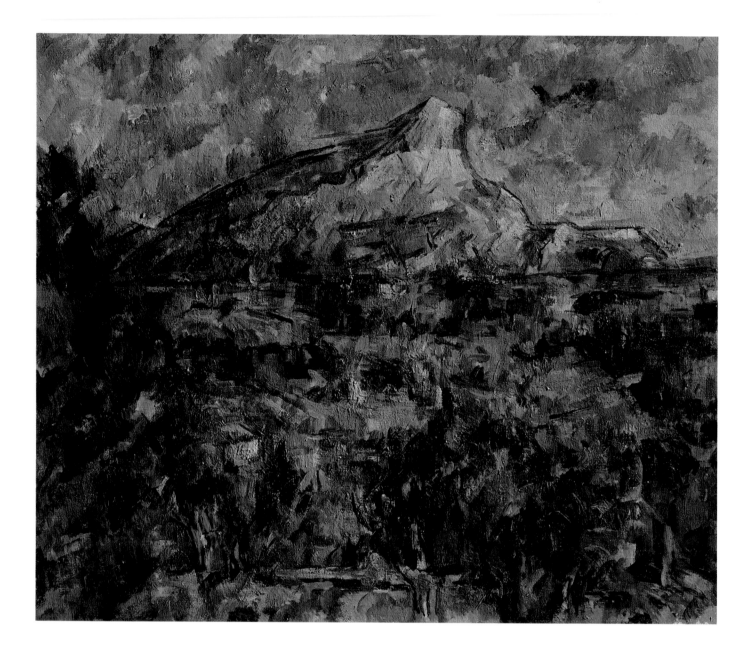

PAUL CEZANNE (1839–1906)

Mont Sainte-Victoire

Oil on canvas, 60 × 73 (23¾ × 28¾)
Pushkin Museum, Moscow (3339)

This is the latest of Cézanne's works in the Pushkin Museum, although opinions differ as to its date: Venturi, Dorival and Barskaya date it to 1905, Rewald to 1905–6 and Reff to 1902–6. Rewald's dating seems to be the most convincing. Gowing considers the painting to have been done in 1906, and says it is possibly the last finished view of Mont Sainte-Victoire made from the artist's studio at Les Lauves.

Rewald identifies the painting with that in a photograph of Cézanne taken at Aix in January 1906 by Maurice Denis; he says it also appears in a painting by Denis, *Cézanne seen against Mont Sainte-Victoire* (1906, private collection, France), which was done from sketches made at Aix. However, one cannot be certain that it is indeed the Pushkin picture that appears in the photograph and in the painting by Denis, since Cézanne produced a number of very similar compositions. Denis wrote about meeting Cézanne in his diaries and in a letter to his wife, but he only mentioned the subject on which Cézanne was working, without describing the picture: 'The motif was in the distance, a view of Sainte-Victoire (a large, pointed mountain of the locality): he goes there in a cart. We saw him there, painting in an olive grove. I drew him . . .' ('*Le motif était loin, une vue de Sainte-Victoire [grande montagne pointue des environs]: il y va en voiture. Nous l'avons donc vu là, dans un champ d'oliviers, en train de peindre. Je l'ai dessiné. . . .*')

Cézanne constantly returned to the subject of Mont Sainte-Victoire: different versions exist in the Basle and Philadelphia museums and in private collections.

The Pushkin canvas is painted energetically with thick geometrical strokes, predominantly in strong blues. In its dramatic imagery and the manner of its painting it belongs to the twentieth century. E.G.

PROVENANCE

Vollard collection, Paris; 1911–18: Shchukin collection, Moscow; 1918–23: Museum of Modern Western Painting (I), Moscow; 1923–48: State Museum of Modern Western Art, Moscow; 1948: transferred to the Pushkin Museum

EXHIBITIONS

1905 Paris, Salon d'Automne; 1926 Moscow, no. 25; 1956 Leningrad, Cézanne, no. 25; 1965 Bordeaux, no. 58; 1965–6 Paris, no. 50; 1972 Otterlo, no. 7; 1978 Paris, Cézanne, no. 91; 1983 Lugano, no. 8; 1986 Washington–Los Angeles–New York, no. 8

BIBLIOGRAPHY

Pushkin Museum catalogues: 1957, p. 128; 1961, p. 169; 1986, p. 163, fig. 168; Cat. Shchukin 1913, no. 210; Tugendhold 1914, p. 45
Meier-Graefe 1920, p. 141; Pertsov 1921, no. 210; Tugendhold 1923, p. 148; Faure 1924, fig. 48
Ternovets 1925, p. 467; Nurenberg 1926; Yavorskaya 1926, p. 7; State Museum of Modern Western Art catalogue 1928, no. 552, p. 97
Réau 1929, no. 734; Venturi 1936, no. 803; Rewald 1939, fig. 76; Barnes, Mazia 1939, no. 183, pp. 420, 282 (ill.)
Rewald 1948, no. 101; Jourdain 1948, p. 9; *Cahiers d'Art*, II, 1950, p. 339, no. 568; Dorival 1948, p. 81
M. Denis, *Journal*, vol. II, 1957, pp. 28–31; Sterling 1957, p. 116, fig. 26 (erroneously stated to be in the Hermitage); Feist 1963, fig. 81
P. Cézanne: Génies et Réalites, Paris 1966, fig. 118, pp. 161, 163; Rusakova, 1970
Gatto 1970, no. 767, p. 121 (ill.) (erroneously stated to be in the Museum of Modern Western Art);
Yavorskaya 1972, fig. 56; Brion 1972, p. 67; idem. 1973, p. 67
Cézanne 1975, no. 25, (ill.); Picon, Orienti, 1975, no. 767, p. 121, (ill.)
Cézanne: The Late Work, exhibition catalogue, Museum of Modern Art, New York 1977, pp. 27, 69, 95, pl. 129, p. 322 (c. 1906)
Ed. W. Rubin *Cézanne: The Late Work*, essays by T. Reff et al., London 1978, p. 322, fig. 129
Georgievskaya, Kuznetsova 1980, cat. and fig. 183; Cézanne, Leningrad 1983, p. 147, figs 50–1

PIERRE BONNARD (1867–1947)

'La Glace du cabinet de toilette' (Mirror in the Dressing Room)

Oil on canvas, 120 × 97 (47¼ × 38¼)
Signed top right in white paint: Bonnard
Inscribed on the reverse: Glace cabinet de toilette. Ne pas vernir. P. Bonnard
On the stretcher: label of the firm Bernheim and Son, title of the picture and number 16744
Pushkin Museum, Moscow (3355)

In 1908–9 Bonnard painted several versions of this subject, featuring the same interior with its wash-basin and mirror. Close to the Pushkin picture are 'La Glace de la chambre verte' of 1909 (Dauberville 529, John Herron collection, USA) and 'La Table de toilette', variously entitled 'La Glace', of 1908 (Dauberville 486, Musée d'Orsay, Paris). In 1913–14 Bonnard again returned to the same subject; he also treated it in his engravings.

In the Pushkin picture the seated woman, seen in reflection holding a cup, may be identified as Martha Bousin who became Bonnard's wife in 1925. She closely resembles Martha Bonnard as portrayed in a number of pictures, particularly the Woman with a Dog (Beyeler Gallery, Basle) and the Rustic Pleasures or Gardener of 1908.

Ternovets, in the manuscript catalogue of the State Museum of Modern Western Art, Moscow, said that Bonnard's Mirror in the Dressing Room was the favourite canvas of Serov, the painter who advised Morozov in his purchases.

E.G.

PROVENANCE

8 September 1908: purchased from Bonnard by Bernheim-Jeune; 3 October 1908: bought by Morozov from Bernheim-Jeune at the Salon d'Automne exhibition for 2,000 francs (a receipt from Bernheim-Jeune for this payment is in the archive of the Pushkin Museum); until 1918: Morozov collection, Moscow; 1918–28: Museum of Modern Western Painting (II), Moscow; 1948: transferred to the Pushkin Museum

EXHIBITIONS

1908 Paris, Salon d'Automne, no. 184; 1965 Bordeaux, no. 75; 1965–6 Paris, no. 73; 1983 Dresden, no. 19; 1984 Leningrad–Moscow, no. 11

BIBLIOGRAPHY

Pushkin Museum catalogues: 1961, p. 21; 1986, pp. 29–30, fig. 187; Makovskii 1912, nos 3–4; Apollon, 1912, nos 3–4 (ill.);
L. Werth, Bonnard, Paris 1923
P. Morand, article on the Museum of Modern Western Painting, Moscow, in Nouvelles Littéraires, February 21, 1925
Exhibition catalogue 1928, p. 24, no. 21; Réau 1929, no. 705; Cahiers d'Art, 1950, p. 192; M. Denis, Journal, vol. II, Paris 1957, p. 101
'Le Musée de Moscou', Cercle d'Art, 1963, p. 192, fig. 193 p. 191;
Dauberville, Bonnard, Paris 1968, vol. II, no. 488, p. 108
N. Yavorskaya, Bonnard, Moscow 1972, p. 161, fig. 27; R. Geller, Bonnard, Budapest 1975, fig. 25
A. Zamyatina, Album of Pushkin Museum, Moscow 1975, no. 91; Georgievskaya, Kuznetsova 1980, no. 215

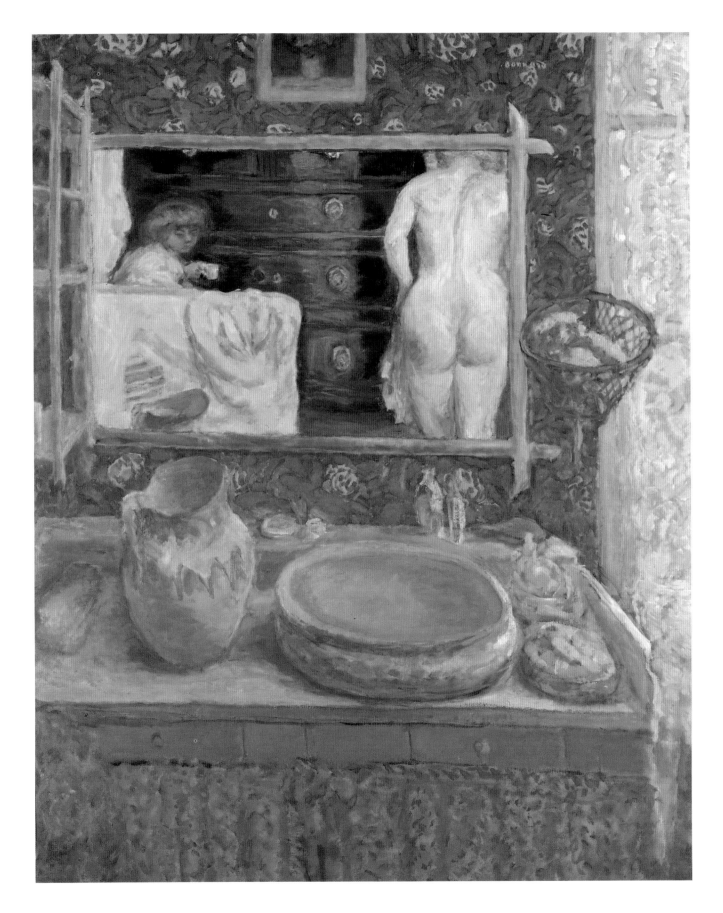

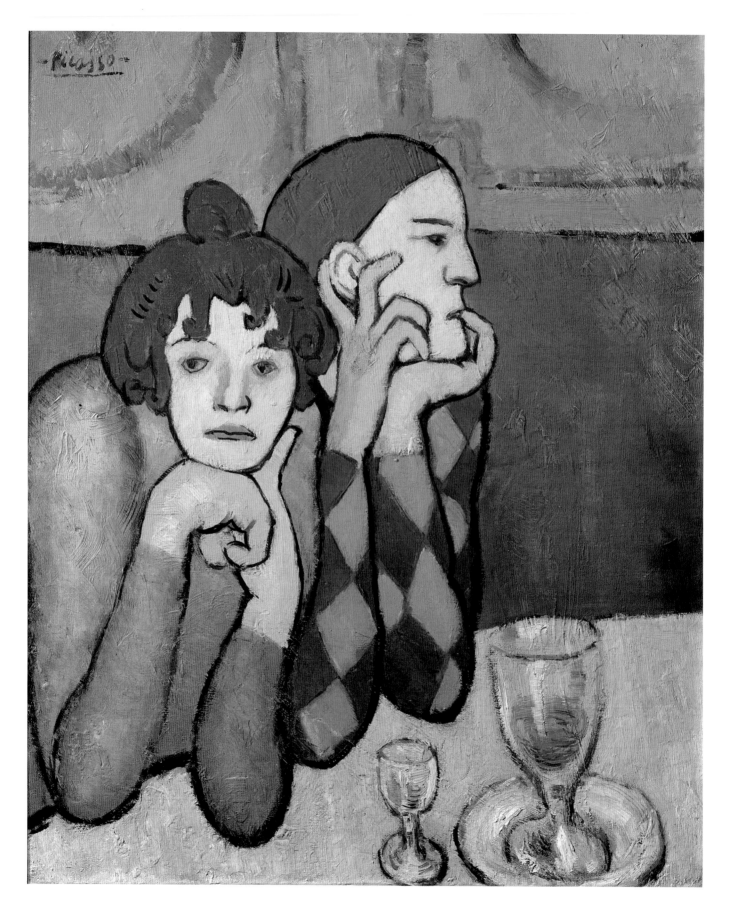

PABLO PICASSO (1881–1973)

'Les Deux saltimbanques' (Harlequin and his Companion)

Oil on canvas, 73 × 60 (28¾ × 24¾)
Signed top left: Picasso
Pushkin Museum, Moscow (3400)

This was painted in Paris towards the autumn of 1901. Typically for the period (Picasso's second visit to the French capital) it depicts a contemporary subject, that of the café, in a symbolic manner. Artistic life is personified by Harlequin, a *commedia dell'arte* character who also appears in the *Seated Harlequin* (Zervos I, 79) painted at the same time. A comparable female character appears in *Woman with a Chignon* (Zervos I, 96). Two other paintings are similar in style: *The Absinthe Drinker* in the Hermitage (Zervos I, 98), and the *Portrait of the Poet Sabartés* in the Pushkin Museum (Zervos I, 97). Among the studies for the Pushkin picture are a pen drawing of Harlequin, a pencil drawing for the figure of the woman, and a drawing showing Harlequin embracing the woman (Zervos XXI, 295, 296, 297).

When Picasso again turns to this subject in the 1905 painting *At the Lapin Agile* (Zervos I, 275) he depicts himself in Harlequin's costume, with a prostitute next to him. This picture also repeats the motif of a goblet beside a wineglass as seen in the foreground of the Pushkin painting, but the significance of the motif is different in the two pictures.

The Pushkin canvas shows Harlequin with the whitened face of the tragic Pierrot, and his companion with a face resembling a Japanese mask. Some authorities, particularly Johnson, see an analogy between the *commedia dell'arte* figures in early Picasso and those in the late Symbolist poetry of Verlaine.

Stylistically the Pushkin picture represents the peak of Picasso's so-called 'stained glass' period, which reached its full flowering towards the end of his second stay in Paris. The period is characterised by strong, sinuous, dark contours which outline the figures and objects. These isolate them from their real environment and create a unifying tension between the characters, who are separated from one another by their loneliness.

The thick layer of underpaint in *Harlequin and his Companion* suggests that it was painted over an earlier, unidentified picture. Picasso frequently overpainted his canvases, even those used quite recently, at the end of 1901. At this time he also reached a new creative stage in his work, one which later became known as the 'Blue Period'. M.B.

PROVENANCE

1908: purchased by Morozov from Vollard in Paris for 300 francs; 1919–23: Museum of Modern Western Painting (II), Moscow; 1923–48: State Museum of Modern Western Art, Moscow (inv. no. 379); 1948: transferred to the Pushkin Museum

EXHIBITIONS

1929 Moscow, no. 19; 1954 Paris, no. 1; 1955 Moscow, p. 50; 1956 Leningrad, p. 47; 1971 Paris, no. 2; 1971 Tokyo–Kyoto; 1974 Kiev; 1978 Budapest, p. 11; 1979 Paris, p. 525; 1982 Leningrad–Moscow, no. 3; 1983 Lugano, no. 34; 1984 Bern, no. 140; 1986 Washington–Los Angeles–New York, no. 33

BIBLIOGRAPHY

Pushkin Museum catalogues: 1957, p. 109; 1961, p. 147; Makovskii 1912, p. 22 (ill.); State Museum of Modern Western Art catalogue 1928, no. 458
Réau 1929, no. 1045; *L'Amour de l'Art*, 1933, fig. 216; *Cahiers d'art*, 1950, p. 345; Cirici-Pellicer, *Picasso*, 1950, p. 112, no. 74
Vercors, D. H. Kahnweiler, H. Parmelin, *Picasso: Oeuvres des musées de Leningrad et de Moscou*, Paris 1955, pp. 48, 49, no. 13
J. C. Aznar, *Picasso y el cubismo*, Madrid 1956, p. 335, fig. 229; Sterling 1957, pp. 190–1, no. 152; Zervos I 1957, no. 92
R. Penrose, *Picasso: His Life – His Work*, New York 1958, p. 354; G. Diehl, *Pablo Picasso*, 1960, p. 12 (ill.); A. Vallentin, *Pablo Picasso*, 1961, pp. 66–7;
P. Daix, *Pablo Picasso*, 1964, pp. 31, 33, fig. 34; Daix, Boudaille 1967, VI.20, p. 47; Moravia, Lecaldano,
Picasso: periodo blue e rosa, Milan 1968, no. 4; W. Rubin, *Picasso in the Museum of Modern Art*, New York 1972, pp. 28, 190
T. Reff, *Picasso*, 1973, p. 31, fig. 42, p. 33; Conoscere Picasso, 1974, p. 104; P. Cabanne, *Le siècle de Picasso*, Paris 1975, pp. 118, 119, (ill.)
R. Johnson, 'Picasso's Parisian Family and the 'Saltimbanques', *Arts Magazine*, 51, January 1977, pp. 90–5; Daix 1977, pp. 46, 50
Ed. W. Rubin, *Pablo Picasso: A Retrospective*, Museum of Modern Art, New York 1980, pp. 29, 41 (ill.); Georgievskaya, Kuznetsova 1980, no. 257
The Saltimbanques, exhibition catalogue, National Gallery of Art, Washington 1980, fig. 15, pp. 26–27, 29, cat. no. 20
Palau i Fabre, *Picasso: Life and Work of the Early Years 1881–1907*, Oxford 1981, no. 666; Barskaya, Bessonova 1985, no. 279

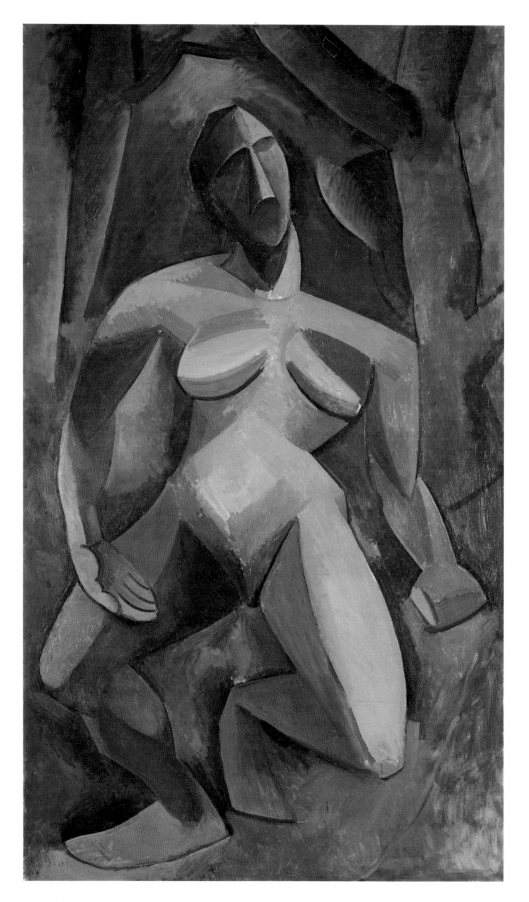

PABLO PICASSO (1881–1973)

The Dryad (Nude in the Forest)

Oil on canvas, 185 × 108 (72¾ × 42¼)
Signed on back: Picasso
Hermitage, Leningrad (7704)

When in Shchukin's collection the painting was called *Naked Woman in a Landscape*; it is also sometimes known as the *Large Dryad*.

It was painted in Paris in the autumn of 1908, when Picasso returned from La Rue-des-Bois. The background of *The Dryad* is a development of the landscape ideas of La Rue-des-Bois. As before, the human figure is the centre of the artist's attention, but here it is surrounded by a mysterious and entirely new landscape which arouses primordial terrors.

In a preliminary pencil drawing formerly in the artist's collection (Zervos II, 661) a similar female figure is seated in an armchair, as though sliding off it. This pose is repeated, but not fully explained, in the painting. Steinberg saw in the introduction of the armchair a connection with the *Demoiselles d'Avignon* (1906–7, Museum of Modern Art, New York), which is set indoors. This connection is clearer in the studies for the *Demoiselles d'Avignon*. Steinberg also identified two earlier sources for *The Dryad*. In the first, *Nudes Embracing* (1905, State Museum of Art, Copenhagen), the woman's pose

contains all the characteristics of the 1908 painting. In the second, a drawing for a female figure (1905, Museé Picasso, Paris), the pose and gesture signify an invitation, and the letters *S.V.P.* inscribed by the artist on the same sheet stand for 's'il vous plaît'. However, *The Dryad* cannot be interpreted in the spirit of the ironic drawing of 1905: the dryad's gesture is both an invitation and a threat.

The painting may be linked to various female nudes of 1906, all direct forerunners of Cubism. Many of his works of this period reveal the influence of primitive art and here his idiom is so vigorous that the figure appears to be hewn by a few strokes of an axe. A comparison of the painting with a preliminary gouache study (Zervos II, 112), in which there is a second female figure in the background, suggests that the 'hewn' quality was evolved in the process of working on the picture since the gouache is more realistic and 'natural'.

The Dryad was preceded by a series of studies, dated by Zervos to 1907, though a later date would be more logical (Zervos XXVI, 145, 163, 164, 165, 180). A.K.

PROVENANCE

Kahnweiler gallery, Paris; Shchukin collection, Moscow; 1918: Museum of Modern Western Painting (I), Moscow; 1923: State Museum of Modern Western Art, Moscow; 1934: transferred to the Hermitage

EXHIBITIONS

1958 Brussels, no. 257; 1960 London, no. 278; 1964 Toronto–Montreal, no. 49; 1965 Bordeaux, no. 94; 1965–6 Paris, no. 93; 1971 Paris, no. 16; 1982 Leningrad–Moscow, no. 26

BIBLIOGRAPHY

Hermitage catalogues: 1958, p. 427; 1976, p. 283; Cat. Shchukin 1913, no. 173
State Museum of Modern Western Art catalogue 1928, no. 435; Réau 1929, no. 1023; Zervos, II, 1942, no. 113
Sterling 1957, p. 209; R. Rosenblum, *Cubism and Twentieth-Century Art*, New York 1960, pp. 28, 29
J. Laude, *La peinture française (1905–1914) et l'Art Nègre*, Paris 1968, pp. 301, 305
The Hermitage, Leningrad: French 20th-Century Masters, Prague 1970, no. 77
L. Steinberg, 'The Philosophical Brothel', *Art News*, September 1972
P. Daix, J. Rosselet, *Le Cubisme de Picasso; Catalogue raisonné de l'oeuvre. 1907–1916*, Neuchâtel 1979, no. 133

PABLO PICASSO (1881–1973)

Portrait of Ambroise Vollard

Oil on canvas, 93 × 66 (36½ × 26)
Pushkin Museum, Moscow (3401)

Ambroise Vollard (1865–1939) was a prominent Paris dealer, connoisseur and art collector. He published a number of memoirs with reminiscences of Renoir, Cézanne and Degas; and played an important role in Picasso's career. He was the first dealer to show an interest in the work of the young Spaniard recently arrived in Paris, and in June 1901 he staged an exhibition of Picasso's work at his gallery in Rue Lafitte. He maintained close business and creative contacts with Picasso right up to the time of his death.

In 1927 Vollard commissioned Picasso to provide illustrations for Balzac's *Unknown Masterpiece*. Between 1930 and 1937 he acquired most of the copper plates engraved by Picasso, and the etchings taken from these plates became known as *The Vollard Suite*.

The Pushkin Museum painting is the earliest and best known portrait of Vollard by Picasso. Fernande Olivier, in a letter to Gertrude Stein dated 17 June 1910 (*A Picasso Anthology*, p. 67), records that it was begun at the end of 1909 and finished in the summer of 1910. In 1915 Picasso did a more realistic pencil portrait of Vollard seated on a chair, and in 1937 he added several etchings of the Pushkin portrait to *The Vollard Suite*.

The *Portrait of Vollard* is the first of the three known Cubist portraits of the Paris dealers who were Picasso's friends and critics: the *Portrait of Wilhelm Uhde* (Zervos II, i, 217) and the *Portrait of Daniel-Henry Kahnweiler* (Zervos II, i, 227) both date from 1910. All the sitter's contemporaries praised the wonderful likeness of the portrait, but Vollard himself was not fond of it, although he judged it to be a considerable work of art. In 1913 he sold it to Morozov who, unlike Shchukin, was not particularly sympathetic to Cubism, but was interested in the expressive qualities of the picture. M.B.

PROVENANCE

1913: purchased by Morozov from Vollard, Paris, for 3,000 francs; 1918: Museum of Modern Western Painting (II), Moscow; 1923: State Museum of Modern Western Art, Moscow; 1948: transferred to the Pushkin Museum

EXHIBITIONS

1953 Milan, no. 339; 1958 Brussels, no. 258; 1964 Tokyo–Kyoto–Nagoya, no. 7; 1965 Bordeaux, no. 96; 1965–6 Paris, no. 96; 1966–7 Paris, no. 67; 1972 Otterlo, no. 45; 1972 Moscow, Portrait, pp. 146, 151; 1976 Dresden, no. 33; 1976 Prague, no. 27; 1978 London, Portrait, no. 28; 1979 Paris, 'Paris–Moscou'; 1981 Moscow, 'Moscow–Paris'; 1981–2; Madrid–Barcelona, no. 56; 1982 Leningrad–Moscow, no. 36; 1983 Lugano, no. 40; 1985 Venice–Rome, no. 41; 1986 Washington–Los Angeles–New York, no. 40

BIBLIOGRAPHY

Ternovets 1925, p. 488 (ill.); State Museum of Modern Western Art catalogue 1928, no. 460; Réau 1929, no. 1047
A. Lhote, 'Naissance du cubisme', *L'Amour de l'Art*, November 1933, no. 9, fig. 271, p. 217
G. Bazin, 'Pablo Picasso', *L'Amour de l'Art*, November 1933, no. 9, no. 222
F. Olivier, *Picasso et ses amis*, Paris 1933, p. 179; A. Vollard, *Souvenirs d'un marchand des tableaux*, Paris 1937, p. 127; 1948 p. 273
J. Camon Asnar, *Picasso y el cubismo*, Madrid 1956, p. 114; F. Elgar, R. Maillard, *Picasso*, London 1957, p. 59 (ill.); Sterling 1957, pp. 209–11, no. 163
Penrose 1958, pp. 154, 354, pl. VI. 7; 1971, p. 167, 409; L.-G. Buchheim, *Picasso, a pictorial biography*, London 1959, pp. 52, 54 (ill.)
Daix 1964, pp. 74 (ill.), 79, 85; E. F. Fry, *Cubism*, New York 1966, fig. 20; 'Il Cubismo', *L'Arte moderna*, 1967, vol. 10, p. 99 (ill.)
Daix, Boudaille 1967, no. 337; A. Martini, *Picasso e il cubismo*, Milan 1967, pl. XVIII; *The World of Picasso*, 1967, pp. 59, 90 (ill.); A. Fermigier, *Picasso a dirigé cet ouvrage*, 1967, p. 99, p. 52 (ill.); G. and P. Francastel, *Le Portrait: 50 siècles d'humanisme en peinture*, Paris 1969, p. 129, fig. 37
A. Fermigier, *Pablo Picasso*, 1969, pp. 87, 408, no. 51; 'Picasso e il cubismo', *Forma e Colore*, no. 66, Florence 1970, pl. 2
G. Boudaille, R. J. Moulin, *Pablo Picasso*, 1971, no. 12; Russoli Minervino 1972, no. 325, pl. XIX; De Draeger, *Picasso*, 1974, p. 113 (ill.); Cabanne 1975, p. 226 (ill.); 1982, p. 218, (ill.); D. Thomas, *Picasso and His Art*, London 1975, pl. 25; T. Hilton, *Picasso*, London 1975, pp. 102–4, no. 70
F. A. Baumann, *Pablo Picasso: Leben und Werk*, Stuttgart 1976, pp. 60–61, fig. 103; R. Rosenblum, *Cubism and Twentieth-Century Art*, New York 1976, p. 44, pl. VIII, Ed. W. Rubin, *Pablo Picasso: A Retrospective*, exhibition catalogue, Museum of Modern Art, New York 1980, p. 121, (ill.)
Georgievskaya, Kuznetsova 1980, no. 266; M. Gedo, *Picasso – Art as Autobiography*, Chicago–London 1980, pp. 86, 88
M. McCully, *A Picasso Anthology: Documents, Criticism, Reminiscences*, London 1981, p. 67
P. Daix, *Cubists and Cubism*, Geneva–London 1983, pp. 51, 55 (ill.); Zervos II, i, 1986, no. 214

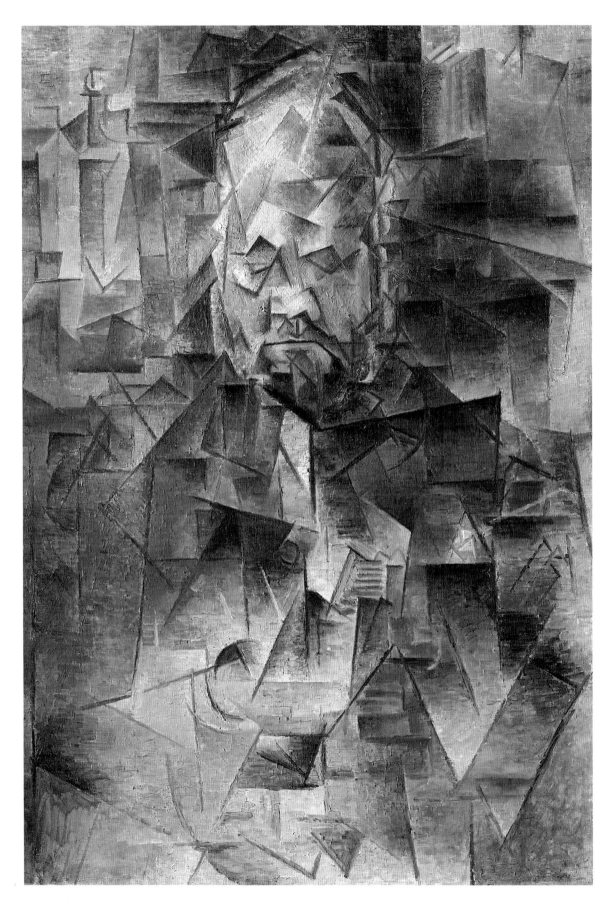

HENRI MATISSE (1869–1954)

Goldfish

Oil on canvas, 140 × 98 (55 × 38½)
Pushkin Museum, Moscow (3229)

This picture of an aquarium with goldfish was painted in 1911 at the studio in Issy-les-Moulineaux near Paris. Between 1911 and 1915 Matisse depicted the subject several times (Elderfield places six works in the series), but the Pushkin picture is one of the best known and finest versions.

Barr dates the Pushkin canvas to 1912 on the basis of a letter, dated 22 August 1912, from Shchukin to Matisse enquiring about the despatch of the painting from Paris to Moscow. Mme Duthuit (according to Elderfield) dated the painting to 1911, which would appear to be more correct. The painting was sometimes known by another name: Escholier called it *Aquarium with Fishes in a Conservatory*. E.G.

PROVENANCE

1912: purchased by Shchukin from Matisse in Paris; 1912–18: Shchukin collection, Moscow; 1918–23: Museum of Modern Western Painting (I), Moscow; 1923–48: State Museum of Modern Western Art, Moscow; 1948: transferred to the Pushkin Museum

EXHIBITIONS

1955 Moscow, p. 45; 1956 Leningrad, p. 39; 1958 Brussels, no. 211; 1966 Tokyo–Kyoto, no. 72; 1969 Moscow–Leningrad, no. 36; 1970 Paris, no. 107; 1983 Dresden, no. 108; 1983 Lugano, no. 29; 1984 Leningrad–Moscow, no. 55; 1986 Washington–Los Angeles–New York, no. 29

BIBLIOGRAPHY

Pushkin Museum catalogues: 1961, p. 121; 1986, p. 116 (col. pl.)
Cat. Shchukin 1913, no. 115; Tugendhold 1914, p. 42; State Museum of Modern Western Art catalogue 1928, no. 330
Réau 1929, no. 944; Romm 1936, p. 32 (ill.); Escholier, *Matisse, ce vivant*, Paris 1937, fig. 11 ('Bocal de poissons dans la sere')
Barr 1951, pp. 144, 154, 164, 537, 555, fig. 376; Diehl 1954, p. 68, 139, 154, 161, fig. 59 ('Poissons d'or')
G. Besson, *Matisse*, Paris 1954, fig. 26; Lassaigne 1959, pp. 76, 68 (ill.);
L'opera di Matisse 1904–1928, Milan 1971, cat. and fig. 146, p. 92
J. Elderfield (with additional texts by W. S. Lierberman and R. Castleman), *Matisse in the collection of the Museum of Modern Art*, New York 1978, pp. 84, 198
'Matisse', Leningrad, 1978, no. 37; Georgievskaia, Kuznetsova 1980, no. 239

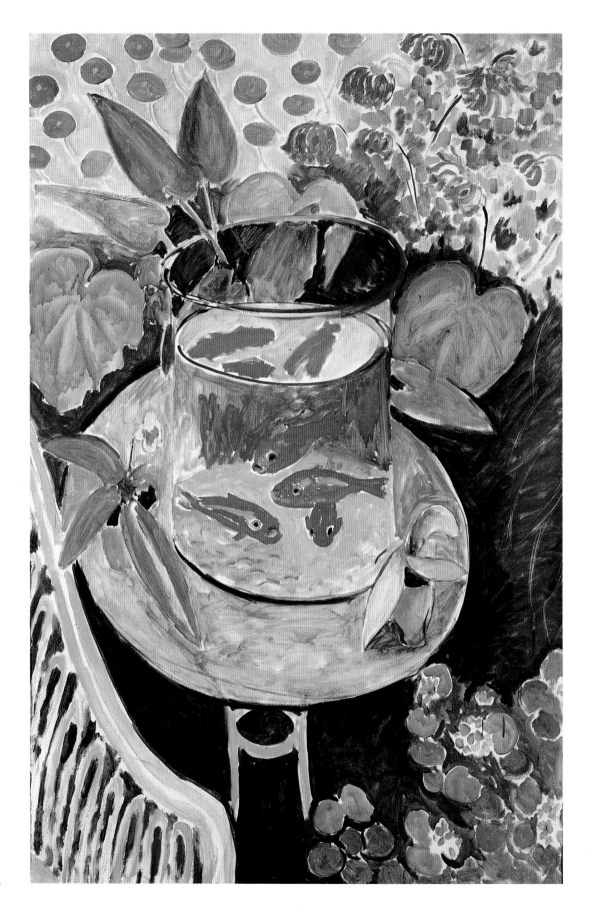

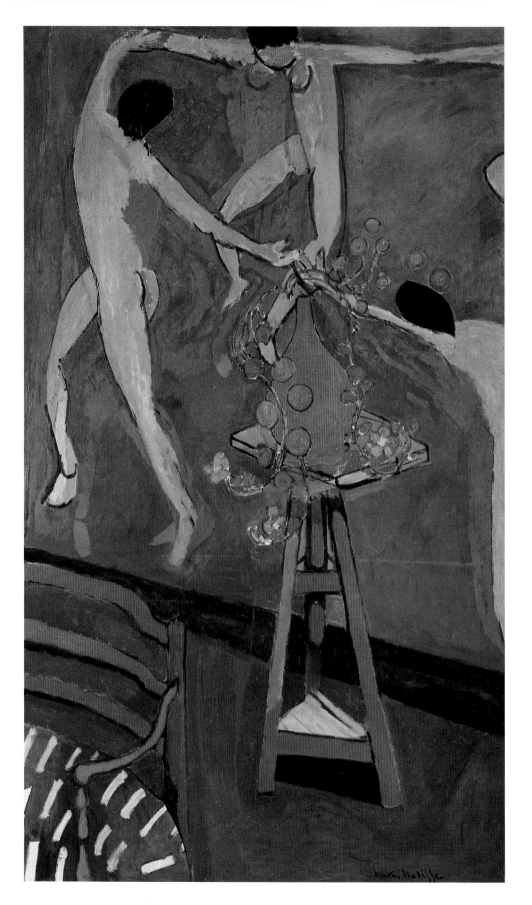

HENRI MATISSE (1869–1954)

Nasturtiums and 'The Dance'

Oil on canvas, 190.5 × 114.5 (75 × 45)
Signed top right: Henri Matisse
Pushkin Museum, Moscow (3301)

Matisse painted this subject twice in the summer of 1912, in his studio at Issy-les-Moulineaux. The other version, which is somewhat different, is in the Worcester Museum, USA. In the background of the Pushkin painting can be seen the sketch made by Matisse in 1909 for 'La Danse' (Museum of Modern Art, New York).

A letter from Shchukin to Matisse, dated 22 August 1912, indicates that Shchukin had loaned Nasturtiums and 'The Dance', already purchased by him, to the exhibition at the Salon d'Automne of 1912. Although the catalogue of the Salon lists 'Dr. G.' as the owner of the painting, Barr considers that only the painting purchased by Shchukin could have been shown at that exhibition, since the other version at that particular time was being exhibited in London. E.G.

PROVENANCE

1912: purchased by Shchukin from Matisse in Paris; 1912–18: Shchukin collection, Moscow;
1918–23: Museum of Modern Western Painting (I), Moscow; 1923–48: State Museum of Modern Western Art, Moscow;
1948: transferred to the Pushkin Museum

EXHIBITIONS

1912 Paris, Salon d'Automne, no. 769; 1958 Brussels, no. 210; 1965 Bordeaux, no. 90; 1965–6 Paris, no. 90;
1967 Montreal, no. 138; 1969 Moscow–Leningrad, no. 41; 1969–70 Prague, no. 12; 1972 Otterlo, no. 34;
1973 Washington–New York–Los Angeles–Chicago–Fort Worth–Detroit, no. 25; 1981 Tokyo–Kyoto, no. 33;
1983 Lugano, no. 31; 1986 Washington–Los Angeles–New York, no. 31

BIBLIOGRAPHY

Pushkin Museum catalogues: 1961, p. 12; 1986, p. 116; Cat. Shchukin 1913, no. 121, p. 29; Tugendhold 1914, nos 1–2, p. 42
Pertsov 1921, no. 121, p. 112; Tugendhold 1923, p. 143; State Museum of Modern Western Art catalogue 1928, no. 331, p. 67
Réau 1929, no. 945, p. 118; Courthion 1934, no. XVIII
Cahiers d'art, 1950, no. 331, p. 343; Barr 1951, pp. 127, 144–5, 148, 156–7, 537, 555, fig. 382
Diehl 1954, pp. 68, 138–48, 154, fig. 57 (erroneously considers that the Shchukin panel 'Dance', at present in the Hermitage serves as the background)
Sterling 1957, p. 186; Lassaigne 1959, p. 66; 'Le Musée de Moscou', Cercle d'Art, 1963, no. 98, p. 206, fig. 207
Alpatov 1969, p. 47, fig. 8 (erroneously called 'A Corner of the Studio'); Orienti 1972, p. 32;
'Matisse', Leningrad, 1978, no. 42
Georgievskaya, Kuznetsova, 1980, cat. and fig. 231

HENRI MATISSE (1869–1954)

Still Life with Arum, Iris and Mimosa

Oil on canvas, 140 × 87 (55 × 34¼)
Signed and dated bottom left: Henri Matisse/Tangier 1913
Pushkin Museum, Moscow (3303)

This was painted in Tangiers early in 1913 during Matisse's second journey to Morocco, as was its pair, *Bunch of Flowers on a Terrace* (Hermitage, inv. no. 7700), which was executed in more sketchy manner.

Hoog believes that the two paintings are among the first of Matisse's large-scale still-life works. The group of still lifes painted in Tangiers also includes the *Basket with Oranges* (1912–13, Louvre, Paris) which Beguin and other authorities consider to be the most important one in this group.

E.G.

PROVENANCE

1913: purchased by Shchukin in Paris; 1913–18: Shchukin collection, Moscow; 1918–23: Museum of Modern Western Painting (I), Moscow; 1923–48: State Museum of Modern Western Art, Moscow; 1948: transferred to the Pushkin Museum

EXHIBITIONS

1913 Paris, Bernheim-Jeune gallery, no. 10; 1955 Moscow, p. 45; 1956 Leningrad, no. 39; 1969 Moscow–Leningrad, no. 48; 1969–70 Prague, no. 13; 1976 Dresden–Prague, no. 20 and no. 19; 1978 Paris, no. 16; 1982–3 Zurich, no. 37; 1983 Düsseldorf, no. 37

BIBLIOGRAPHY

Pushkin Museum catalogue 1986, p. 117; Cat. Shchukin 1913, no. 125, p. 28; Tugendhold 1914, 1–2, p. 42; Pertsov 1921, no. 125, p. 112
State Museum of Modern Western Art 1928, no. 334, p. 67; Réau 1929, no. 948, p. 118; *Cahiers d'art*, 1950, no. 334, p. 343
Barr 1951, pp. 159, 206, 215, fig. 389; Diehl 1954, pp. 69, 117; Sterling 1957, p. 186; Alpatov 1969, p. 48, p. 15 (ill.)
L'opera di Matisse 1904–1928, Milan 1971, no. 176 pp. 92 (ill.), 93 (erroneously stated to be in the Hermitage)
Alpatov 1973, fig. 27, s. 73
'Matisse', Leningrad, 1978, no. 49, p. 177 (ill.); Georgievskaya, Kuznetsova 1980, cat. and fig. 230, no. 375, p. 391

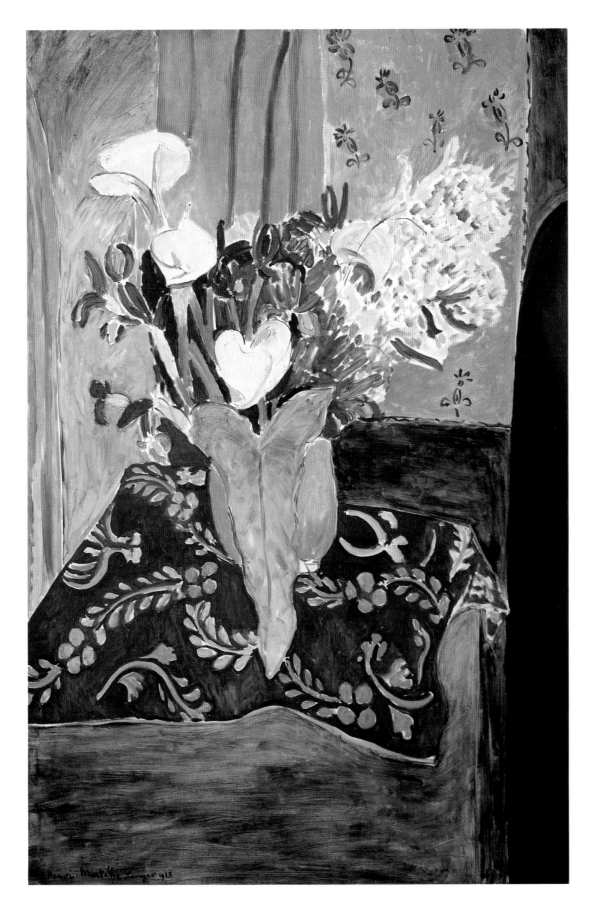

Exhibitions

1673–1800 PARIS, SALONS
Collection des livrets anciennes expositions depuis 1673 jusqu'en 1800. Salons. Paris, 1869–71

1870 ST PETERSBURG
'Historical portraits of the 16th–18th century'.
Society for the Promotion of Artists. Catalogue by P. N. Petrov

1889 ST PETERSBURG
'Old and contemporary paintings from private collections'

1905 ST PETERSBURG
'Historical exhibition of Russian portraits'. Tauride Palace

1908 ST PETERSBURG
'The Old Years' (Starye Gody). Exhibition of pictures, Starye Gody, November–December.

1922–5 PETROGRAD
'French paintings of 17th and 18th centuries'.
Hermitage

1923 PETROGRAD
'19th-century painting'. Hermitage.
Catalogue compiled by F. F. Nothaft

1926 MOSCOW
'Cézanne–Van Gogh'. State Museum of Modern Western Art

1926 MOSCOW, GAUGUIN
'Paul Gauguin'. State Museum of Modern Western Art

1936 PARIS
'Cézanne'. Orangerie des Tuileries

1937 PARIS
'Chefs-d'oeuvre de l'art français'. Exposition universelle.
Palais National des Arts

1938 LENINGRAD
'18th–20th century portraits'. Hermitage.

1939 MOSCOW
'French 19th and 20th-century landscapes'.
State Museum of Modern Western Art.

1954 PARIS
'Picasso: oeuvres des musées de Léningrad et de Moscou, 1900–14'.
Maison de la Pensée Française

1955 MOSCOW
'15th–20th century French art'. Pushkin Museum.

1956 LENINGRAD
'12th–20th century French art'. Hermitage. Catalogue, Moscow 1956

1956 LENINGRAD, CEZANNE
'Paul Cézanne: The 50th anniversary of his death'.
Hermitage.

1958 BRUSSELS
'50 ans d'art moderne'. Exposition Universelle

1960 LONDON
'Pablo Picasso'. Tate Gallery

1960 MOSCOW
'French art of the second half of 19th century from the Museums of Fine Art Fonds in the USSR'. Pushkin Museum

1960 PARIS
'Vincent van Gogh'. Musée Jacquemart-André.

1964 TORONTO–MONTREAL
'Picasso and Man'. Art Gallery of Toronto/Montreal Museum of Fine Arts

1965 BORDEAUX
'Chefs-d'oeuvre de la peinture française dans les musées de l'Ermitage et de Moscou'. Catalogue by G. Martin-Méry

1965–6 PARIS
'Chefs-d'oeuvre de la peinture française dans les musées de Léningrad et de Moscou'. Musée du Louvre

1966–7 PARIS
'Hommage à Pablo Picasso: Peintures'. Grand Palais

1966–7 TOKYO–KYOTO
'Masterpieces of modern painting from the USSR: Hermitage, Pushkin, Russian and Tretyakov Museums in Leningrad and Moscow'. National Museum of Western Art, Tokyo/City Art Museum, Kyoto

1967–8 DRESDEN
'Meisterwerke der Ermitage, Leningrad. Französische Maler des 17 und 18 Jahrhunderts'. Staatliche Kunstsammlungen Dresden

1967–8 PARIS
'Ingres'. Petit Palais

1968 GÖTEBORG
'Ermitaget i Leningrad. 100 malningar och technigar fran renässans till 1700-tal. Ulställing'. Catalogue, Göteborg 1970

1968 VIENNA
'Pablo Picasso'. Oesterreichisches Museum für angewandte Kunst

1969 BUDAPEST
'Francia mesterek a Leningradi Ermitazsbol'. Szépmüvészeti Múzeum

1969 MOSCOW–LENINGRAD
'Henri Matisse: Painting, sculpture, graphics, letters: On the occasion of the 100th anniversary of the artist's birth'.
Pushkin Museum, Moscow/Hermitage, Leningrad

1969–70 PRAGUE
'Henri Matisse 3e sbírek sovétských muzeí'. Národní Galerie

1970 LENINGRAD
'François Boucher 1703–1770: Painting, graphics, applied art'.
Hermitage.

1970 PARIS
'Henri Matisse: Exposition du centenaire'.
Grand Palais

1971 PARIS
'Picasso dans les musées soviétiques'.
Musée National d'Art Moderne

1971 TOKYO–KYOTO
'One hundred masterpieces from USSR museums'.
Tokyo National Museum/Kyoto National Museum. Catalogue, Tokyo 1971

1972 DRESDEN
'Meisterwerke aus der Ermitage, Leningrad, und aus dem Puschkin-Museum, Moskau'

1972 LENINGRAD
'Watteau and his times: Painting, graphics, sculpture, applied art'.
Hermitage. Catalogue with introduction by I. Nemilova and N. Biryukova

1972 LENINGRAD, PORTRAIT
'The art of the portrait: Ancient Egypt, Ancient Greece and Rome, the Orient, Western Europe'. Hermitage.

1972 MOSCOW, PORTRAIT
'Portraits by 15th–20th century European artists from museums in Soviet and satellite countries'. Pushkin Museum, Moscow/ Tretyakov Museum, Moscow/Hermitage, Leningrad. Catalogue, Moscow 1972

1972 OTTERLO
'From Van Gogh to Picasso: 19th and 20th-century paintings and drawings from the Pushkin Museum, Moscow and the Hermitage Leningrad'. Kröller-Müller State Museum

1972 PRAGUE
'From Poussin to Picasso: Masterpieces from the Pushkin Museum in Moscow'. Národní Galerie

1973 WARSAW
'Malarstwo francuskie 17–20 w. ze zbiorów Ermitażu. Muzeum Narodowe w Warszawie'

1973 WASHINGTON–NEW YORK– LOS ANGELES–CHICAGO–FORT WORTH–DETROIT
'Impressionist and Post-Impressionist paintings from the USSR, lent by the Hermitage Museum, Leningrad and the Pushkin Museum, Moscow'. National Gallery of Art, Washington/M. Knoedler and Co., New York/Los Angeles County Museum of Art, Los Angeles/ Art Institute of Chicago/Kimbell Art Museum, Fort Worth/ Institute of Arts, Detroit. Catalogue, New York 1973

1974 LENINGRAD
'Impressionist paintings'. Hermitage

1974 MOSCOW
'Impressionist paintings'. Pushkin Museum

1974–5 PARIS
'De David à Delacroix: La peinture française de 1774 à 1830'. Grand Palais

1974–5 PARIS–MOSCOW
'L'URSS et la France: Les grands moments d'une tradition'. 50th anniversary of Franco-Soviet diplomatic relations

1975–6 USA–MEXICO–CANADA
'Master Paintings from the Hermitage and the State Russian Museum, Leningrad'. National Gallery of Art, Washington/ M. Knoedler and Co., New York/ Institute of Arts, Detroit/ Los Angeles County Museum of Art, Los Angeles/Museum of Fine Arts, Houston/Museo de Arte Moderno, Mexico/Winnipeg/ Montreal

1976 DRESDEN
'Meisterwerke aus dem Puschkin-Museum Moscau und aus der Ermitage Leningrad'. Gemäldegalerie Neue Meister, Albertinum

1976 PRAGUE
See 1976 Dresden above

1976 PRAGUE, MONET–LEGER
'From Monet to Léger'. Národní Galerie

1977 NEW YORK–HOUSTON
'Cézanne: The late work'. Museum of Modern Art, New York/ Museum of Fine Arts, Houston. Catalogue, New York 1977

1977 TOKYO–KYOTO
'Master paintings from the Hermitage, Leningrad'

1978 BUDAPEST
'French painting from Renoir to Picasso from the Pushkin Museum, Moscow'. Szépmüvészeti Múzeum

1978 LE HAVRE
'La peinture impressionniste et post-impressionniste du Musée de l'Ermitage'. Musée des Beaux-Arts André Malraux

1978 LONDON, PORTRAIT
'20th-century portraits'. National Portrait Gallery

1978 PARIS
'De Renoir à Matisse. 22 chefs-d'oeuvre des musées soviétiques et français'. Grand Palais

1978 PARIS, CEZANNE
'Cézanne: Les années dernières 1895–1906'. Grand Palais

1979 CLEVELAND–BOSTON
'Jean-Baptiste Siméon Chardin 1699–1779'. Cleveland Museum of Art, Cleveland/Museum of Fine Arts, Boston. Catalogue by P. Rosenberg, Cleveland, Ohio 1979

1979 PARIS
'Jean-Baptiste Chardin'. Grand Palais. Catalogue edited by P. Rosenberg

1979–80 MELBOURNE–SYDNEY
'Old master painting from the USSR'. National Gallery of Victoria, Melbourne/Art Gallery of New South Wales, Sydney. Catalogue, Melbourne 1979

1980 TOKYO–KYOTO
'Jean-Honoré Fragonard'. National Museum of Western Art, Tokyo/Kyoto Municipal Museum, Kyoto. Catalogue, Tokyo 1980

1981 MEXICO
'36 Impressionist and Fauvist masterpieces from the Hermitage and Pushkin Museum'. Instituto Nacional de Bellas Artes

1981–2 MADRID–BARCELONA
'Picasso 1881–1973. Exposicion Antologica'. Museo Español de Arte Contemporaneo, Madrid/Museo Picasso, Barcelona

1982 LENINGRAD–MOSCOW
'Pablo Picasso: 100th anniversary of his birthday'. Paintings from Soviet collections. Hermitage, Leningrad/Pushkin Museum, Moscow. Catalogue, Leningrad 1982

1982 TASHKENT
'French art of the 19th and early 20th centuries from the Pushkin Museum, Moscow'. State Museum of Art, Uzbekistan

1982 TOKYO–KUMAMOTO
'François Boucher 1703–1770'. Catalogue with introduction and text by D. Sutton, Tokyo 1982

1982 TOKYO–KYOTO–KAMAKURA
'Claude Monet'. National Museum of Western Art, Tokyo/ National Museum of Modern Art, Kyoto

1982–3 ZURICH
'Henri Matisse'. Kunsthaus Zürich/ Städtische Kunsthalle, Düsseldorf. Catalogue, Zurich 1982

1983 DRESDEN
'Das Stilleben und sein Gegenstand: Eine Gemeinschafts-ausstellung von Museen aus der UdSSR, der CSSR und der DDR'. Gemäldegalerie Neue Meister, Albertinum

1983 DÜSSELDORF
See 1982–3 Zurich

1983 LUGANO
'Capolavori impressionisti e postimpressionisti dai musei sovietici'. Thyssen-Bornemisza collection, Villa Favorita. Catalogue, Lugano–Milan 1983

1984 BERN
'Der junge Picasso: Frühwerk und Blaue Periode'. Kunstmuseum.

1984 LENINGRAD
'Antoine Watteau: The 300th anniversary of his birth'

1984 LENINGRAD–MOSCOW
'Still life in European painting'. Paintings from USSR and East German museums. Hermitage, Leningrad/Pushkin Museum, Moscow. Catalogue, Moscow 1984

1984 TOKYO–NARA
'French artists of late 19th and early 20th centuries from the collections in the Hermitage and Pushkin Museum'. Metropolitan Museum of Art, Tokyo/Nara Prefecture Museum of Art, Nara. Catalogue, Tokyo 1984

1984–5 PARIS
'Watteau 1684–1721'. Grand Palais

1985 LENINGRAD
'Hubert Robert and the architectural landscape of the second half of 18th century'. Catalogue with introduction by I. N. Novesel'skaya, Leningrad 1984

1985 VENICE–ROME
'Cézanne, Monet, Renoir, Gauguin, Van Gogh, Matisse, Picasso: 42 capolavori dai musei sovietici'. Museo Correr, Venice/Musei Capitolini, Rome. Catalogue, Milan 1985

1985 SAPPORO–FUKUOKA
'Western European paintings from the Hermitage collection'. Catalogue, Sapporo (Hokkaido) 1985

1986 QUEBEC
'Tableaux des maîtres français impressionnistes et postimpressionnistes de l'Union Soviétique'. Musée du Québec

1986 WASHINGTON–LOS ANGELES– NEW YORK
'Impressionist to early modern paintings from the USSR'. Paintings from the Hermitage, Leningrad and the Pushkin Museum, Moscow. National Gallery of Art, Washington/Los Angeles County Museum of Art, Los Angeles/Metropolitan Museum of Art, New York. Catalogue, Los Angeles 1986

1986–7 PARIS
'La France et la Russie au siècle des lumières: Relations culturelles et artistiques de la France et de la Russie en 18ème siècle'. Grand Palais.

1987 LENINGRAD
'Russia–France: The Age of Enlightenment: Russo-French cultural links in the 18th century'

1987 LUGANO
'Capolavori impressionisti e postimpressionisti dai musei sovietici, II'. Thyssen-Bornemisza collection, Villa Favorita.

1987 PARIS
'Subleyras 1699–1749'. Musée du Luxembourg

1987 TOKYO–NAGOYA
'Paul Gauguin'. National Museum of Modern Art, Tokyo/ Aichi Prefectural Art Gallery, Nagoya. Catalogue, Tokyo 1987

1987–8 BELGRADE–LJUBLJANA–ZAGREB
'Svetski majstori iz riznica Ermitaža od 15–18 veka' (Masterpieces from the Hermitage: 15th–18th century paintings and drawings). Narodni Muzej, Belgrade/Narodna Galerija, Ljubljana/ Muzejski Prostor, Zagreb. Catalogue, Belgrade 1987

1987–8 DELHI
'Masterpieces of Western European art from the Hermitage, Leningrad'. Catalogue, Leningrad 1987

1987–8 PARIS
'Fragonard'. Grand Palais. Catalogue by P. Rosenberg

Bibliography

HERMITAGE CATALOGUES

Cat. 1774
 E. Munich, *Catalogue des tableaux qui se trouvent dans les Galeries et dans les Cabinets du Palais Impérial de Saint Pétersbourg*, St Petersburg 1774
Cat. 1863
 B. von Kohne, *Imperial Hermitage: Catalogue of Pictures*, St Petersburg 1863
Cat. 1908
 Imperial Hermitage: Short Catalogue of the Picture Gallery, St Petersburg 1908
Cat. 1916
 Imperial Hermitage: Short Catalogue of the Picture Gallery, Petrograd 1916
Cat. 1958
 State Hermitage: Department of Western European Art: Catalogue of Paintings, Leningrad–Moscow 1958, vol. 1
Cat. 1976
 State Hermitage: Western European Painting: Catalogue I: Italy, Spain, France, Switzerland, Leningrad 1976

Nemilova, Cat. 1982
 I. S. Nemilova, *French 18th-Century Painting in the Hermitage Collection*, Leningrad 1982
Berezina, Cat. 1983
 V. N. Berezina, *State Hermitage: Western European Paintings: Early and mid-19th-Century French Painting*, Leningrad 1983
Nemilova, Cat. 1985
 I. S. Nemilova, *State Hermitage: Western European Paintings: 18th-Century French Painting*, Leningrad 1985

PUSHKIN MUSEUM CATALOGUES
Pushkin Museum Catalogues, Moscow 1948, 1957, 1961, 1986

Alpatov 1969
 M. W. Alpatov, *Matisse*, Moscow 1969
Alpatov 1973
 M. W. Alpatov, *Matisse*, Dresden 1973
Ananoff 1976
 A. Ananoff, D. Wildenstein, *François Boucher*, Lausanne–Paris 1976
L. Aragon, *Henri Matisse*, Paris 1971

O. Arnould, 'Subleyras' in M. Louis Dimier, ed., *Les Peintres français du 18eme siècle: Histoire des vies et catalogue des oeuvres*, Paris–Brussels 1928–30

'L'art moderne français dans les collections étrangers: Le Musée d'Art Moderne Occidental à Moscou', *Cahiers d'art*, 1950

Barnes, Mazia 1939
A. C. Barnes, V. de Mazia, *The Art of Cézanne*, Merion 1939

Baroque and Rococo Masters 1965
Baroque and Rococo Masters, Hermitage, Leningrad, Leningrad-Prague 1965

Barr 1951
A. H. Barr, *Matisse: His Art and his Public*, New York 1951

A. Barskaya, *Paul Cézanne*, Leningrad 1975

Barskaya, Bessonova 1985
A. Barskaya, M. Bessonova, *Impressionist and Post-Impressionist Paintings in Soviet Museums*, Oxford 1985; Leningrad 1985

A. Barskaya, M. Bessonova, E. Georgievskaya, *Impressionisten und Postimpressionisten in den Museen der Sowjetunion*, Wiesbaden 1986

J. Becker, 'The Museum of Modern Western Painting in Moscow', *Creative Art*, April 1932

Blanc 1862
C. Blanc, *Histoire des peintres de toutes les écoles: Ecole française*, 2 vols, Paris 1862

L. J. Bouge, *Gauguin, sa vie, son oeuvre*, Paris 1975

Brion 1972
M. Brion, *Paul Cézanne*, Milan 1972

Cabanne 1975
P. Cabanne, *Le siècle de Picasso*, Paris 1975

Cachin 1968
F. Cachin, *Paul Gauguin*, Paris 1968

Cat. Shchukin 1913
Catalogue of Pictures in the Shchukin Collection, Moscow 1913

Cat. State Museum of Modern Western Art 1928
State Museum of Modern Western Art: Illustrated Catalogue, Moscow 1928

Cat. Youssoupoff 1839
Musée du prince Youssoupoff contenant les tableaux, marbres, ivoires et porcelaines qui se trouvent dans son hôtel à Saint-Pétersbourg, St Petersburg 1839

Cézanne 1975
Paul Cézanne, introduction by A. Barskaya, notes by A. Barskaya and E. Georgievskaya, Leningrad 1975

Paul Cézanne, Hermitage and Pushkin Museums, introduction by A. Barskaya, commentary by A. Barskaya and E. Georgievskaya, Leningrad 1983

A. Chappuis, *The Drawings of Paul Cézanne: A Catalogue Raisonné*, 2 vols, London 1973

Charmet 1970
R. Charmet, *La peinture française dans les musées russes*, Paris–Geneva–Munich 1970

Cooper 1983
Ed. D. Cooper, *Paul Gauguin: 45 lettres à Vincent, Théo et Jo van Gogh*, The Hague 1983

Courthion 1934
P. Courthion, *Henri Matisse*, Paris 1934

Daix 1964
P. Daix, *Picasso*, New York 1964

Daix 1977
P. Daix, *La vie du peintre Pablo Picasso*, Paris 1977

Daix, Boudaille 1967
P. Daix, G. Boudaille, J. Rosselet, *Picasso: The Blue and Rose Periods: A Catalogue Raisonné of the Paintings*, New York 1966

Danielsson 1967
B. Danielsson, 'Gauguin's Tahitian Titles', *Burlington Magazine*, April 1967

Dauberville 1965
J. and H. Dauberville, *Bonnard: Catalogue raisonné de l'oeuvre peint*, 4 vols, Paris 1965

F. Daulte, *Alfred Sisley*, Lausanne 1959

Daulte 1971
F. Daulte, *Auguste Renoir: Catalogue raisonné de l'oeuvre peint*, Lausanne 1971

De la Faille 1928
J.-B. de la Faille, *L'oeuvre de Vincent van Gogh*, catalogue raisonné, 4 vols, Paris–Brussels 1928

De la Faille 1939
J.-B. de la Faille, *Vincent van Gogh*, London 1939

De la Faille 1970
J.-B. de la Faille, *The Works of Vincent van Gogh: His Paintings and Drawings*, Amsterdam 1970

Diderot 1875–7
D. Diderot, *Oeuvres complètes publiées par J. Assezat*, 20 vols. Paris 1875–7

Diehl 1954
G. Diehl, *Henri Matisse*, Paris 1954

Dorival 1948
B. Dorival, *Cézanne*, Paris 1948

L. van Dovski, *Gauguin*, Zurich 1950

Dussieux 1856
L. Dussieux, *Les artistes français à l'étranger*, Paris 1856

Ernst 1928
S. Ernst, 'L'exposition de la peinture française des 17ème et 18ème siècles au Musée de l'Ermitage à Pétrograd, 1922–5'. *Gazette des Beaux-Arts*, vol. 17, 1928

Ettinger 1926
P. Ettinger, 'Die modernen Franzosen in den Kunstsammlungen Moskaus', *Der Cicerone*, 1926

Faure 1924
E. Faure, *Paul Cézanne*, Paris 1924

Feist 1961
P. H. Feist, *Auguste Renoir*, Leipzig 1961

Feist 1963
P. H. Feist, *Paul Cézanne*, Leipzig, 1963

Fezzi 1972
E. Fezzi, *L'opera completa di Renoir nel periodo impressionista 1869–1883*, Milan 1972

J. Flam, *Matisse, the Man and his Art 1869–1918*, London 1986

Fosca 1961
F. Fosca, *Renoir*, London and Paris, 1961

French 19th-Century Masters 1968
French 19th-Century Masters in the Hermitage, introduction by A. N. Izergina, notes by A. G. Barskaya, V. N. Berezina, A. N. Izergina, Prague 1968

French 20th-Century Masters 1970
French 20th-Century Masters in the Hermitage, introduction by A. N. Izergina, notes by A. G. Barskaya, A. N. Izergina, B. A. Zernov, Prague 1970

Gatto 1970
A. Gatto, S. Orienti, *Cézanne: L'opera completa*, Milan 1970

J. Genthon, *Cézanne*, Budapest 1964

Georgi 1794
I. T. Georgi, *Description of St Petersburg, the Russian Imperial Capital, and of Monuments in its Environs*, Parts 1–3, St Petersburg 1794

E. Georgievskaya, I. Kuznetsova, *French Paintings from the Pushkin Museum of Fine Arts: 18th–20th Centuries*, Leningrad 1980

L. Gowing, *Cézanne*, exhibition catalogue, Arts Council of Great Britain, London 1954

L. Gowing, *Matisse*, London 1979

Les Grands Maîtres de la peinture au Musée du Moscou, Paris 1963

E. Heilbut, 'Die Wiener Impressionisten-Ausstellung',
Kunst und Künstler, 1903

M. Hoog, *L'univers de Cézanne*, Paris 1971

Ingersoll-Smouse 1926
F. Ingersoll-Smouse, *Joseph Vernet: peinture de marines, 1714–89*,
Paris 1926

Izergina, Barskaya 1975
A. Izergina, A. Barskaya, *La peinture française: Seconde moitié
du 19ème siècle, début du 20ème siècle*, Leningrad 1975

Jourdain 1948
F. Jourdain, *Cézanne*, Paris 1948

A. S. Kantor-Gukowskaia, *Paul Gauguin: Life and Work*,
Leningrad–Moscow 1965

A. G. Kostenevich, *French Art of the 19th and early 20th centuries
at the Hermitage*, Leningrad 1984

Kostenevich 1987
A. G. Kostenevich, *Western European Painting in the Hermitage:
19th-20th Centuries*, Leningrad 1987

Kuznetsova 1982
I. Kuznetsova, *Pushkih Museum: French Painting of the 16th to the
first half of the 19th century*, Moscow 1982

Lagrange 1864
L. Lagrange, *Les Vernet: Joseph Vernet et la peinture française
au 18ème siècle*, Paris 1864

Lassaigne 1959
J. Lassaigne, *Mattise*, Geneva 1959

Leymarie 1951
J. Leymarie, *Van Gogh*, Paris–New York 1951

S. Makovsky, 'French artists in the collection of I. A. Morozov',
Apollon, 1912, nos 3–4

Henri Matisse: Peintures et sculptures dans les musées soviétiques,
introduction by A. Izergina, commentary by A. Izergina, T. Borovaya,
N. Kossareva, Leningrad 1978

Meier-Graefe 1920
J. Meier-Graefe, *Cézanne und sein Kreis*, Munich 1920

Monet 1969
Claude Monet, introduction by I. Sapego, catalogue by A. Barskaya,
E. Georgievskaya, Leningrad 1969

A. Moravia, P. Lecaldano, *Picasso: periodo blu e rosa*,
Milan 1968

P. Muratov, 'Shchukin's Gallery', *Russkaja Mysl*, 1908, no. 8

Nemilova 1975
I. Nemilova, 'Contemporary French art in eighteenth-century
Russia', *Apollo*, June 1975

Nurnberg 1926
P. Nurnberg, *Cézanne*, Moscow 1926

Orienti 1972
S. Orienti, *Henri Matisse*, Florence 1971

Penrose 1958
R. Penrose, *Picasso: His Life and Work*, London 1958

Penrose 1971
R. Penrose, *Portrait of Picasso*, London 1971

H. Perruchot, *La vie de Renoir*, Paris 1964

Pertsov 1921
P. Pertsov, *The Shchukin Collection of French Painting*,
Moscow 1921

Picon, Orienti 1975
G. Picon, S. Orienti, *Tout l'oeuvre peint de Cézanne*,
Paris 1975

Prokofiev 1962
C. Prokofiev, *French Art in the Museums of the USSR*, Moscow 1962

Réau 1924
L. Réau, *Histoire de l'expansion de l'art français moderne:
Le monde slave et l'Orient*, Paris–Brussels 1924

Réau 1929
L. Réau, *Catalogue de l'art français dans les musées russes*,
Paris 1929

L. Rossi-Bortolatto, *Tout l'oeuvre peint de Monet (1870–1889):
Document*, Paris 1981

Reff 1977
Ed. William Rubin, *Cézanne: The Late Work*, essays by T. Reff et al.,
exhibition catalogue, Museum of Modern Art, New York 1978

Reuterswärd 1948
O. Reuterswärd, *Monet*, Stockholm 1948

Rewald 1939
J. Rewald, *Cézanne: sa vie, son oeuvre, son amitié pour Zola*,
Paris 1939

Rewald 1962
J. Rewald, *Post Impressionism: From van Gogh to Gauguin*,
2nd edn, New York 1962

J. Rewald, *Paul Cézanne: A Biography*, New York 1968

J. de Rotonchamp, *Paul Gauguin. 1848–1903*. Weimar 1906

Ed. W. Rubin, *Pablo Picasso: A Retrospective*, exhibition catalogue,
Museum of Modern Art, New York 1980

Rusakova 1970
R. Rusakova, *Paul Cézanne*, Moscow 1970

Russoli, Minervino 1972
F. Russoli, F. Minervino, *L'opera completa del Picasso cubista*,
Milan 1972

Scherjon, Gruyter 1937
W. Scherjon, W. J. de Gruyter, *Vincent van Gogh's Great Period:
Arles, Saint-Rémy and Auvers-sur-Oise*, Amsterdam 1937

C. Seiberling, *Monet's Series*, New York 1981

Sterling 1957
C. Sterling, *Musée de l'Ermitage: La peinture française de Poussin
à nos jours*, Paris 1957

C. Sterling, *Great French Painting in the Hermitage*, New York 1958

Tralbaut 1969
M. E. Tralbaut, *Vincent van Gogh*, London 1969

Ternovets 1925
B. Ternovets, 'Le Musée d'Art Moderne de Moscou',
L'Amour de l'Art, 1925, no. 12

Tugendhold 1914
'The French Collection of S. I. Shchukin', *Apollon*, 1914, nos 1–2

Tugendhold 1923
J. A. Tugendhold, *The First Museum of Modern Western Paintings:
The Former Collection of S. I. Shchukin*, Moscow 1923

A. Vallentin, *Pablo Picasso*, Paris 1957

Venturi 1936
L. Venturi, *Cézanne: son art, son oeuvre*, Paris 1936

Vercors, D. H. Kahnweiler, H. Parmelin, *Picasso: Oeuvres des musées
de Leningrad et de Moscou*, Paris 1955

A. Vollard, *Paul Cézanne*, Paris 1914

Waagen 1864
G. F. Waagen, *Die Gemäldesammlung in der Kaiserlichen Ermitage
zu St Petersburg, nebst Bemerkungen über andere dortige
Kunstsammlungen*, Munich 1864

Wildenstein 1964
D. Wildenstein, *Gauguin: Catalogue raisonné*, Paris 1964

G. Wildenstein, *Claude Monet: Peinture*, Lausanne–Paris, vols 1–3
1979, vol. 4 1985

Zervos
C. Zervos, *Pablo Picasso: catalogue illustré*, Paris 1952–